The Plain Style

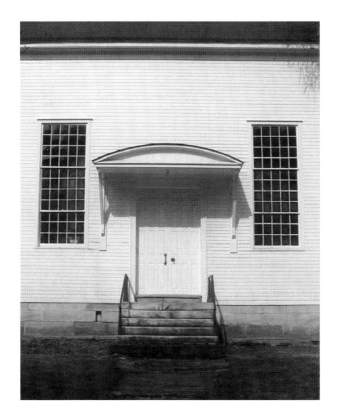

David Brett

The Lutterworth Press

The Lutterworth Press
P.O. Box 60
Cambridge
CB1 2NT

www.lutterworth.com
publishing@lutterworth.com

ISBN (10): 0 7188 3032 6
ISBN (13): 978 0 7188 3032 8

British Library Cataloguing in Publication Data
A catalogue record is available from the British Library

First published in 2004

Printed and bound in Great Britain by Athenaeum Press Ltd.

Contents

List of Illustrations

Preface to the second edition

The first edition of this book came about in circumstances that prolong themselves into this, its much enlarged and extended second edition.

Some twenty years ago, when I first made my home in Northern Ireland, I chanced to remark that I regarded myself as an atheist. I was then asked, with what seemed to be a straight face, whether or not I was a Protestant atheist or a Catholic atheist. The question, which anywhere else in the United Kingdom might seem bizarre, struck me at once as very interesting, because I recognised myself as belonging to the first category. I positively and firmly disbelieved in what I intuited was a very Protestant style. Moreover, looking more closely into the matter, I felt I could identify in my own convictions a clear and definite dimension which I understood to myself as a consequence of Quaker schooling. I wanted to understand what this dimension meant, because in the circumstances of neighbourly hatred then existing in the streets around me, there could be entailments. This was at a time when a man might be shot for simply walking on the wrong side of the road. Indeed, during the time of writing, seven were killed in my immediate neighbourhood, including one woman beaten to death with clubs; one acquaintance survived a political assassination attempt merely because the gun jammed, and another died on active duty. In the context of a piece I had written on the notion of 'heritage', a unionist journal described me in print as a member of a clique 'who would be given corrective therapy when the facts were known'.

At the time of starting this second edition, the major acts of violence have become a thing of the past; yet around me sectarian hatred continues to drive people from their homes and schools, and random murders scar the peace. Religious

differences are used to account for these crimes.

It seemed to me then, as it does now, important to understand these matters at a level beyond the daily or recent historical explanation, because religious differences have been one of the great moving engines of political history. The constitution and creation of the British State, and the subsequent settlement of what was to become the United States of America began with the assertion and the subsequent consolidation of religious difference. These differences have not been the sole causes: but without doubt qualitative factors of great consequence, which have a bearing on how people see themselves and conduct themselves.

In Northern Ireland the apprehension of these questions in recent years has led to an extended and not always fruitful debate on the supposed existence of 'two cultures' in an oppositional relationship. Affiliation to one or the other was seen as a guarantor of 'identity'. Now we are all classified under 'perceived religious affiliation' in official documents.

Under modern conditions, to align culture with a singular identity is to miss the main and salient fact of contemporary life, that we all simultaneously participate in many cultural domains and plural identities, and do so continuously in all levels of private and public life – nearly all of which are held in common. Singular identity has been reduced almost to vanishing point by the empires of capital and global communication. The insistence on 'identity politics' serves to hide or confuse common experience and interests, and to erect or reinforce barriers that cloak or deny that common sphere. This book is not a contribution to that misleading discourse.

However, to live only within contemporary plurality is to miss another main and salient fact, that the conditions under which we experience are not of our choosing; we live in historical time and bear the scars of it, along with the blessings. Accordingly, the aim of the first edition of The Plain Style was to enquire into the historical reality of a putative 'Protestant culture' so as to make it a little clearer what it might mean to assert this identity on the little, but bloodily vindictive, stage of Northern Ireland.

It soon became apparent that I had engaged upon a task that needed a good deal more space than I had allotted. The theme was running away with itself; I could only point to where it might lead, or allude to further 'topics for research'. In the end what I wrote was not much more than a suggestive sketch of a book. I

described it as 'a kind of provocation'. It was well received by those that read it.

My aim in this edition is to turn that sketch into a painting, by filling in all those forms I had merely outlined before, and by giving my study greater perceptual depth. The main theses remain, but given what I hope is greater critical attention and support, together with a much wider geographical and historical scope, leaving behind what Churchill once described as *'the dreary steeples of Fermanagh and Tyrone'* for wider and more fertile territory.

The essential method remains the same – that of aligning material practices of building, design and the like with theological concepts. Like Max Weber:

> we are interested . . . in those psychological sanctions, which, originating in religious belief and the practice of religion, gave a direction to practical conduct, and held the individual to it. Now these sanctions were to a large extent derived from the peculiarities of the religious ideas behind them.[1]

I am concerned with what I call a 'Protestant aesthetic'. By 'aesthetic' I mean a characteristic attitude toward materials and workmanship: by 'Protestant' I mean grounded in certain theological concepts and in the attitudes to authority that spring from them. Together these formed a set of intellectual structures which helped to fashion canons of taste and aesthetic expectations, which in turn outlasted the original situations that gave them birth. They also, I shall argue, informed the development of technics and the manufacture of objects. This complexity is the substance of design history, in all circumstances.

In the seventeenth century these interactions produced, throughout Britain and (with many local differences) other parts of Protestant Europe, a manner of building, of furnishing, of clothing, as well as of writing, speech and music, that was based upon two perceived qualities, 'plainness' and 'perspicuity'. This was sometimes spoken of as The Plain Style:

> This term plain style' is not something I have devised or that some ingenious historian has invented, like 'metaphysical', 'Augustan' or 'Victorian' as a convenience in narration. It was consciously used by the Puritans themselves.[2]

This manner or Plain Style was then extended by British and Dutch immigrants into the North American colonies, and later reinforced by numerous other settlers until it became a predominant feature in the material culture and visual *habitus* of the new found lands.

This book also relates to two large-scale questions which historians often refer to as the Weber Thesis and the Merton Thesis. The first, originating in Max Weber's book *The Protestant Ethic and the Spirit of Capitalism* (1905), links the Protestant and specifically Calvinist discipline with an ethic of work and purposive living which leads to an accumulation of capital and its investment in both economic and social forms. The second, first stated by Robert Merton in *Science, Technology and Society in Seventeenth Century England* (1938) argues that the Puritan spirit fostered the growth of independent enquiry which led in due course to the development of science. Both of these volumes have attracted and continue to attract criticism, commentary and development to an extraordinary degree. My discussion of the Plain Style and the rejection of imagery relates to that discourse, and gives some support to both theses. I do not, however, attempt to tackle either of them directly.

The principal debt that I owe to Weber lies in the general strategy or method of the present work; the presupposing of an ideal type, albeit of a provisional nature. One supposes the existence of an object of study in order to gain leverage on the leaden weight of data. If the data can then be moved into a comprehensible pattern, then we may assume (again, provisionally) that the lever we have chosen corresponds to some feature of reality.

The weakness of the strategy lies in this; that the ideal type is a mental construct that can never fit exactly to any one real case. The method cannot be a map that exactly renders the terrain; what it aims to give is a method of surveying the ground. To refer to Weber again:

> Thus, if we try to determine the object, the analysis and historical explanation of which we are attempting, it cannot be in the form of a conceptual definition, but at least in the beginning only a form of provisional description.[3]

Both writer and reader are in the position of those early navigators who, knowing that there is land, attempt to sail round

it to prove it an island, and having landed make straight for the highest point. We ask of their description not, is it accurate, but, is it useful? It is certain that the accumulating mis-matches between the ideal type and the brute facts must in time render the original chart redundant; but in the meantime the explanatory structure provided has generated discourse and helped to direct research toward sounder conclusions.

In fact, one thesis that begins to emerge in this book arrives at conclusions significantly different from those put forward by Weber. It discounts the sole importance of Calvinism and argues that the essential qualities of our 'Protestant aesthetic' are not particular to Calvinism or reducible to its influence.

What has not received much attention in these debates is the effect upon cognition of the destruction of pictorial memory and its replacement by emblematic and diagrammatic schemes of memorisation, which was one of the main aims of Reformation education, following upon the destruction of actual imagery in worship. This is an important theme in the following pages, in which I argue that it was a significant element in the early formation of modernity, and that it had significant aesthetic consequences. These matters seem to me to have some important bearing on the development of scientific language, through the refusal to use figurative speech and the espousal of plain terms. As such, parts of the following book tend to support the 'Merton hypothesis', as will become clear. I enlarge upon this in Chapter Five.

The book has its origins in an article that I wrote for CIRCA magazine in 1986. 'The Reformation and the Practice of Art' (CIRCA No.26. pp. 20-23) was part of a larger enquiry into this question occasioned by the deplorable condition into which Northern Ireland had fallen. That article derived from a much larger, book-length study on which I had engaged, covering much the same ground as this book. I was unable to interest any publisher with that project and so it lapsed. Much of the research work I had begun was being undertaken, at an altogether higher level, by historians such as Margaret Aston and Patrick Collinson. But today one perceives, on a worldwide scale, ancient antagonisms being revived for modern reasons. It becomes all the more important to look into the foundations of cultural difference to find our common humanity.

In writing this book I have benefited from the work of some of my students, and from conversations and seminars I have had with staff and students in Columbia University, the University of Pennsylvania and the Keogh Centre for Irish Studies at Notre Dame University, not to mention friends and colleagues here in Belfast. The staff of the University of Ulster Library have never failed me. In my short case studies of Quakers, Shakers, Amish and other 'plain people' I met several friendly and helpful individuals from whose conversations I have had benefit. They are too numerous to mention and some of their names are unknown. But I should like to mention Graham Gingles and Alastair MacLennan, whose art provided me with a way back into these matters, and I owe a particular debt to the friendship of Michael Quinn, who edited the early edition, and with whom I worked on several ventures.

I have tried to write in as straightforward a style as I can, as befits the subject, but some matters are unavoidably difficult or technical and don't resolve into easy prose. I have put a lot of detail into the footnotes, but on some occasions readers may have to grit their teeth. If you want to eat the kernel you must first crack the nut. Most of the books I have cited contain extensive and useful bibliographies.

All photographs, unless otherwise stated, have been taken by the author or Barbara Freeman.

1. Weber, M., *The Protestant Ethic and the Spirit of Capitalism* tr. Parsons (London 1976) p. 97
2. Miller, G.E.P., *Nature's Nation* (New York 1967) p. 211
3. Op. cit p. 48

INTRODUCTION

The basic argument is simple. It is, in its barest form, that the propagation of imagery in any society is directly related to the dissemination of authority. Consequently, attempts to restrict imagery relate to changes in the extent, location and exercise of power. I believe this to be a general principle of cultural development, though I am not at all sure how far it can be pressed in contemporary conditions when images can be reproduced and broadcast with such ease. By images I shall generally mean pictures and statues; but I shall also be concerned with the role of mental imagery in the development and training of thought, and of imagery in language, especially in scientific and religious speech.

The removal of imagery from worship that took place at the Reformation was therefore both an index and an ancillary cause of a dramatic shift in the location of authority; this had significant aesthetic consequences. The central issue of the Reformation was indeed the same – the location of authority. Did it reside in the accumulated teachings of the Church, or in scripture only? And if in scripture, by whom was it to be interpreted? By a learned clergy, by the congregation, or by the individual? And if in accumulated teachings, under what system of government? Papal, Episcopal, princely, or devolved? John Robinson, the pastor in 'The Mayflower' put the matter thus:

> The papists plant the ruling power of Christ in the pope, the
> Protestants in the bishops, the Puritans in the Presbytery,
> we in the congregation of the multitude called The Church.[1]

Put another way – did authority flow from the top down or rise from the bottom up? In Ecclesiastical terms the test case was pre-eminently the status and power of bishops who were appointed and subsequently controlled appointments and ordination, and were held to guarantee legitimate succession. As one anti-Puritan pamphleteer put the matter in 1644 *'Dislike*

of Bishops is the beginning of all Heresie, and needs must end in Anabaptism and rebellion'. To which we may append the axiom attributed to James VI of Scotland (James I of England): *'No bishops, no king'.*

The location of authority has further consequences of an administrative and financial character which, as we shall see, have further consequences still for the art of building, ornament and personal embellishment. At its crudest, a pastor is unlikely to build a cathedral; he could not command the resources even if he wished to. He would not wish to, whereas a bishop might and could and often did.

The location of authority aligns almost exactly with the attitude taken toward imagery by the several systems of religious governance. Briefly – the more centralised the system, the more imagery in worship. In the increasingly anti-authoritarian 'left' hand end of the spectrum, imagery comes to be entirely rejected; but here we have to do with a system of ideas in which any mediation, ritual or formal structure that stands between God and man may be inherently wicked. An image is such a mediation. This appears to be a general principle in all the major religions.[2]

Once again we should note that the suspicion of visual display that Protestant (and more particularly 'Puritan') communities have often demonstrated, even while having a distinct visual style of their own, is both a cause and an effect of their organisational structure. But the point to make is that both are the consequences of a theological definition of authority.

This can be shown easiest by means of a diagram that I think holds well in nearly every case, though like a strong and simple idea it is a better servant than a master. There are also problems, which we shall encounter later in the text, with the idea of a truly an-iconic worship.

Image-Rich	←	Papal	→	Centralised Authority
		Episcopal		
Image-Scarce	←	Presbyterian	→	Dispersed Authority
		Congregational		
Image-Less	←	Individual	→	Anarchist

It will be understood, I think, that in the central column of this chart I am referring to general principles of governance, not specific instances. Thus Presbyterian churches have had a

variety of practices with regard to imagery, and within Lutheran and Anglican Episcopalians, practice varies from region to region in different periods. Thus the (Episcopalian) Church of Ireland, though part of the Anglican communion, is notably less iconic than its sister church across the Irish Sea because historically it has always had to mark itself off sharply from Catholic and 'popish' practices to avoid being outflanked on this issue by Presbyterian and Congregational rivals. This has not been the case in England, where Catholicism was historically of smaller significance, and popularly seen to be alien and even hostile.

In the second chapter I shall be able to align this organisational scheme with others that are similar, referring to mental imagery, emblems and the training of memory.

The more we examine the issue of imagery and authority, the more we begin to see that any discussion of a possible 'Protestant aesthetic' has to begin with a study of the destruction of religious imagery during the Reformation. The account of this destruction has to be both historical – the when and the where of a varied and often zigzagging process; and the why – the spiritual and more especially theological rationale behind an activity that can only seem dismaying to anyone concerned with beautiful objects, craftsmanship and art.

For the purposes of this book we shall first concentrate upon English and Scots accounts and documents. Equivalent material from Ireland is rather scarce, and the extensive material from Germany, Switzerland and Holland refers to events in significantly different political situations. Briefly, Reformation iconoclasm in England and to a lesser degree in Scotland was part of a drive toward the expansion of secular power, and partook of a redefinition of the political state and its limits. A concentration on English theological argument through a short study of the thought of John Wyclif enables me to bring out more strongly the important Platonic tendency in the Reformers' programmes. All this forms the substance of the first chapter, entitled 'Imageless Worship'.

In Chapter Two I will argue that the elimination of physical imagery was accompanied by a deep change in internal psychic or mental imagery, particularly as it applied in memory training and the formal curriculum. It was also in large measure a reconstruction of character, since identity is preserved in memory. The process demanded a constantly vigilant self-scrutiny. The Reformers attempted

to extirpate mental imagery just as much as they successfully removed religious statues and pictures from worship, but they were always aware how difficult this was, since the human mind is, as Calvin wrote, 'a factory of idols'. These matters are intimately connected to the spread of printed text which progressively replaced the systematic training of memory, though they cannot be reduced to that. We may surmise that it also has bearing on the development of science and the habits of thinking in technological terms. This chapter is entitled 'Imageless Thought?'

In Chapter Three I describe the beginnings of 'the Plain Style' and the concept of 'perspicuity'. The terms were first used in reference to preaching and the language of sermons, but they also related to the demand for a style of singing in which the words had equal place with the music and were fully audible, and of course to the new appearance of reformed churches and meeting houses. The removal of imagery, the 'cleansing' of the church buildings by whitewash, the removal of altars and their replacement by tables in the body of the nave, recreated the architectural setting of worship with a plainness that soon became attached to household goods, clothing and everyday furnishings of all kinds. The term 'Puritan Minimalism' has been used to describe the new domestic setting. The spread of plainness into everyday matters indicated, during the seventeenth century, a shift in and a blurring of the boundaries between the sacred and the secular realms. Briefly, secularisation of society had to be preceded by a secularisation of the imagination.

Chapter Four deals with the Plain Style as an orthodoxy – especially as in the American colonies where it is now often referred to as the Colonial Style. This is a misnomer, I argue; because it was the style taken by the first settlers as a sign of their reformed beliefs and, meeting with no alternative, became the characteristic aesthetic of the new States. Quaker and Mennonite settlers reinforced this transatlantic plainness, which reaches its height in the architecture and design of Shaker communities.

Chapter Five is in part a critique of the concept of 'functionalism'. Of particular importance is the technical culture of the seventeenth century, in Britain and the Low Countries, and of the relations between Puritan habits of thought and the spread of technology both through products and through an extensive technical literature. The guiding intellectual structure I suggest is an amalgamation of the utilitarian and the Platonic, typical of aspects of the Reformed

curriculum. This amalgamation is seen as the foundation of early industrial design in Britain and America and the generator of a body of design theory in the late eighteenth century. If valid, such a thesis must modify our understanding of subsequent 'modernisms', by insisting upon a theological substratum.

At several places in the text I make use of the sociological concept of *habitus,* which in Pierre Bourdieu's terms designates the deeply 'interiorised' master patterns of a culture or a class which, persisting over time, substantiate particular cultures and modes of behaviour *in* time. The visual aspect of habitus I shall sometimes refer to as visual ideology, I have also found useful the distinction made in social sciences between *Gemeinschaft,* that form of community established on the basis of traditions, social customs and beliefs, and its modernising successor, *Gesellschaft,* which replaces custom by contract, rationality and codified law.

My last chapter has both a summarising and a critical intention. I remain interested in the historical and theological substrata of contemporary culture in much the same way as a geologist is concerned with the underlying rocks of the landscape about him. The rocks are not seen, but they are there, nonetheless, and largely determine what will grow, how the water runs, and where it is safe to dwell.

1. See Hall, B., 'Puritanism: the problem of definition' *Studies in Church History* Vol 2, ed. G. Cuming. (London 1965)
2. One can see, in both Buddhism and Hinduism, a full spectrum between a rich panoply in iconography and a spare asceticism. Islam is notionally suspicious of any imagery but introduces it surreptitiously through calligraphy, as does Judaism. In wider terms still, political authority has always been supported by imagery, and revolutions require the almost ritual procedures of statue breaking and picture defacement. For a general discussion of 'iconic' and 'an-iconic' cultures, see entries in the McGraw Hill *Encyclopaedia of World Art* under 'Images and Iconoclasm' by Silvio Ferri and Rosario Assunto: 'the more spiritualised religious conceptions – in general the monotheistic religions – tend more or less rigorously to an-iconism; the more severely aniconic the attitude, the less anthropomorphic the conception of divinity, and the less important the place assigned in the theology to intermediaries between God and Man'. But Freedberg (1989) has criticised this summary account of the matter

I
IMAGELESS WORSHIP

We live in a post-religious world.

Religious beliefs and practices continue to be held and followed, devoutly and with passion, and with consequences for those concerned: but their public significance and scope have narrowed. Concepts and doctrines that were held to be veridical and rooted in a coherent ontology have been thinned out into metaphors. They seem to have etherialised almost to vanishing point in most areas of life.

One such area is that of the visual arts and architecture. For the past hundred or more years it has been almost impossible to produce a clearly 'Christian' iconography that has not appeared kitsch or laboured. I write 'almost' because we can find counter-examples.[1]

This points toward what I take to be a sustainable thesis; that the general failure to develop a convincing Christian iconography in contemporary conditions is matched by the withdrawal of theologically articulated doctrine from the public realm. The central Christian concepts of sin, redemption, grace and salvation can no longer be pictured. There is no visual or plastic language adequate to the task. The expression of Christian doctrine, as opposed to sentiment, has been reduced to the private sphere; it is in this sense that I write of a 'post-religious society'.

However, the absence of coherent doctrine and iconography has not deterred artists from attempting the spiritual transcendent or the sublime. Even a slight acquaintance with the classic painters of what is usually called 'Modernism' shows us this ambition at work. Malevich, Mondrian and more recently Rothko all, in some measure, refer or allude to religious iconography, although the overt doctrinal origins of a black square, the vertical and horizontal axes, or the cloud of unknowing are no more than hinted at.

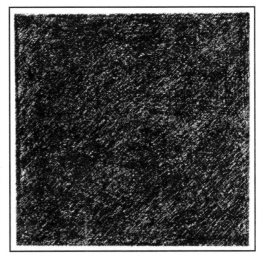

K. Malevich 'Black Square'. In 1917 (or earlier) Malevich began a series showing 'the supremacy of pure feeling'. Believing representational painting to be based on crass materialism, he tried to show that spiritual art must be 'non-objective'. At the first exhibition of this work, a black square was hung diagonally across the hall from the doorway; the place traditionally assigned to the holy icon.

It is now well recognised that all three of these artists had their formative cultural heartland well within the anti-pictorial traditions of, respectively, the Greek Orthodox Church, Calvinism, and Judaism. What is not so often noticed is the absence of Catholic background in early non-figurative painting. These are matters to which I return in my final chapter.

What this suggests to the present writer is that the idea of a 'post-religious society' is only partial. There remains an undertow of assumptions and deep theory which have their origins in religious tradition and specific doctrines which, though now largely disavowed or unrecognised, are still active and formative. As I shall argue later, many of these have deep political consequences. It is because these assumptions and deep foundations are mainly disavowed, ignored, or simply unknown, that certain important topics in the cultural history of Europe and America have become difficult to see, let alone think about. The one that concerns us here, is the destruction of imagery that took place during the Reformation, and the aesthetic consequences of that destruction, and how these are enmeshed with political matters.

*

For art-historians, the Reformation and its attendant iconoclasm marks an 'event horizon', beyond which is a void. It has been described by two authors as follows:

The task of the historian [of English medieval sculpture] *is*

not unlike that of the palaeontologist who from a jawbone, two vertebrae, a rib and a femor contrives to reconstruct the skeleton of a long extinct creature and endow it with flesh. The result of the destruction of well over 90% of English medieval imagery is gravely to distort our vision of the past.[2]

The sobering fact remains that the furnishing of the churches in carved wood and stone, in painting, embroidery and metalwork represented almost the entire cultural heritage and achievement [of Scotland]. *The wilful destruction of all this by misguided men was a natural calamity of the first magnitude, the effects of which on native industry and craftsmanship have been far-reaching.*[3]

More generally, the lack of an art to historicise gave rise to the assumption that the Reformers – those 'misguided' men – were against 'Art'. Since sixteenth century men and women *did not have a concept of art in any way comparable with our own*, this assumption misses the point. What they were against was the use of imagery to enforce religious authority, which is something very different. The failure to grasp this simple point affected generations of scholars, clerics and lovers of the beautiful. Our understanding of the great gothic cathedrals, for example, was largely formed by the Ecclesiological movement of the mid-nineteenth century that was concerned to revive liturgical splendour and 'restore' church fabric. Few of the writers of that period ever considered that the Reformers might have had very good reasons for their work of breaking.[4] And that they were not vandals.

Since those responsible for the image breaking were nearly always acting within the law and under the direction of civil or religious edicts; or if they were not within the law, then they were acting with the support or connivance of powerful interests, it seems much sounder to describe the events as being a stage in a political and cultural revolution whose purpose was to reconstruct patterns of power, beginning with ecclesiastical power. The destruction of images was an essential, public, and immediately understood element in this reconstruction, which everyone witnessed and in which large numbers of people participated. To anyone (irrespective of belief) who cares for beautiful objects, a study of image breaking is distressing; but

to discuss it in terms of vandalism is, to repeat, missing the point. We are led to do so, because most of the reports we have are from those who complained, and because they chime with our prejudices.

In 1547, after a Royal Injunction warning against all uses of imagery in worship, Bishop Stephen Gardiner of Winchester wrote a bitter letter of complaint to the garrison commander in Portsmouth, referring to the '*hogs*' who had pulled down a figure of the crucified Christ '*so contemptuously handled as was in my heart terrible, to have the one eye bored out and the side pierced*'. Portsmouth was a Tudor naval base of great importance, recently developed by Henry VIII as part of a system of coastal defences; its control was an important part of royal power. Yet neither civil nor military authorities appeared to have tried to quell the '*tumult*' that Gardiner described. It is not impossible that they encouraged it. This, the Bishop warned, was a very dangerous precedent:

> For the destruction of images containeth an enterprise to subvert religion, and the state of the world with it, and especially the nobility, who, by images, set forth and spread abroad, to be read of all people, their lineage and parentage, with remembrance of their state and acts. The King's standards, his banners, his arms, they should hardly continue in their due reverence.[5]

Gardiner was right. That same year, as part of the same injunction in which Gardiner and his diocesan priests had been ordered to '*take away, utterly extinct and destroy all shrines, all tables, all candlesticks, pictures, paintings and all other monuments of feigned miracles . . . so that there remain no memory of the same within their churches and houses*' the ecclesiastical authorities were ordered that '*any image or picture set or graven upon any tomb in any church only for a monument of any King, Prince or Nobleman . . . may stand and continue in like manner*'.[6]

It cannot be stressed too strongly that the enterprise of religious image breaking contained always, from the first, an immanent possibility of secular revolution. It was thus a dangerous creature for the civil authorities to unleash and then attempt to ride. Exactly a hundred years later, the Royal standards, banners and arms had been cast down and Charles I was facing trial and execution. To this day, the defacement of pictures and the pulling down of statues is a powerful and well-

understood demonstration of sudden change of regime.

Today the signs of this iconoclasm in British churches are visible only to those with the eyes to see them. Looking at the facade of a cathedral or the interior of an old parish church now, we see only what is left or what has been added much later; we have few sure means of knowing what might have been. In 1530 the interiors of such buildings, and in some measure their exteriors too, were richly coloured with wall paintings (fragments of which are sometimes found under layers of old whitewash), vividly coloured statuary, and woven or embroidered wall hangings. By 1550, most of this had gone, and by 1600 virtually all of it, despite stubborn rearguard action in some dioceses and country districts, and despite major attempts to reverse the direction of events. We have to deduce the physical setting of worship (which was also, of course, the physical setting of major social events and the primary public space of every small community), from occasional documents, by inference from distant examples, and from the remaining fragments.

We may take as a small case study the Lady Chapel of Ely

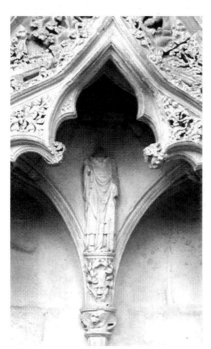

Detail of the Lady Chapel, Ely. An 'executed' unknown saint or bishop

Cathedral. The statues of saints and biblical figures that inhabit the many small carved niches in this dainty space are almost all intact, save in one crucial respect. Each has been neatly relieved of its head. The orders to do this came from the bishop himself in 1541; he was deeply involved in Henry's dissolution of the monasteries and church reforms. Bishop Goodrich's decision was one of the first examples of iconoclasm in Great Britain. It is notable that the figures have not been smashed wholesale, in a frenzy, but (as it were) executed. The larger niches, which evidently held life-size figures, have been emptied completely of their statues. Behind the altar there

Detail of the Lady Chapel, Ely. The scars of the broken reredos left unrepaired as a record of history. The painting is dull orange or red, with patches of gold leaf. There was evidently a substantial structure here in the Middle Ages judging from the solid plugs of wood.

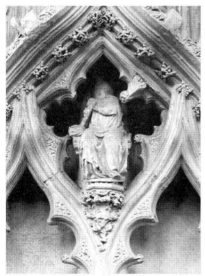

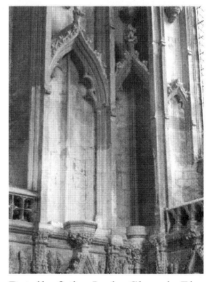

Detail of the Lady Chapel, Ely. Another executed figure. The act of beheading was not 'vandalism', but an official sanction, ordered by the bishop himself in 1541, during the reign of Henry VIII.

Detail.of the Lady Chapel, Ely. Niches presumably built to house life-size images of saints or angels of great beauty, probably carved in lime-wood, and brightly painted and decorated.

are unmistakable signs that the reredos or elaborate altarpiece has been torn out. The chapel has also been cleaned of colour, down to the original stone, though traces of orange red and blue paint remain. And there is good reason to suppose that these images were in fact very brightly painted. We can infer it from a similar situation in Utrecht where a plastered-in niche was recently re-opened and revealed similar carvings, brilliantly painted in red, blue and gold leaf. The chisel marks that ritually and selectively defaced them stand out as fresh as the day, in 1580, when they were made.

The destruction of church imagery came close to a destruction of all public imagery, since outside the church large scale pictures of any kind were rare objects available only to the rich and powerful. Colour, or at least permanent bright colour, was itself scarce and expensive. Thus the destruction of statuary and the obliteration of wall paintings and altarpieces can only have been a visual shock to the whole population, whose consequences are hard to imagine today.

In time, this destruction directed artistic ambitions toward non-religious subjects (which stood in, now and then, for Christian icons); and it encouraged a manner of secular design that endowed formerly secular objects with a sacred nimbus. But before we can investigate this 'plain style', we have to ask why it was necessary for reform in religion to demand the removal of imagery from worship.

The origins of iconoclasm are ancient. All the Abrahamic religions have in different degrees treated imagery with suspicion. Judaism retains the general prohibition, as does Islam. The early Christian churches had prolonged disputations in and around the topic before settling them at the Council of Nicaea (787). In fact, most dissenting movements in the Middle Ages, and in earlier times still, had been iconoclast to some degree. *Dissent* is a generic term for the rejection of some authority, but clearly, from the orthodox point of view, we are concerned with ideas of *heresy*. Heresy, by specifying the grounds of dissent and stiffening emotional resistance with theory, may turn dissent into a counter-cult. It is in part a search for new forms of association in conditions of weakened authority: *'To become associated with an heretical sect . . . was to accept a new solidarity'.*[7]

This solidarity did not have to be earthly. Amongst the promises made to one Vilgard (who was burned in 1022) was

Reredos in the Chapel of van Arken (St Anne, The Virgin and Child). The Dom Church, Utrecht. Bright red, blue and gold leaf.

'When you have fed on the heavenly food and achieved inner satisfaction you will often see angelic visions with us.' The wretched man had been tempted from the orthodox path by two clerks, Stephen and Lisois; the details of their counter-cult are unimportant beside the fact of their utter defiance:

> *You may tell all this to those who are learned in earthly matters, who believe the fabrications that men have written on the skins of animals. We believe in the law written within us by the Holy Spirit, and hold everything else, except what we have learned from God the maker of all things, empty, unnecessary and remote from divinity. Therefore bring an end to your speeches and do with us what you will. Now we see our king reigning in heaven. He will raise us to his right hand in triumph and give us eternal joy.*[8]

In such an utterance, with its stress on the internally inscribed word, its reformulation of knowledge, and in its assertion of the direct experience of the divine, we have the authentic voice of the mystical anarchism that is one of the recurring themes in these pages.

The prisoners had been brought before the Bishop of Cambrai to answer a long string of charges, which included the rejection of baptism, the Eucharist, confession, and the veneration of saints later than the apostles and early martyrs. These were all sticking points five hundred years later. R.I. Moore observes:

> *The consistent tendency of these points is to set aside the role of the church as the mediator between man and God, and with it the paraphernalia of saints and sacraments through which the layman officially approached his Maker.*[9]

The painted or carved image was manifestly a part of this mediation.

The Waldensian church provides a stable and long-lasting example of a counter-cult. From its founding by Peter Valdes in 1176, it took a mere three years for their teachings to be prohibited. Five years later they were included in the general condemnation of heresies propounded at the Council of Verona (1184) and later by the fourth Lateran Council (1215). From then on their path lay

> *outside the Church. As we shall see, they came the closest to constituting, if not an ecumenical, at least a European-wide counter-church, which outlasted the Middle Ages and became part of the Reformation.*[10]

Their beliefs included the refusal to swear oaths (an arrow aimed at the very heart of feudalism); that there was no purgatory (rendering prayers for the dead and the cult of saints unnecessary); and that anyone not in a state of sin (including women) could dispense the Eucharist. We know about their attitude to imagery in negative terms only, from propositions published against them by the rector of the University of Prague, in 1417. This writer, John of Jesenic, sought to affirm what the Waldensians evidently denied; that images might be worshipped, that the kissing of images was not idolatry, that the splendid decoration of images increased the fervour of devotion, and that no images should be destroyed. This is very close to the English Lollard position on imagery – that images should not be worshipped because they tended to idolatry, that decoration distracted from devotion, and that all or some imagery should be destroyed. In Waldensian communities, the use of vernacular scriptures was stressed, and the sole source of spiritual authority was the words of Christ and his apostles.

However, it was not necessary to be heretical to be sceptical as to the value of imagery in worship. The major example of this position is provided by the Cistercian Order.

Following the teachings of Bernard of Clairvaux, the Order rejected visual display. Bernard's 'Apologia for Abbot William' (c.1125) is a polemical writing on monastic discipline addressed to the Cluniac or 'black' order from within his own Cistercian or 'white' order. It is not a set of prescriptions which are to be strictly followed, but an ironic commentary on current practice. Bernard's salient attack is against what he calls 'superfluity', because:

> It is a cruel mercy that kills the soul while cherishing the body . . . what evidence of humility is here when one solitary abbot travels with a parade of horseflesh and a retinue of lay-servants that would do honour to two bishops?[11]

After numerous comic examples, the author passes on to:

> the place of pictures, sculpture, gold and silver in monasteries. . . . I pass over the vertiginous height of the churches, their extravagant length, their inordinate width and costly finishings . . . one sees in churches nowadays great jewelled wheels bearing a circle of lamps, themselves as good as outshone by the inset gems. Massive tree-like structures, exquisitely wrought, replace the simple candlestick . . . what is this show of splendour intended to produce? The walls of the church are ablaze with light and colour, while the poor of the Church go hungry.

From this tirade he passes on to another:

> But what can justify that array of grotesques in the cloister where the brothers do their reading, a fantastic con-glomeration of beauty misbegotten and ugliness trans-mogrified? What place have obscene monkeys, savage lions, unnatural centaurs, manticores, striped tigers, battling knights or hunters sounding their horns? You can see a head with many bodies . . . this one has horns in front and a horse's quarters aft. With such a bewildering array of shapes and forms on show, one would sooner read the sculptures than the books, and spend the whole day gawking at this wonderland rather than meditating on the law of God. Ah Lord! if the folly of it does not shame us, surely the expense might stick in our throats?

This is, he observes, a rich vein, *'and there is plenty more to be quarried'*. There might be some advantage for people who need material ornamentation to inspire their devotion:

But we who have separated ourselves from the mass, who have relinquished for Christ's sake all the world's beauty and all that it holds precious, we who, to win Christ, count as dung every delight of sight or sound, of smell and taste and touch, whose devotion do we seek to excite with this appeal to the senses? You want me to explain? It's an amazing process, the art of scattering money about that it may breed . . . it disposes to giving rather than praying . . . etc.

I have quoted this famous diatribe at length because it was often and tediously paraphrased during the Reformation. It was not primarily theology that directly inspired these words, but the desire to return to an original simplicity of observances, which had been the aim of the Cistercians from the start. This included not only a simplification of the liturgy, but also of its setting.

All writers note the relative bareness of Cistercian churches, and their use of plain rather than coloured glass: the typical Cistercian abbey seems to have had a distinctly 'Protestant' appearance.

The desire for pristine simplicity is a frequent demand of all reform movements, and the more radical reformers were always more likely to break images rather than simply remove them.

Polemicists cited well-known authorities to justify the destruction – chapters in Exodus and Romans, and early churchmen such as Eusebius and Origen. They largely repeated the arguments of the eighth century when the official church attitudes to the use of church imagery were comprehensively sorted out, and they did so at wearisome and redundant length. In essence, they began by repeating the distinction between a legitimate use of imagery as an aid to education and memory (*dulia*), that is to say, as a *sign*; and then they contrasted that with a suspect devotion to the image itself (*latria*) which in extreme cases is taken to be a wonderworking presence, akin to the *Real Presence*, which might then become the object of worship in its own right.[12] In the process, depending on where one located the source of authority, all use of imagery became increasingly suspect lest the first turn insidiously into the second. Bishop John Jewel of Salisbury (1522-71), to whom we will return,

concluded that *'the best remedy in this behalf is utterly to abolish the cause of the ill.'*

This is not, however, a theory of the image. For the destruction of imagery to become systematic, legal, and directed by great powers, there must be such a theory. A distinct theory of the image became necessary when church authorities were compelled to differentiate between competing dissenters, when movements for orthodox reform (like the Cistercians, and later the followers of Erasmus) sought to put a distance between themselves and dissenters, and when these parties contended as approximate equals. Until then, image breaking was merely part of the general demand of the disaffected, to be rid of so much mediation between God and man, observable throughout Europe as a more or less permanent possibility of divergent religious practice, all through the Middle Ages.

Moreover, the dissenters and heretics did nothing to stem the astonishing development of late medieval painting, sculpture and decorative art. Fifteenth century England in particular appears to have had an exceptional flowering of such work, parallel with and at least the equal of contemporary work in the Low Countries and German-speaking Europe. I stress the importance of England in this, because it was in England, through the theology of John Wyclif (d.1380), that the religious functions of imagery received their most telling philosophical and theological criticism. It is important to understand the force of this criticism because a great deal follows from it.

Readers now have to engage, for the while, on the unfamiliar terrain of philosophical theology. As I wrote above; if you would eat the kernel you must first crack the nut.

Wyclif reintroduced into Christian thought an extreme Platonism: that is to say, a conviction that the reality existing before our eyes is an imitation or simulacrum of the Real, which itself exists only as an archetypal Idea. Platonism compels us to regard images as doubly unreal, as the imitations of imitations of the Idea. This Idea was the *esse intelligibile* of something that, in Wyclif's thought, existed only in the mind of God. As applied by Wyclif to the actually existing medieval Church, this meant that the devout believer should pass over the actually existing institution and its teachings in favour of the Idea of the True Church which existed eternally in the Divine Nature. This True Church was the archetype or *esse intelligibile* of the worldly

church, and it was impossible to tell whether or not any actually existing feature or practice of ecclesiastical life on earth partook of the Truth. These actual features included, of course, the panoply of imagery and ritual. If it did so partake, this was solely through the operation of God's Grace, and since Grace is given only by God to His Elect (and they can be identified only by God), all worldly religious authority is subverted. Thus the actually existing church and its practices might indeed be an Anti-Church of an Anti-Christ. From which it most certainly followed that the apparatus of mediation – in which imagery played a leading part – might very well be a devilish simulacrum of True Worship.

By these means, Wyclif *created an alliance between the individual and the apostolic tradition against the present church hierarchy, with far-reaching results*.[13] Henceforth, objections to imagery were rooted in a theology that was essentially anti-authoritarian.

Considered ideologically, this theory also provided a fine rationale for the dissolution of religious orders and the extension of the state. In his two last writings. *De Officio Regis* and *De Potestate Papem* (1378-9), Wyclif specifically called upon monarchs to do for the church what the church cannot do for itself – reduce it to holy simplicity. Wyclif, not surprisingly, had powerful protectors and was able to escape the punishment of heretics: but as Stephen Gardiner observed, such ideas are inclined to run wild. Wyclif's argument against the actually existing church could later be applied to the actually existing state it helped to create.[14]

How far Wyclif's teachings informed the Lollard tradition of dissent is a matter for expert debate. W.R. Jones described the Lollards as possessing *'not a systematic body of belief, but rather a loose assortment of opinions and attitudes'*.[15] Whatever closer study might yield in this respect, there is certainly a persistent an-iconic tendency in reports of Lollard activities.

In the published records – nearly all trial records – we read of men and women being ordered to carry crucifixes and candles into church, to kiss images, and to genuflect. We hear of others indicted for cutting up images for firewood. In Strype's *Ecclesiastical Memorials* (1822), a man questioned replied violently that:

> There is no other church of God, but man's conscience
> . . . that if I had the crucifix, the Image of Our Lady, and

other saints and crosses set by the way, in a ship, I would
drown every one in the sea. (Ibid. p. 57)
To which a modern writer comments that this:
Vehement iconoclastic language anticipates the physical
attacks on holy objects which were perpetrated under
Edward VI.[16]
When Lutheran ideas reached England they met an already
existing native tradition that was primed to receive them.

All the major reformers showed a concern to look again at
the earliest church fathers, especially St. Augustine, who had
himself been concerned to bring Christianity into some
philosophical agreement with classical theory and Platonic
philosophy. He made a distinction between the 'visible' actual
church, and the 'invisible' eternal Church which could only induce
criticism of the former. This tendency was strong in Martin
Luther's writings, which stressed the saving and inscrutable
nature of Grace and set individual responsibility to the 'invisible'
against actual ecclesiastical authority. Once again, this was an
argument that ran wild. It served the ambitions of German civil
authorities against princely overlords, and the overlords against
their Emperor, and, what was worse, it could be used as a
justification for an assault on all authority. Luther was keenly
aware of this possibility and found it necessary to warn against
the excesses of those who had begun as his followers.

Where images were concerned, Luther took a conservative
attitude, likening them in a familiar argument to *'the people's*
books'. As a believer in organised authority at the level of princes
and bishops, he sought to retain imagery for commemorative
and educational purposes *(dulia)*, providing always that it was
based upon Biblical sources. He, like Gardiner, was keenly aware
of the dangers of anarchy:
No-one who sees the iconoclasts raging thus against wood
and stone should doubt that there is a spirit hidden in
them which is death-dealing, not life-giving, and which at
the first opportunity will also kill men, just as some of
them have begun to teach.[17]
And Luther was right. In German-speaking Europe, where
political power was dispersed, the relocation and decentralisation
of religious power had immediate disruptive consequences. There
was a series of crises – peasant uprisings, urban mayhem and
civil wars. And though today Lutheran churches tend to be

unadorned and often Spartan in their simplicity, during the sixteenth century Luther's support for a reformed imagery sparked a very vigorous increase in religious painting and statuary – provided always that its subject matter was scriptural in provenance.[18]

<center>*</center>

It is not necessary to go through a detailed history of the Reformation in order to seize the essential points; but it is important to understand reformation as a process rather than an event. It did not proceed at a uniform pace, but in sudden shifts, often reversed. It varied from country to country and region to region. It was at every point enmeshed with complicated class and sectional interests whose details are now hard to disentangle. Nor was it uniformly popular; it was frequently a revolution made 'top-down' rather than 'bottom-up', as part of the creation of the state.[19]

At Christmas 1521, during Luther's absence from Wittenberg, Andreas Karlstadt celebrated a simplified form of the mass with the crucial words in German. This has been described as *'an act of revolutionary leadership, and recognised as such.'*[20] It was followed a month later by a civil ordinance which ordered that images were to be removed from churches and altars divested of ornament. Karlstadt then printed and had widely circulated a treatise *On The Removal of Pictures,* which was specifically concerned to demolish the idea that images served as books for the poor. It is far better to have real books, he writes, because:

> *If the flock had books, the Pope's fairy-tales would not be accepted. . . . God's word is spiritual and alone useful to the believer. Scripture states clearly that God hates and rejects images, which papists refer to as books. I ask you, how would you feel if I made an image of you and sought to know you, worship you and teach about you by honouring it. You would hate me and the 'book', without a doubt . . . all those who pray to God through idols are praying to lies, to external appearances. . .* [21] etc.

The modern reader is likely to find this and the many similar tirades extremely difficult to read – full of violence, and what seems to us hysterical abuse. But we need to understand what

is being set in motion; an enormous, sudden and overturning re-alignment of authority, loyalty and, in effect, the sense of reality. We are witnessing a cultural revolution of immense force. As Gardiner was to write, *'it was in my heart terrible'*. Such a realignment cut through the web of customs and traditional beliefs that held social life together.

Spreading out from Wittenberg the movement went by way of the Baltic cities to Zurich, Strasbourg and Basel. In Zurich matters were handled peaceably; the civic decrees of 1523 reorganised worship in the Minster and forbade the use of the organ during services. At Basel, however, there was serious rioting and an armed confrontation between different factions. Many left the city. On Ash Wednesday 1529 there was a great bonfire of images and it was reported that poor people carried away church furniture for their own use and that a goldsmith and a painter with a red beard were seen hunting through the rubble for treasures. The eighth of the ten 'Theses of Berne' promulgated to reorganise worship in that city says flatly *'when the setting up of images involves veneration, they are to be abolished'*. Next year an ordinance of 1st April reads *'we have in our churches no images which may lead to idolatry'*.[22]

Iconoclasm reached Geneva with a jolt in August 1536 when, according to a Catholic witness *'heretics acted with great insolence'*, beating priests and tearing surplices and vestments. The next day they took

> *furniture and treasures, estimated to be worth over ten thousand écus, broke the images and fine portraits covered with beautiful and excellent workmanship, leaving behind them none of the insignia of devotion.*

Consequently, the Bernese sent out on 19 October, 1536, a commission to

> *put down popery in the Pays de Vaud in good order, without tumult. You are expressly commanded, without exception, to beat down all images and idols, and also the altars in the said churches and monasteries.*[23]

Continental events very largely took place in city-states where imperial or princely power was limited; there the Reformation was effected by groups of citizens. In England, Wales and Ireland, however, the Reformation took place at the same time as, and as a component of, a great consolidation of state power. This was to be financed by the appropriation of ecclesiastical wealth,

as foreseen by John Wyclif. Henry VIII was, in doctrinal matters, conservative and understood well what might be the consequences. When brought a pamphlet in which Wyclifite ideas were advanced, it is reported that

the kynge mad a long pause, and then sayde: if a man should pull downe an old stone wall and begin at the lower part, the upper part thereof might chaunce to fall upon his head: and then he tooke the booke, and put it into his deske.'[24]

The removal of images and ornament from abbeys and other foundations appears as a side effect of the larger plan by which Henry sought to subjugate the Church to the authority of the Crown. Nevertheless, the sixth of the 'Ten Articles' of 1536 gives the removal of images from parish churches the force of law, if they are subject to idolatrous attentions. This was followed very quickly by the *Institutes of the Christian Man* (1537) (sometimes known as the *Bishop's Book*), by Thomas Cranmer and his colleagues, in which we find that: *'God by his substance cannot by any similitude be represented or expressed'.*

His image, however, is allowed in churches:

Not that he is any such thing as we in that image do behold (for he is no corporeal substance) but only to put us in remembrance that there is a Father in Heaven, and that he is a distinct Person from the Son and the Holy Ghost.

Cranmer seemed to fear that a complete abolition of imagery would increase doctrinal confusion: he attempted to add that the common people should strive to conceive of God without graphic representation, but Henry forbade him to do so.[25]

If the State had the legitimate right to suppress religious orders, then it had the power to reform the Church at large. What we see in the English Reformation is an extension of power 'top-down' meeting a religious movement rising 'bottom-up', like two millstones grinding out the middle. English divines, well aware of and sympathetic to developments in German-speaking Europe could make common cause with a long standing native tradition of dissent, and with the intellectual defence of the extension of state power sanctioned by Wyclif's theology. As elsewhere, the role and status of images was a point of maximum visible conflict, along with the wording and language of services and the layout of the church space.

In Ireland, Scotland and The Low Countries different conditions obtained, which altered and delayed the spread of iconoclasm.

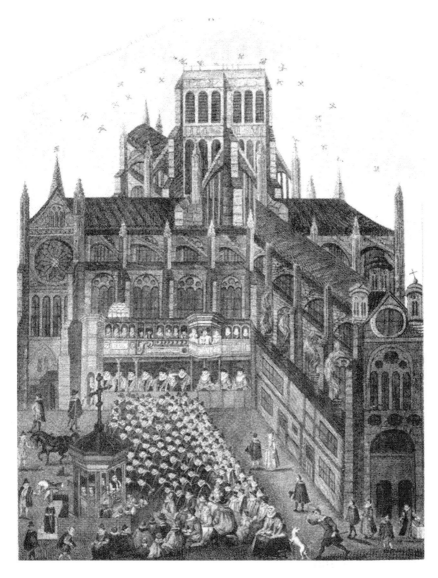

The Sermons at St. Paul's Cross; from an early seventeenth-century print. The sermons given here frequently gave public utterance to official policy. A similar open-air pulpit existed outside Westminster Abbey. The choice of preacher was invariably political. The sermons were often published, and read in other public places.

The process by which ideas became policies has been amply described by Margaret Aston in her *England's Iconoclasts* (Oxford 1988/97) and does not have to be repeated here. For our purposes, the key events can be summarised as follows.

i. 1538

Archbishop Cranmer issued injunctions in order to monitor observance of the new practices; these were enforced ('top-down') by visitations of the higher church authorities upon the lower. Officially sanctioned removal of images began. In the St. Paul's Cross Sermon of Feb. 24th, the Bishop of Rochester examined abuses that had grown up around a well known image of the crucifixion, which he demonstrated to be worked by wires to give it the illusion of speaking. *'It turned its head, rolled its eyes, foamed at the mouth and shed tears'.* The bishop broke the mechanism and threw the image to the crowd, who completed the destruction.

A royal proclamation in November removed Thomas Becket from the calendar of saints; his magnificent shrine was dismantled and his relics scattered. Pictures of the man were so thoroughly effaced that no record now remains of the appearance of the venerated and eminent churchman. Becket and his shrine had always been intensely hated by the Lollards as a symbol of an over-mighty and worldly Church. Henry's total extirpation of Becket's image was a vivid sign to the world that a new state of affairs had come into being.

In Ireland, the nearest equivalent to this was the burning of the wonder-working figure of Our Lady of Trim, kept in the monastery there and seized when the foundation was dissolved. It had long been an object of veneration and pilgrimage. Also destroyed were shrines at Limerick, by the Archbishop of Cashel and the crown solicitor (acting under military protection). At least fourteen churches in Dublin were also *'cleansed'.*

ii. 1547

A series of proclamations, injunctions and visitations banned even the commemorative use of images. In several cities there was now widespread popular feeling against images. Bishop Gardiner, as noted above, wrote his letter of complaint, comparing the rioters to *'Lollards, who, denying images, thought therewithal the crafts of painting and graving to be generally superfluous and nought, and against God's laws'.* For this letter and a subsequent sermon preached before King Edward, Gardiner was put into the Tower. He remained there for five years. His warning, however, was heeded; secular monuments were to be protected. From now on the only permissible imagery in places of worship

was to be the imagery of secular power.

This did not go unopposed; there were a series of risings and disturbances, especially in the West Country, that had to be put down with force.

Once again, Ireland was a different case. Royal power was by no means uniformly spread and was barely enforceable. When John Bale took up the bishopric of Ossory in 1553, he found that not a lot had changed, even in a major centre of English power like Waterford. Brendan Bradshaw concludes that:

Dislike for Protestantism, intense and general though it was, had not yet been channelled into a counter institution controlled by the papacy. For Ireland, as for England, the real watershed was to be the reign of Mary.[26]

iii. 1553

At Mary's accession the process came to a sudden halt. Stephen Gardiner was taken out of prison. Images and relics thought to be 'utterly extinct' suddenly re-appeared (the whitewash having been very thin), to be cleaned or painted afresh; statues were polished and set up again with great ceremony. John Jewel wrote to a colleague:

It is hardly credible what a harvest, or rather what a wilderness of superstition has sprung up in the darkness of Marian times. . . . We found in all places votive relics of saints, nails with which the infatuated people dreamed that Christ had been pierced, and I know not what small fragments of the sacred cross.

This is hardly surprising. Margaret Aston dryly observes that it was easier to whitewash a wall than to brainwash a people. At the same time, priests attempting to say the old rites were threatened with a lynching, and a dagger was thrown at one notable preacher. There are several instances of images newly repaired being once again defaced. But there is strong evidence to show that outside a number of cities and districts, notably London and East Anglia, the reformed liturgy had taken only shallow root.

The Protestant divines fled abroad, to Geneva, Strasbourg and other reformed cities.

In Ireland the old order hardly needed to be restored since it had been merely scratched. John Bale left his bishopric in a hurry, and the return to the old ways was more or less immediate.

Mary's (and Gardiner's) intention was to restore the full panoply of catholic worship, what John Jewel described in his vivid letters as *'the stage scenery'*. But this was by no means easy. Great wealth had passed into other hands, great and irreplaceable artistry had been destroyed, those who had benefited under the changes had done so under law, not banditry. The response to the fresh round of injunctions and visitations varied from place to place. In some cases the craftsman and artists required to make new work neither could nor would; there are records of a German sculptor (perhaps having been put out of work at home) having to be employed. Nor is it always clear just what was replaced and by what.[27] And if local churchwardens and village priests had been unwilling to respond too quickly to the injunctions about removing images, they were just as sceptical about setting them up again at great expense. And in this they were correct, given Elizabeth's succession to the throne in 1558.

iv. 1559

Elizabeth was welcomed by the Protestant party as a new Hezekiah. In several places, local authorities jumped the gun and started throwing away what Mary had replaced. Public bonfires of images were held in London during August and September *'with such shouting and applause of the vulgar sort, as if it had been the sacking of some hostile city'*. Elizabeth and her counsellors, determined to keep matters within the law and their control, quickly drafted and redrafted injunctions full of strategic ambiguity, hoping hereby to keep ahead of events. The issue had gone beyond the religious realm and into the immediate one of respect for the law. The problem, as Elizabeth saw it, was to establish a common frame of legitimacy: her position during the first three years of her reign, was like that of the lady of Riga (the one who went for a ride on a tiger and found it hard to dismount).

Elizabeth herself was more of a Lutheran evangelical than a puritan, and she had ecumenical instincts unusual for the time. She kept a crucifix in her private chapel, insisted on the highest possible standard of church music, and on dignified ritual. John Jewel wrote to Peter Martyr:

> *That little silver cross, of ill-omened origin, still finds its place in the queen's chapel. Wretched me! This thing will soon be drawn into a precedent. There was at one time some hope of its being removed, and we all of us diligently*

exerted ourselves, and still continue to do, that it might be so. But so far as I can perceive, it is now a hopeless case. Such is the obstinacy of some minds.[28]

The Queen's obstinacy was political more than personal. The issue of church government was inextricably linked to that of royal power. To maintain a conservative interpretation of the strategically ambiguous regulations was a means of defending her freedom for future action; she had only a limited control over her clergy who inclined more and more to the 'bottom-up' Calvinist line – no images and probably no bishops neither. Some of them believed, like Calvin, that to leave the matter unclear was to leave the Reformation unfinished. But a certain unclearness allowed for a latitude of interpretation and Elizabeth and her ministers were determined not to forfeit popular support. They were well aware that the population at large was far less reformed than the newly returning and reforming clergy.

The crucial piece of legislation was what came to be known as the 'ornaments rubric'; the *appearance* of the liturgy was to be under the monarch's control. As a result, a deal of Catholic practice remained, or at least sufficient to make the new settlement *look* sufficiently Catholic to all but doctrinal zealots, and it was left in the monarch's hand to determine just how much. The Act of Supremacy (1561) aimed at stabilising the situation, was part of a wider attempt to create a workable post-feudal state. Thus the newly Anglican bishops had to dress the part, and wear copes and mitres on formal days; and although there were to be no images, there was to be seemly ceremony and fine music. The Queen kept a sharp personal eye on these matters, and encouraged choral music.

Once again, injunctions and visitations followed, which ordered the removal of *'all monuments of feigned miracles, pilgrimages, idolatry and superstition, so that there remain no memory of the same in walls, glasses, windows or elsewhere'*. Texts were to be painted on the walls of churches *'not only for edification, but also to give some comely ornament and demonstration, that the same is a place of religion and prayer'* (Sept. 1561) In those words we get a glimpse of an aesthetic to succeed imagism – an aesthetic of comely ornament and text amongst white walls.

However, a study of articles, injunctions and edicts gives only part of the story. There is always a gap between intention and

actuality, which can be glimpsed through the little windows of visitation records and the proceedings of diocesan courts.

A lot depended on where you were. In London, at least, one might argue that

the zeal of the visitors exceeded the terms of the injunctions to the extent of effecting an almost irreversible alteration in the physical setting of Anglican devotion.[29]

But Bishop Grindal, promoted to the See of York, in the 1570s found himself still removing monuments of superstition. The diocesan court books record that the churchwardens of Kildwick had *'two altar stones which they have hid in the church, a holy-water vat or trough, a cross and certain pieces of the rood-loft'*. One Leonard Laffric was examined for retaining *'divers of the church goods, serving for Latin service'*. Two men of Wilberfoss had kept intact the timbers of the rood-loft claiming they intended to use them to make a bridge. A man from Masham was accused of retaining *'certain superstitious monuments and images'* and ordered to take them to Richmond market and burn them *'when the most multitude of the people be assembled'*. He had to do the same with two other images in Masham market, and do penance in the church. On a second appearance he was fined ten marks and ordered to erect a *'fair pulpit'* in Masham Church at his own expense and to pay for a copy of John Foxe's *Acts and Monuments*. Masham was a disaffected parish; as late as 1595 it still had five sets of mass vestments hidden away in the keeping of nine different parishioners.[30]

Grindal was forced to redouble his efforts. All books of the Latin service were to be *'utterly defaced, rent and abolished'* along with vestments, handbells, censers, crosses, candlesticks and other such *'relics and monuments of superstition and idolatry.'* Collinson comments: *'The summer of 1571 was no time or place to be a church warden or local dean'*.[31]

Some argue that this shows the existence of rural resistance to the Reformation. Undoubtedly, it existed; but of course the evidence is all of instances of defiance and rarely do we find mention of those parishes where the new policy was embraced with fervour or where the villages went along with it for the sake of a quiet life. As a recent writer has put it:

One wonders how many English village communities passed through (these times) *. . . without extraordinary social cleavage, and whether the impression of polarity given by John Foxe has yet received the critical scrutiny it deserves.*[32]

What is more, the pressure was not all one way. Grindal came under severe pressure from the Queen herself, for permitting unlicensed preachers to go about their work. It was in Grindal's time as Bishop of London that the term 'Puritan' first came into use, denoting a supporter of a Calvinist or 'bottom-up' style of imageless, decentralised church; and that we have the first records of unregulated private meetings for worship. Grindal was in time forced to retire and put under house arrest for permitting such radical gatherings.

Nor were all monuments of superstition defaced; glass was often permitted to remain, ostensibly because it protected the fabric of the building. Elizabeth took a personal interest in the preservation of the 'popish' practice of keeping choir schools. And we know little of what took place in the private chapels of the conservative noble families. There was at least sufficient traditional practice left to cause the commission of great works of music (notably, of course, the masses of William Byrd (d.1623), who was himself a member of Elizabeth's own Chapel Royal). But where imagery was concerned, the progress toward imageless worship was steady and irresistible. Margaret Aston has summed up the progress as follows:

At each stage the dangerous force of iconoclastic deeds added power to biblical words. At each stage, too, the ground shifted a little and the argument moved forward. What started with monastic shrines and abused pilgrimage images, progressed to pictures and statues of all kinds, to church windows, to the crucifix, even to the cross itself. From the removal of some images the issue became the annihilation of all.[33]

Such a steady, even insidious progress, could only be imposed upon Ireland by force. The necessity for legal forms at home meant that Elizabeth's Lutheran caution always moderated Calvinist zeal. In Ireland such scruples counted for nothing: the necessity for military security meant that any means whatsoever might be employed to protect England's Atlantic flank. This has always been the case. The spread of reformed worship was co-terminous with the spread of military power: the results are with us still. Happily this is not a topic we need study here. Our task is to sort out, as best we can, that spectrum of authority which aligned itself with the uses of imagery. To do this properly we have to take account of the progress of Reformation in Scotland and the Low Countries, and its intellectual and aesthetic assumptions.

v. Scotland

In Scotland a general reform of church and monastic practice was 'on the agenda' as elsewhere, but had no revolutionary intent. David Lindsay's play *Ane Pleasant Satyre of the Thrie Estaites* was first performed before James V in 1540, and on several occasions after. It treats religious abuses gently, but introduces the severe, even terrible figure of Divine Correction at the climactic moment, as if in promise of events to come.[34] A sign of the growing influence of Lutheran ideas was the license (in 1543) to print vernacular translations from the scriptures; and a series of disturbances in Dundee, Perth and elsewhere which included *'holding an assemblie and conventioun . . . conferring and disputing there upon holie scripture'.* In 1549 and 1552, what might be called a 'half-reformed' catechism was introduced to counter the growing influence of *'dampnable opinzeouns of heresie'* and a growing number of incidents of image breaking.[35]

The assumption of Mary of Guise to the regency of Scotland brought a new urgency to the cause of reform, which now began to play a part in national politics. John Knox, who had hitherto been of more Lutheran persuasion, returned a convinced Calvinist from his stay in Geneva, and it was that 'bottom-up' model of organisation and radical iconoclasm that formed the core of opposition to the 'French' court party. Throughout 1559 several towns, Dundee, Perth and Stirling prominent among them, opted for the new form of Calvinist worship, thereby declaring their shift in political allegiance to the 'English' reform party. By March 1560, with the aid of English arms, a newly convened parliament had accepted a Confession of Faith, and committed Scotland to a church system based upon self-governing but state-confirmed 'Presbyteries'. These were, it is hardly necessary to say, opposed to any imagery whatsoever in places of worship.

The reformed worship in Ireland, established by force and law, was strongly Calvinist in persuasion and often staffed by Scots. It was also a home for English and Welsh clerics who had found Elizabeth's conservative caution tiresome or unrewarding. Moreover, it was implicated from the first with the process of plantation, expropriation of land, and a more or less forced 'Anglicisation'. Actually, this was just as much a 'Scoticisation', even more so after the 1640's, when Presbyterian worship and civil habits spread more widely, fixing Ulster's Protestants (and especially the incoming Scottish settlers) ever more firmly into the Calvinist *habitus*.[36]

vi. The Low Countries

In the Low Countries yet another complicated story unfolded, in which the very invention of the state was involved. Charles V effectively stifled the first attempt at Reformation, despite the early involvement of Antwerp in the printing and dissemination of Protestant literature. But the successes of co-religionists and sympathisers in England and Scotland encouraged the formation of underground sects. Local gentry too found the Hapsburg demand for uniformity objectionable. When, in 1565, a small body of Calvinist minor nobility established a league to put an end to repression, they unwittingly set off a religious revolt, the so-called 'Wonderyear' of 1566, which resulted in unlicensed preaching, iconoclasm and local violence. This was put down quickly, but the remnants of the Reformed leadership regrouped in Emden where, at a Synod in 1571, they proposed a Presbyterian system of church government.

An account of the outbreaks in Flanders has been preserved, which neatly shows the mixed social character of the iconoclasts. Having driven away the civil guards, the 'rabble' set about destroying the fittings of the principal church of Antwerp:

The Virgin's image, that had been carried about in procession only two days before, was the first to suffer. . . . They then attacked the other statues, pictures and altars as well as the organ, heedless of their antiquity, beauty or value. They cast down or plundered these with such vehemence and headlong insolence that before midnight they had reduced one of the largest, most glorious and splendidly adorned churches in Europe with its seventy altars to an empty and ghastly hulk. . . . Yet there was no quarrelling about this booty: indeed; no less strange, in the confused commotion of this raging mob . . . there was such unity and orderliness that it seemed as if each person had been allotted his task beforehand . . . no-one was injured. . . . This rage, which grew unchecked through the perplexity of the magistrates, lasted for three days. In addition the mob grew yet more bold because some people of quality and means, armed with pistols and daggers under their clothes, mixing with them and lurking in corners and side streets, terrified all that were inclined to oppose them.[37]

The 'rabble' of Antwerp was clearly no ordinary rabble, any more than the 'hogs' of Portsmouth, twenty years earlier, had been out of all control. We have, generally, to do with a transfer

of allegiance and with the construction of a new political order. But we perceive events through the eyes of those to whom it was '*in their hearts terrible*'.

In this book we shall generally have to do with Presbyterian and congregational patterns of organisation. The ideal type of this pattern can be glimpsed in the numbered conclusions of the Synod of Emden, by which the reformed churches of the Netherlands and parts of northern Germany outlined their mutual relations (4. October 1571):[38]

> *1. No church shall have dominion over another church, no minister of the Word, or elder or deacon shall exercise dominion over another. Rather they shall be vigilant lest they should give cause of being suspected of desiring dominion. . . .*
> *6. Each church shall have assemblies or consistories, composed of the minister of the Word, the elders and deacons. These shall meet at least once a week.*
> *7. Besides these consistories . . . meetings of neighbouring churches shall take place every three or six months.*
> *8. In addition, separate annual meetings shall be held each year for all the churches scattered through Germany and East Friesland, for all the churches in England and for all those under the cross.*
> *9. Furthermore, a general assembly of all the Netherlands churches shall be held every two years. What unites these scattered churches in doctrinal harmony is mutual subscription to each other's 'confessions of faith'.*

This is a striking and truly revolutionary document devolving authority downward to the individual churches and binding them together by voluntary association across state boundaries irrespective of the secular powers. It is no wonder that Elizabeth, while offering limited aid to the Dutch reformers and practically advancing religious toleration within her own realm, should be so vehemently opposed to what was coming to be known as 'Puritanism'. It was also in flat contradiction to the Lutheran settlement whereby the religious character of each region was to be determined by the local ruler. The organisational principles involved created, in their system of autonomous but interlocked units, social entities of great power. In principle, they formed a limit against both the power of a centralised state church, and against a centralised secular state. In the fullness of time they gave birth to the Constitution of the United States. And in the shorter term, as

we shall see, the aesthetic consequences were also extensive for they limited the possibilities for ostentatious artistry and display, by limiting the powers of churches and courts.

In the long and bitter resistance to Habsburg dominion, the Dutch both created themselves as a nation, and a national system of congregations.

vii. 1641

Back in England, in the reign of Charles I attempts were made, under the guidance of Archbishop Laud, to reintroduce ceremony and display into the Anglican liturgy, coupled with an attempt to assert stricter Episcopal control of the clergy. The vehemence with which Puritan writers attacked these quite modest proposals stemmed not simply from the attempt to assert central control, but from a perceived attempt to undo a cultural revolution. This vehemence passed over into conduct during the period of the Civil War.

It is not easy to decide, in the renewal of image-breaking that followed how much that was destroyed was ancient, and how much of more recent origin. In an account of the 'defacement' of Peterborough Cathedral by Cromwell's own regiment in 1643, the point is made that 'the stately screen, well wrought, painted and gilded, that was pulled down 'had no imagery-work upon it, or anything else that might justly give offence'. But it was the fact that it 'bore the name of High Altar' that outraged the soldiers, who 'pulled all down with ropes, lay'd low and level with the ground'.[39] Royalist propaganda made much of these incidents, especially the 'sacking' of Canterbury Cathedral in August 1642. There is a noticeable tendency amongst country churchwardens and cathedral guides to heap all the blame for the absence of medieval art in English churches on Cromwell's soldiers; but this is part of a wider difficulty parts of English society have with The Lord Protector.

Similar questions hang over the career of William Dowsing, the parliamentary visitor commissioned to monitor and oversee the removal of images from churches. In 1644 he and his men travelled East Anglia engaged on this work. It was thorough, and if we are to believe Dowsing's report, many thousands of acts of breakage, 'pulling down' and defacing took place. In some places he met with obstruction; in others the work had already been done. But how many of these images were anything more than printed paper? And how many trivial acts did Dowsing report to bolster up his mission? The figures that he gives seem inflated.

Fortunately we do not have to solve this problem, either. From

Beginning with throwing down images you may end with throwing out the whole hierarchy of the church. A pamphlet cover from 1641. The bishops fall out of the shaken tree, complete with their popish attributes of rosary, bell, crucifix, crozier, mitre, candle, book and a pair of pilgrim sandals. Anti-Laudian propaganda of typical force:

'The tottering prelates, with their trumpery all, shall moulder downe, like Elder from the wall.'

the perspective of this study, the extent and character of this later iconoclasm is not of primary importance because the new style of plainness and perspicuity was established in its essentials before 1640. Much more important is the rise of many smaller sects and groupings having minimal organisation but maximal aims; Quakers, Levellers, Anabaptists and Ranters and their fellows, who, in general, denied the necessity of hierarchical order and with that, of special places of worship and even of a clerisy. In these gatherings, the sacred and secular worlds increasingly intersected, so that any homely object might become the bearer of sacred significance, and be designed and made with that possibility in mind.

When, with the restoration of the monarchy in 1659, there was a slow movement toward broadening of the Anglican community again, this did not effect the status of imagery. The most generous and civilizing movement of thought of the period – Cambridge neo-Platonism – was no less opposed to imagery in worship than its more sectarian predecessors. And this remained the case until the nineteenth century.

1. Within a British context, the paintings of Stanley Spencer in Burgclere Chapel are apposite; work of scale and skill and some intensity, drawing deliberately upon centuries of tradition and alluding directly to modern experience of terrible warfare. Here, in a semi-public situation (a private chapel) we come near to what a modern religious art might be. But the same iconography executed on the private scale in his smaller canvases, can be dismissed as eccentricity. There is also the remarkable example of David Jones and some of Graham Sutherland's work. But most contemporary devotional work is lamentable, and its appearance in churches utterly dismaying

2. Stone, L., *Sculpture in Britain in the Middle Ages*, London 2nd ed, (1972) pp. 1-2

3. McRoberts, D., 'Essays on the Scottish Reform', *The Innes Review*, Glasgow (1962)

4. See for example Ch.17 of G.H. Cook's otherwise admirable *The English Cathedral Through the Centuries*, London (1960). P.A. Scholes in *The Puritans and Their Music*, Oxford (1934), has collected a mass of such charges as they relate to music; he describes them as 'making imagination do the work of research'

5. First cited in Foxe's *Acts and Monuments*, Vol VI pp. 27-37; and many later writers

6. Tudor Royal Proclamations, Vol I, pp. 396-7

7. Moore, R.I. *The origins of European Dissent,* London (1977) p. 272

8. Ibid. p. 26

9. Ibid. p. 9

10. Leff, G., *Heresy in the Later Middle ages: the relation of heterodoxy to dissent 1250-1450,* 2 vols. Manchester (1967) p. 78 et seq

11. All quotes from *The Cistercian World; monastic writings of the twelfth century,* Penguin: London (1993) tr. and ed. by Pauline Matarasso

12. In Orthodox tradition, icons could legitimately be treated as holy objects capable of working wonders. This followed from an interpretation of the doctrine of Incarnation not followed in the Roman tradition, which was never ready officially to make that step although images were often treated 'as if' they were holy objects. The distinction also informs arguments about the nature of the Communion. The whole subject is difficult and technical for contemporary minds

13. Leff (op. cit.) pp. 523-4. And see also Kaminsky, H. 'Wyclifism as an Ideology of Revolution' in *Church History,* 32 (1963), pp. 57-74, and Smalley, B. 'the Bible and Eyternity: John Wyclif's Dilemma' in *Jnl. of the Warburg and Courtauld Inst.,* Vol.27 (1964)

14. As to this day American radicals oppose the state in the name of an Ideal America, and Ulster Loyalists oppose the British state in the name of being 'British'

15 Jones W.R., 'Lollards and Images: The Defence of Religious Art in Later Medieval England', *Jnl. of the History of Ideas,* Vol.34 (1973) pp. 27-50

16. Mullett M.A. *Radical Religious Movements in Early Modern Europe,* London (1980) pp. 113 et seq. And see also Dickens A.G. *Lollards and Protestants in the Diocese of York 1509-1558,* Oxford (1959)

17. See *Works,* ed. J. Pelikan (St. Louis. 1955) 'Lectures on Deuteronomy', Vol.9, p. 80 etc. For a broad discussion, see Scribner, R.W., *For the Sake of Simple Folk: Popular Propaganda for the German Reformation,* Cambridge (1981)

18. At the time of writing a volume is about to be published. I anticipate that *The Reformation of the Image* by Joseph Leo Koerner (2003) will deal with these matters in terms apposite to this study

19. See esp. Collinson, P., *From Iconoclasm to Iconophobia: The Cultural Impact of the Second English Reformation*, Reading (1986)

20. Rupp, G., *Patterns of Reformation,* London (1969) pp. 99-105: and see also Sider, R.J., *Andreas Bodenstein von Karlstadt: the development of his thought, 1517-1525,* Leiden (1974)

21. Translated for me by Brian Fitzpatrick from the edition of Lietzmann, H.,

(Bonn 1911). There does not seem to be any English edition
22. For the wording of these and similar proclamations, see Hillebrand, H.J., *The Reformation in Its Own Words,* London (1964), Cochrane, A.C., *Reformed Confessions of the Sixteenth Century; with an historical introduction*, Philadelphia (1966) and Kidd, B.J., *Documents Illustrative of the Continental Reformation,* Oxford (1911) etc
23. See Kidd, B.J., *Documents Illustrative of the Continental Reformation,* Oxford (1911), p. 513-p. 555 etc
24. Cited, along with much interesting material, in Knowles, D., *Bare Ruined Choirs: The Dissolution of the English Monasteries,* Cambridge (1976) p. 85
25. These events are well described by Phillips, J., in *The Reformation of Images: The Destruction of Art in England (1535-1640),* Los Angeles (1973)
26. Bradshaw, B., *The Dissolution of the Monastic Orders in Ireland under Henry VIII,* Cambridge (1974) p. 96. And see a paper by Canny, N. 'Why the Reformation failed in Ireland', *Jnl'. of Ecclesiastical History,* Vol.30 No.4 Oct 1979 pp. 423-450
27. See 'Worcester; a Cathedral City in the Reformation' by McCulloch, D. in Collinson, P., and Craig, J., eds. *The Reformation in English Towns 1500-1640,* London (1998)
28. Letter to Peter Martyr, Nov. 1559, often cited. Elizabeth also kept candlesticks on the altar, to the utter horror of some; they were removed from time to time, when her back was turned, but kept re-appearing
29. Collinson, P., *Archbishop Grindal 1519-83: The Struggle for the Reformed Church,* London (1979) p. 101
30. Collinson ibid. pp. 201-203
31. Ibid, p. 198. And see also the writings of Eamonn Duffy who has looked closely and sympathetically into the persistence of late-medieval catholic practice
32. Marsh, C.W., *The Family of Love in English Society 1550-1630,* Cambridge (1994) p. 69
33. Aston op. cit. p. 342
34. Those who had the luck to see Tyrone Guthrie's production of this play at successive Edinburgh Festivals in the 1950s will remember the sudden arrival of Divine Correction as an extraordinary coup-de-theatre
35. These events have been summarised by Cowan, I.B., in *The Scottish Reformation: Church and Society in Sixteenth-Century Scotland,* London (1982) esp. Ch.7 and 8
36. The sociological concept of *habitus* will play a larger role in Chapter Three (see below)
37. And used by Brandt in his *History of the Reformation etc.,* (1671-1704) cited in *Calvinism in Europe (1540-1610) a collection of documents,* ed. Duke, A, Lewis, L, and Pettigrew, A., Manchester (1992). p. 148-9
38. Ibid. p. 158
39. From the *History of the Church of Peterborough,* by S. Gunton (1686) cited by Aston (op. cit. p. 64) with other material. See also Cook, G.H. *The English Cathedral Through the Centuries,* London (1960), Ch.17

II
IMAGELESS THOUGHT?

The removal of imagery from worship entailed the removal of imagery from public life. For the population at large the church was the principal public space, and almost the only place in which an ordinary person might encounter an image. Great persons might well have had a private picture gallery of family portraits, tapestries along the walls, carved overmantles with figures, lockets and miniatures. But with the 'cleansing' of the reformed churches went a public world of imaginative and affective splendour. The only images readily available, from around 1560 in England (though not, of course, uniformly so), were now to be found in broadsheets and pamphlets, as illustrations made in black ink on white paper. This was a new cultural situation, an unprecedented shift in the character of public space, with, I hypothesise, consequences for the inner space of 'private' experience and habits of visualisation.

In an attempt to open up this topic we must turn from the external process of image-breaking to the parallel development of what I shall call inner or psychic iconoclasm. This has two aspects under which it can be studied – that of the individual for whom the whitewashing of churches and the bonfire of vanities externalised the inward obliteration of imaginary figures, and an institutional aspect which appears in changes to public language, the curriculum, and the training of memory. They both raise a problem: can the mind do without images? Is an imageless thought possible? Jean Calvin doubted it, and saw in the human propensity for mental picture-making a continuing occasion for idolatry.

Man's nature, so to speak, is a perpetual factory of idols . . . the mind begets an image; the hand brings it forth.[1]

Men and women must be able to conceive of the Highest without recourse to visual aids; but it was only through Grace and subsequent illumination that we could be freed from a

dependency upon mental pictures. This refusal of picturing might well require a mortification of the visual sense, rather as mortification of the flesh is required of the celibate. At the extreme end, it was a sacrifice every devout person must make. This is beautifully expressed in Elizabeth Poole's homily 'A Vision' of 1648:

> *This is therefore the great work which lieth upon you, to become dead to every pleasant picture, which might present itself to your delight, that you perfectly dying in the will of the Lord, you may find your resurrection in Him.*[2]

Examples taken from an extreme region of individual experience may still shed light on the commonplace. In 1649, the Ranter, Abiezer Coppe, wrote a pamphlet describing his conversion to extreme radicalism. This was in the midst of the religious and political debates that followed upon the Parliamentary victory in the Civil War, when large sections of the army and the population as a whole were developing democratic and levelling theories of government and when England was passing through its last phase of iconoclasm. Coppe's language is typically vivid; it seems touched with pathology, but we must try to distinguish between what is conventional for the period and what seems authentically unhinged. The relocation of authority is not just a political or religious event, but a psychic earthquake inducing extreme states of mind.

> *Under all this terror and amazement there was a little spark of transcendent, transplendent, unspeakable glory which survived . . . confounding the very blackness of darkness (for you must take it upon these terms, for it was infinitely beyond expression). Upon this the life was taken out of the body (for a season) and it was thus resembled, as if a man with a great brush dipt in whiting, should with one stroke wipe out, or sweep off the picture upon a wall . . . (I then saw) . . . streams of light . . . and immediately I saw three hearts . . . of exceeding brightness; and immediately an innumerable company of hearts filling each corner of the room where I was. And methought there was variety and distinction, as if there had been several hearts, and yet most strangely and unexpressibly complicated or folded up in unity. I clearly saw distinction, diversity, variety, and as clearly saw all swallowed up in unity. And it has been my song many times since.*[3]

What Coppe gives us, in a very condensed form, is the transformation of imagery *as it happens*. We are moved from the pictorial to the symbolic, and from the symbolic to the abstract.

pictorial → symbolic → abstract

It is this journey which was followed in the transformation of places of worship, and also, I surmise, in the transformation of the understanding. The first two stages were those enacted in every church in the land. The brush of whiting passed over every fresco, every painted wall, in an act of cleansing that every household would recognise as a spring cleaning. Pictorial imagery was replaced by texts, by heraldry and in time by emblems of hearts, urns, roses and skulls that symbolised rather then pictured the doctrines of the reformed churches. The newly whitened walls of the churches were lit by uncoloured glass, letting in plain daylight, which in the great ministers revealed for the first time the structural logic of their architecture. New kinds of churches, called meeting houses, were being built without any decoration or emblematic ornament at all. And for those like the Ranters and the Quakers who had passed beyond institutional religion, there was naked, unmediated thought alone, which always has something of the ecstatic about it.

Coppe's account is, of course, dramatic. It is not possible to say how many, in the long process of the Reformation, went through similar upheavals. Most people, we can be sure, were uncertain, elated, opportunistic or depressed as occasion and temperament decided. All were caught up in whirlwinds of communal passion, '*of terror and amazement*', that destroyed the familiar landmarks of social location. The existential stress of reformation arose because it was just that – a re-forming of the self within the social group. Such a change may induce extreme insecurity, in which the ethical distinction between conversion and the hysterical reversal of allegiance becomes blurred. The student encounters, whilst reading of image-breaking episodes, elements of hysterical desecration and hate-filled violence that indicate a profound disturbance. Pathological symptoms come to mind, for the ritual execution, burning, stabbing and drowning of images previously held to be sacred suggests that this complex transfer of allegiance had an undertow of psychotic rage.[4] But this does not lend itself to clear analysis. What we can study, with much more certainty, is the relation of

psychic iconoclasm to preaching and to formal education.

I have chosen the word psychic because we have to do with an upheaval in both the affective and the cognitive domains. It is certain that we have to do with a cognitive revolution, in which knowledge is redefined, but it appears we have also to think of an affective revolution in which a sense of identity (and, correspondingly, of community) is put on a new basis. For this to be manifested it has to take on an aesthetic character.

This character or quality first appears in the style of sermons; in what came to be know very early as 'the plain style'.

This term 'plain style' is not something that I have devised or that some ingenious historian has invented, like 'metaphysical' Augustan' or 'Victorian' as a convenience in narration. It was consciously used by the Puritans themselves.[5]

I have not been able to find a secure date on which the term was first employed, but coupled with 'perspicuous' it is certainly to be found in 1548. John Jewel's *Oratio contra Rhetoricam* sets out the stylistic desiderata of the reformed sermon very clearly:

Truth indeed is clear and simple: it has small need of the argument of the tongue or of eloquence. If it is perspicuous and plain, it has enough support in itself; it does not require flowers of artful speech. If it is obscure and unpropitious, it will not be brought to light in vociferation and flow of words . . . why pursue all these verbal graces, these obscurities . . . why call down the gods from heaven . . . why raise the shades from the underworld? Idle men have fashioned all these things for themselves.

Exactly a hundred years later Thomas Hooker uses the same words in the Preface to his *Survey of the Summe of Church Discipline* (1648).

That plainesse and perspicuity, both for matter and manner of expression, are the whole thing, I have conscientiously endeavoured in the whole debate; for I have ever thought writings that came abroad, they are not to dazzle, but direct the apprehension of the meanest; and I have accounted it the chiefest part of judicious learning, to make a hard point easy and familiar in explanation.

The idea of 'plain' is simple enough, but by 'perspicuous' we are to understand *transparent*. The language must not stand in

the way of our apprehension of its referent; the meaning must come, like clear light, through the utterance into the receptive mind. As Herbert puts it,

The man that looks on glass
on it may stay his eye
or if he pleaseth through it pass
and then a Heaven espy.
The Elixir (1633)

W.S. Howells comments on John Jewel's prescription that *'It is not so much an attack on rhetoric, however, as an ingenious and ironical condemnation of what rhetoric had come to mean in the schools and at Oxford.'* He aligns Jewel with a much older counter-rhetorical tradition in English, going back to the days of the Venerable Bede and looking forward to the founding of the Royal Society (which enjoined a plain style of writing on its members) and subsequently to the preface to Wordsworth and Coleridge's *Lyrical Ballads* (1798). It remains a standard of good usage to this present day.

Jewel was appealing back to Roman models of simplicity and terseness, and reviving for his contemporaries Cicero's precepts on style. What this meant in practice was the avoidance of complicated grammatical structures, extended analogies and involved classical references. Images and analogies were indeed permissible, but they had to be direct and apt. He set the pattern for subsequent manuals. As Richard Boxter insisted:

God biddeth us to be as plain as we can, for the informing of the ignorant, and as convincing and serious as we are able, for the melting and changing of unchanging hearts . . . (but pride) persuadeth us to paint the window that it may dim the light . . . if we have a plain and cutting passage, it throws it away as too rustical or ungrateful.[6]

Wholly to avoid mental imagery would be likely too difficult for the congregation at large, so it was, as Richard Baxter put it, permissible to *'bring down our conceivings to the reach of sense. . . . Go to, then, when thou settest thyself to meditate on the joys above, think on them boldly, as scripture hath expressed them.'*

But what was not permitted was to turn these mental images into idols and contemplate them for their own sake.

In passages such as this we see the educative and the evangelistic aspects of the Reformation come together in simple

and passionate language.

The dislike of facile classicism was very strong in puritan circles. It sometimes led to eccentric results, as for example, Ralph Lever's *The Arte of Reason, Rightly Termed Witcraft* (1573). This was a manual of logic and rhetoric in which the author refused Latinate terms and attempted to coin cognate words in a kind of Anglo-Saxon; thus 'witcraft' for reason, 'speechcraft' for rhetoric and 'backset' for predicate. But that aside, the preference for the plain and powerful has definite connections with the shorter forms of Tudor and later Elizabethan poetry. The compressed, monosyllabic strength and the emblematic imagery of Shakespeare's sonnets should probably be understood in the context of 'Plain Style'. At the time it may well have felt unnervingly direct and bold.[7] It still does.

When my love tells me she is made of truth
I do believe her, though I know she lies.

*

When we turn to formal education we are compelled to turn first to the spread of literacy and to the concomitant changes in the teaching of memory. Learning through seeing and remembering was being replaced by learning through hearing and reading. The old order had to be extirpated before the new order could be fulfilled, and paramount was the destruction of visual memory.

All reliques and monuments of idols, for these (after the idols themselves) must be razed out of all memory.
William Perkins *The Golden Chain* (1597)

'Razed out of all memory'! The brutal radicalism of those words echo down to today. The Year Zero. The New Man. The Personal is the Political. Whatever concerns the organisation of memory is integral to the organisation of the entire psyche, since identity consists in and is preserved by memory. And reciprocally, the collective memory constitutes the community and to reorganise its memory means to rewrite its past. The reformers aimed at replacing or wiping away one version of history in order to recover beneath it the fresh original energy of scripture. The destruction of the old memory images – which are the genetic code of a culture – was necessary before that could take place.

It is very easy to forget how necessary a trained memory was before the invention of the printed book and other even more

comprehensive data-retrieval methods; before even the existence of cheap writing materials and note-pads. Virtually all learning, of whatever kind, had to be memorised. This required a systematic training to a degree of exactness hardly conceivable today.[8]

The methods used from classical times until the sixteenth century were always some variant of the method summarised by Cicero in the *De Oratore*:

Persons desiring to train this faculty of memory must select places and form mental images of the things they wish to remember, and store the images in the places, so that the order of the places will preserve the order of the things, and the images of the things will denote the things themselves.[9]

The favoured means of 'ordering the places' was to create an imaginary architecture of facades and rooms, full of pediments and niches to hold the images. The images were of figures with symbolic attributes. To remember the concept of Justice in all its fullness meant to recall a figure with scales, sword, blindfold etc. located in or on a building, the disposition of whose parts placed Justice in relation to the other virtues, to principles of government etc.. The parts of the building – the places – gave the abstract or logical order of whatever topics you needed to remember; the images indicated the character of those topics. This method was used typically to aid the public orator or preacher who might need to organise great quantities of material without written aids, and be able to deliver it fluently. But the method also stood in a modelling relationship with real buildings. We should imagine the classical or medieval architect constructing his plans and elevations in the sure knowledge that they could and would stand for memory places, and knowing that they might, in the imagination, be enlarged or altered at will to accommodate new topics. The balances and the symmetries in one mirrored the balances and symmetries in the other. Then the artist and craftsman fashioned images to populate the places, both following existing conventional memory images and helping to create new ones. It has further been argued that the constructional methods of major buildings had a similar representative function. In the mature Gothic cathedral, for example, we are faced with what can be called visualised logic.

A man imbued with the Scholastic habit would look upon the mode of architectural presentation, just as he looked upon the mode of literary presentation, from the point of

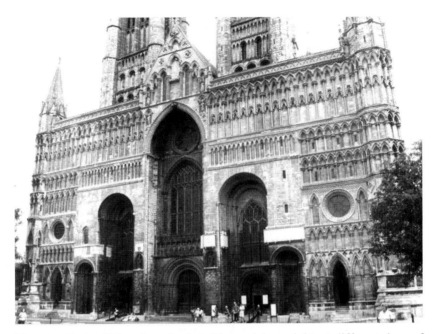

The west front of Lincoln cathedral. These niches might, at different days of the Church calendar, have been peopled with images from which the common folk could 'read' the church's teaching. The covered sections on either side of the great porch, are of a long frieze of the Last Judgement, now being restored/ replaced. But the arrangement of the niches would also have served as a memory place system for those who knew the *ars memoria*. They could people it with imaginary images from which a discourse could be 'read'.

> *view of manifestation . . . the membrification of the edifice permitted him to re-experience the very process of architectural composition just as the membrification of the Summa permitted him to re-experience the very processes of cogitation.*[10]

In a most obvious sense the decoration of the medieval church, and of a Catholic church to this day, is a system of memory places whose function was to teach. The altar piece pictured essential doctrines, side chapels celebrated patron saints, and the Stations of the Cross enabled the congregation to participate in the Passion by literally and metaphorically following it, not simply in its affecting and passionate imagery, but through its spatial progress. The church building was, in a sense, a performance of the Church's teaching.

One of the very first printed books in English was a memory treatise. Caxton's *Mirrour of the World* (1481) contains the following:

A small section of the remaining medieval glass in the Lady Chapel at Ely shows how niches could serve to hold actual memories of real people and, simultaneously, virtual, memories of abstractions.

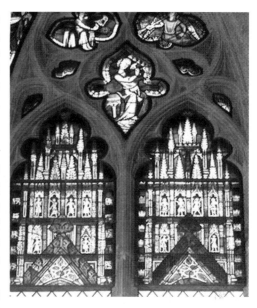

Thou must have ever images of corporal thinges that thou must see with thine eyn which thou must imagine in thy minde that thou seest them set in the places . . . and of every corporal thing thou must imagine that thou sees the same corporal thing in the place. . . . But if you canst not have corporal image of the same thing as if thou wouldst remember a thing which is irself no bodily nor corporal thing, but incorporal, then thou must yet take an image therefor that is a corporal thing. As if thou wouldst remember this word 'Wisdom', an old man with a white head, so that every image must be a bodily and a corporal thing.[11]

But it was precisely at the attempt to picture the incorporeal that the Protestant theologians directed their fiercest scorn. It was, argued Calvin *'a bestial stupidity'*, especially blasphemous when attempting to picture the Divine.

The question then arises; what sort of memory training and cognitive organisation would Protestant divines and teachers deem suitable for the new task? Clearly not one that attempted to depict the incorporeal or took its places from church architecture and its imagery from saints. The new memory training, like the new language, would have to be one that razed out of all memory the allegorical figures and personifications of the classical treatises, and the dramas of medieval art. On no account would it employ images because, wrote William Perkins:

The animation of the image, which is the key to memory, is impious, because it requireth absurd, insolent and prodigious

cogitations, and those especially which set an edge upon and kindle the most corrupt affections of the flesh.[12]
The new training would need to be given an abstract form.

*

A halfway house on the journey from pictorial to abstract memory appears to be the use of emblems as devotional and educational mnemonics. An emblem, appearing typically on the printed page, consisted of a single symbolic image or scene – a heart, a flower, an urn or an allegory, sometimes accompanied by a short text or motto. They ranged from the simple and direct, to the very involved which required special knowledge to understand; from the burning heart of catholic devotion to the burning bush of Presbyterianism, from the complex allegories of alchemical treatises to the 'spiritual drawings' of the Shaker women and the sisters of Ephrata.

Emblems on title pages might offer a kind of visual abstract of the contents; but on architecture or clothing they appeared as badges of allegiance or significant statements. Throughout the sixteenth century they appear in paintings, tapestries, triumphal arches, gardens, poetic conceits, sermons and books of edification, and even in the steps of dances. They accompanied the dead on their tombs and the living on their jewellery.

Marble and gold-leaf urn from a tomb in Ely Cathedral.

One cannot interpret Tudor decoration without an extensive knowledge of the emblematic use of flowers, animals and other figures. A very striking use of emblematic clothing and jewellery will be found in the formal state appearance of Elizabeth 1, both in person and in portraits, in which she arrayed herself as the representative figure of the state. Major motifs, colours and jewels were drawn from a readily comprehensible 'language' closely related to the emblem books of the day. All the official portraits of the queen were of this

The Presbyterian burning bush

kind. The 'Rainbow Portrait' now at Hatfield House has been analysed in some detail by scholars of renaissance allegory; it becomes clear that the cloak the Queen wears, with its embroidery of eyes and ears, derives from the *Iconologia* of Cesare Ripa where we find figures of Fame and Reason of State wearing similar garments. On her left sleeve a great coiled serpent, with a heartshaped ruby in its mouth and a sphere for a crown, is probably to be read as 'Intelligence' holding and sustaining 'Good Counsel'.[13] The 'Ermine Portrait' of 1585 is another such image in which the actual appearance of the person of the Queen is wholly subordinate to the emblematic function of the image, in which the ermine on her sleeve (a creature so pure it will die if it is sullied) prances above the terrible sword of state. If we had the full 'key' to this image we would probably find that the jewels of the dress, the spangled flower motifs and much else beside had supporting significance. The black and white coloration was constantly alluded to by the lady herself as 'These are my colours', signifying constancy and the unmarried state. Contemporaries probably saw the Queen as personifying also the fictional figure of Helen of Corinth, the virtuous ruler in Sidney's *Arcadia*. Thus the emblematic portrait is itself an allusion to an emblematic portrait, itself a term in a lengthy precession of allegories.

Books such as Henry Peacham's *Minerva Brittanica* (1612) and Francis Quarles *Emblemes* (1635) took emblems and devices from what were mainly continental catholic sources, and altered or reassigned them for Anglican and even Calvinist devotional use.[14] The emblem has been described as . . .

a quintessential renaissance form of expression to which the visual aspect was integral. This presented cultures within the grip

Detail of the Ermine Portrait, showing purity and the hand and sword of state

The attributes of kingship –
James I from *The Mirror of
Majestie, 1618*

*of Reformation icono-
clasm with a very
special problem . . .
naturalizing, as it did,
a Counter-
R e f o r m a t i o n
devotional approach
into the Anglican*

tradition.[15]

Though emblems appear ubiquitously in the sixteenth and seventeenth centuries, for the an-iconic communities of radical dissent – Anabaptists and others – they provided the only permissible imagery. In the world of the Amish and the Ephrata community, the world of learned emblems and folk art overlap.

The emblem was a visual sign, but not a picture; it was thus appropriate to body forth reformed doctrine. In the later Tudor and early Stuart period it provided a matrix or resource of visual material that, not being pictorial, could aid both worship and the art of memory and consequently, education. In the context of the English Reformation it should probably be understood as a stage between Catholic iconicity and the an-iconic world of extreme dissent. As such, the stress on emblematic expression was an appropriate part of the attempt to stabilise the new Anglican state and its ideology. It also had the strategic advantage of not being quite specific; the emblem had to be interpreted and admitted diverse meanings; it was thus a factor in the spread of religious toleration and civic moderation.

The fruitful tree of life, after a Shaker drawing of the 1840s.

Turtle dove on a rose representing the soul resting on Jesus, after a music book from Ephrata (1750s)

Emblems, too, could provide a mean for hiding, in compressed form, secrets and occult doctrines that were safer hidden; they played a large part in the transmission of alchemical and other lore.

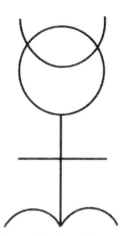

As we shall see, emblems and emblematic drawings became the principal graphic art of the radical dissenting groups that, originating in Europe, found new homes in the American colonies. Emblems and emblem books clearly played an important part in the visual culture of early Protestantism in Ulster; their traces remain visible on the banners and regalia of the Orange and Black Orders. The collarette insignia of the Royal Black Institution, for John Dee's 'Monas Hieroglyphica', after 1564 – occult knowledge.

examples, includes square and compass, dove and ark, pierced heart, ladder, skull and bones, cross, scales etc. which have a precise meaning to members (and are obscure to the rest of us). These in turn are related, through complicated paths, to masonic emblems.[16]

The predominant use of the emblem also had a part to play in the transition to a more completely print-based learning and devotion. As an *ars memoria* it remained an aid to meditation and a symbolic language of power or devotion; but for the creation and dissemination of knowledge, something more radical was required.

<div align="center">*</div>

For the hour, the man. Petrus Ramus (Pierre de la Ramee) was born in 1515, and died by an assassin's hand in the St. Bartholemew's Day Massacre of 1572. His life thus spans the first major period of iconoclasm. That life's task was the reform of the old scholastic curriculum and the restructuring of basic formal education up to graduate level. His educational reforms were based around an imageless and diagrammatic art of memory.

Christopher Marlowe portrays him dying a martyr's death, defending his logic to the last.

Ramus: *I knew the Organon to be confused*
and I reduced it to a better form;
and this for Aristole will I say,

that he that despiseth him can neer
be good in logic and philosophy;
and that's because the blockish Sorbonnists
attribute as much unto their own works
as to the service of the eternal God
Guise: *Why do you suffer that peasant to declaim?*
Stab him, I say, and send him to his friends in hell.
Anjou: *Ne'er was there collier's son so full of pride.*
(stabs Ramus, who dies).[17]

T h e Massacre at Paris (1594) Act 1.

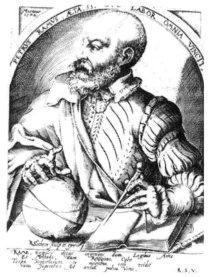

Ramus became a Protestant in 1561 and, as the leading reformist teacher in Paris had, with his colleague Omer Talon, a position of immense influence which he increased by diligent use of the printing press. Walter Ong has estimated over 1,000 editions or compilations of the 60 known books by Ramus and the smaller number written by Talon. They were essentially teaching texts, whose readership was immense and especially strong in reformed and puritan circles.[18] Ramist ideas were the main educational baggage of the American colonists.

Petrus Ramus after a print by Christoph von Sichem; the scholar is portrayed holding the emblems of rationality, calculation and geometry.

For an extended survey of Ramus' ruthless simplification of the old curriculum, the reader is referred to Walter Ong's seminal study, *Ramus, Method and the Decay of Dialogue* (1958). The essential point for our purposes here is that Ramus and Talon attempted to prune all rhetoric of everything except logic which they deemed, not a method of enquiry, but the art of disputing well[19] . His characteristic method – and the notion of method is particularly important since he is concerned with orderly teaching – is to arrange every subject/topic or discourse in terms of an ordered series of 'dichotomies' that descend from the most general statements to the most particular. This ordered sequence

The plan of the Sciences and Artes Mathematicall; the 'groundplat' of the subject: as printed in John Dee's *Preface to Euclid* (1570) This diagram, which precedes the text, lays out the logical architecture of the subject. The aim was, to memorise this 'epitome' in order to imprint the structure of the subject on your mind, without the aid of images.

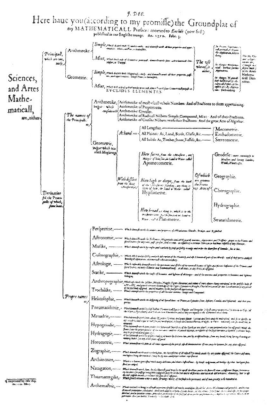

is the 'epitome' of that topic or discourse. The epitome can be expressed diagrammatically in the form of a decision 'tree' which is, as Ong points out, an algorithmic form applicable to every subject. This is also a place system for the memorisation of that subject, and being the logical form of that subject it affords (Ramus argued) the purest means for its memorisation. It could also stand at the opening of a textbook or work of philosophy where it operated both as a table of contents and as a mnemonic. Memorise the algorithm and you have the topic complete in all its logical relations.

A good example will be found at the head of a key work of the period; John Dee's *Mathematicall Preface* to Billingsley's edition of Euclid (1570). It is addressed to *'common artificers . . . who by their own skill and experience . . . find out and devise new works, strange engines and instruments for sundry purposes in the Common Wealth'*[20] The *'Sciences and Artes Mathematicall'* are dichotomized into those that are *'Principall'* (what we would call 'pure') and *'Derivative'* (or 'applied'), which are then further divided. Dee calls this epitome his 'groundplat' or architectural ground-plan.

An algorithm is an organisational instrument of great power and adaptability. The Soviet logician A.A. Markov has given a general theoretical description of an algorithm as follows.

a) It will be definite: the prescription for the algorithm will be precise, with no place for arbitrariness, and it will be universally comprehensible.

b) It will be general: it will be possible to start from the given data, but the data itself will vary within certain limits.

c) It will be conclusive: the algorithm will be orientated toward some desired result, obtained with certainty, provided that the proper kind of data has been fed in.[21]

To anticipate: a method that is definite, general and conclusive is something truly remarkable: in the field we are to consider, it foreshadows rationalist or functionalist design methods. Geoffrey Broadbent, who in several writings has traced rationalist design methods and architecture to their source in Descartes' concept of method, writes:

It is salutary for us to note that already, in 1637, the basis was available on which all rationalised and systematised design methods have since been built.[22]

A study of the Ramist dichotomies and epitomes suggest we should modify this by now conventional wisdom; the principal intellectual tool for the systematisation of design (or anything else for that matter) was in existence eighty years earlier and was already, at that time, being applied directly to the teaching texts of subjects (such as geometry) essential to manufacturing, science and technology. The readership (as we shall see in Chapter Five) was primarily amongst English and Dutch skilled craftsmen and puritan teachers who were beginning the generation of the industrial system in the dockyards of London, Portsmouth and Amsterdam, from where they were setting out to found the American colonies.

We can now add to the scheme of the individuals inner iconoclasm, that of educational practice; thus:

pictorial	→	symbolic	→	abstract
imagistic	→	emblematic	→	diagrammatic

*

Frances Yates in *The Art of Memory* (1966) has some memorable sentences on the consequences of the new diagrammatic *ars*

memoria.

> *No more will places in churches and other buildings be vividly impressed upon the imagination. And, above all, gone in the Ramist system are the images, the emotionally striking and stimulating images the use of which had come down through the centuries from the art of the classical rhetor. The 'natural' stimulus for memory is now not the emotionally exciting image; it is the abstract order of dialectical analysis which is yet, for Ramus, 'natural' since dialectic order is natural to the mind.*[23]

Walter Ong and Marshall McLuhan, amongst many others, have written of this period as one of change from a predominantly aural/oral culture to one that is visual/typographic. While not dissenting from this in the broad terms they use, I must note here that they very largely restrict themselves to texts and to language. When we move away from literary to material culture a different conclusion may be drawn. A Ramist education (as much else in reformed religion) involves the mortification of the capacity to visualise. We move away from an intensely visual and pictorial memory, with its networks of allusion, analogy and association, toward an inner life organised by abstract schemes expressed diagrammatically, an essentially cognitive organisation of memory, and hence of identity. With this may go access to a whole range of unconscious systems of association. The consequences of this change for the aesthetics of material culture and practice is perhaps the main theme of this book.

Petrus Ramus was in no sense a design theorist except insofar as the organisation of textbooks constitutes an exercise in design that followed from his logical premises. But as Ong points out, Ramus' texts did employ novel typographical layouts,

> *more organised for visual, as against auditory, assimilation by the reader. Paragraphs and centred headings appear, tables are utilised more and more . . . this increased sophistication in visual presentation is not restricted, of course, to Ramist writings, but is part of the evolution of typography.*[24]

Several examples come to mind. We have looked at John Dee's *Mathematical Preface* already, but John Jewel's *Defence of the Apologie of the Church of England* (1609) uses different typefaces for different speakers and for quotations. William Perkin's many writings present their contents in epitome form;

and both these writers are vehement against imagery in worship and education.

Perkins appears as a systematic Ramist in a book entitled *The Arte of Prophesying or a Treatise concerning the sacred and Only True Manner and Methode of Preaching* (1592). This advises on the organisation of sermons for their maximum rhetorical and dialectical force. Howells writes *"The prevailing dichotomous structure is, of course, Ramistic, and so far as I know, Perkins is the first Englishman to write of preaching in terms of that kind of structure."*[25] As already noted, prophesying was unlicensed preaching by unbeneficed clergy or by lay persons, and it was associated with the growth of Calvinist ideas within the Elizabethan church. Elizabeth had required her justices and bishops to suppress it, and it was on this issue that Archbishop Grindal was forced to retire.

Howells gives a detailed account of Ramus' influence in England and Scotland, and on English education, beginning with Roger Ascham, tutor to Elizabeth Tudor. Later in this book we shall encounter Ramus again, as a leading actor in a great publishing endeavour in the field of popular science and technics. But his work was not admitted unopposed. Howells gives a detailed description of the disputes between Everard Digby and others, and between Gabriel Harvey and Thomas Nashe. Francis Yates gives us an oblique picture of the fierce encounter between Giordano Bruno and his henchman Dicson, and the assembled Ramists of Oxford led by Perkins (in 1584). The obscurities of this academic fracas are lightened a little if we regard it as a clash between iconic and anti-iconic pedagogies.

Miller and Johnson have researched the reading, writing and teaching of the first settlers in Massachusetts and conclude *"For the Puritans of New England there was one man they looked to for guidance in the management of reason – the great French Protestant, a martyr in the St. Bartholomew Massacre, Petrus Ramus."* Amongst Ramist texts in use in Harvard in 1672 were such standard volumes as Fraunces' *The Lawyer's Logicke* (1588), Richardson's *The Logician's Schoolmaster* (first published in 1657 but circulated in manuscript form for many years before), John Milton's *A Fuller Institution of the Art of Logic* (from 1630) and the works of Perkins already mentioned.[26]

Typical of the material they have gathered is a piece of Polonian advice from Leonard Hoar, the second president of Harvard, written in 1661 to his freshman nephew; he is describing

how to organise notebooks with proper headings.

Let all those heads be in the method of the incomparable P. Ramus, as to every art which he has wrote upon. Get his definitions and distributions into your mind and memory. Let these be the titles of your several pages and repositories in the books aforesaid. He that is already in these of P. Ramus, may refer all things to them. And he may know where again to fetch any thing that he hath judiciously referred: for there is not one axiom of truth ever uttered, that doth not fall under some speciall rule of art.

In such advice we see the Ramist algorithmic place-system used for systematic information retrieval. Ramus can sometimes appear as the father of the modern textbook and 'how-to-learn' manual!

Miller and Johnson give a decidedly platonic interpretation of Ramus' principal concepts and method. In Ramism, they argue:

The world is a comprehensible logical structure to which the mind of man, in spite of the fall of Adam and human corruption, almost exactly corresponds . . . the basic premise of his system was a platonic conception; that the world is a copy or material counterpart of an ordered hierarchy of ideas existing in the mind of God . . . the generalized concepts of the mind, the principles of 'art' are not human constructions, not mere hypotheses or useful categories, but eternal and inviolable ideas. Truth becomes perception of immutable essences, beauty become correspondence to them, virtue becomes conformity with them. . . . Thinking was not conceived as a method by which we compose our knowledge, but as the unveiling of an ideal form . . . [and later] *Ramist logic was a grouping of all the ideas, sensations, causes and perceptions in the world, laying them out in a simple and symmetrical pattern, so that a description of the logic was practically a blue-print of the universe.*[27]

This interpretation places Ramism very much in a line of descent from medieval Platonism and from Wyclif; it is a kind of platonic fundamentalism (not unlike the more recent phenomenon of 'vulgar Marxism'). The Ramist epitome, in this reading, is the *esse intelligibile* of the topic. But Ong and other writers deprecate the philosophical quality of Ramus' thought and stress its essentially utilitarian and pedagogic character, and its contribution to quantitative precision and method – and thus to

the growth of science and technology. And it was on these grounds that, according to Paolo Rossi, Bacon (having learnt from Ramus) rejected him (see Ch.5 below). Insofar as Ramism assumes the function of thought to be the unveiling of ideal form, so far it was not efficacious in the logic of discovery, which Bacon took to be the creation of new knowledge. In Ramism, there is no new knowledge.[28]

This leads us back to reflect upon the requirements of plainness and perspicuity.

It is frequently possible, without violating the sense of the argument, to transform advice on the design of a sermon to advice on the design of a building; to step from things said or written, to things constructed or wrought. Plainness and perspicuity are aesthetic terms first of all, intellectual and moral only by metaphor. We first encounter this aesthetic of simplicity and directness in spoken and written language, because a speech may be made without capital investment and organisation. A chair, a table, a suit of clothes, a house and its garden, take a little longer to fashion than a sermon.

Considered philosophically, it becomes clear that, insofar as reformed religion was re-Platonised religion (after the examples of St. Augustine and Wyclif), so that the perspicuity demanded was logically necessary; what we saw perspicuously through the discourse (or the table) was its essential Idea; its *esse intelligibile*.

My contention in the next chapter will be that the development toward what is commonly called 'functionalism' and `rationalism' in seventeenth century Plain Style is really (where tables are concerned) a progress toward the Ideal Type of the Table, that which was in the Upper Room, the object that unites the domestic with the liturgical, Communion and community. In the extreme cases, such as that of Shaker furniture in the early nineteenth century and in certain Quaker and Mennonite interiors we may describe such tables as *ontological statements in which the meaning of the word `table' is laid bare.*[29]

*

As we have seen, in the world of Abiezer Coppe and his fellows we have to do with a vein of extravagant mysticism or pietism which, no longer content to remain a private matter of individual

devotion, bursts out into political conduct. This has a bearing, I believe, on the attitude to materials that manifests itself in the Plain Style.

Norman Cohn has argued that Coppe and his fellow Ranters were drawing upon a medieval tradition of 'the Free Spirit' which proclaimed the unity of God with his creatures, and His immanence in the material world. He has reprinted many striking excerpt or accounts of their beliefs. . . .[30]

Every creature in the first state of creation was God, and every creature in God, every creature that hath life and breath being an efflux of God, and shall return into God again, be swallowed up in him as a drop is in the ocean . . . a man baptised with the Holy Ghost knows all things even as God knows all things, which point is a deep mystery and a great ocean, where there is no casting anchor. . . .

Thomas Edwards *Gangraena* (1646)

They maintain that God is essentially in every creature and that there is as much of God in one creature, as in another. . . . I saw this expression in a book of theirs; that the essence of God was as much in an Ivie leaf as in the most glorious angel; I heard another say that the essence of God was in that board, as much as it was in heaven; he then laying his hand upon a deal board. They say there is no other God but what is in them . . . the titles they give God are these; they call him The Being, The Fulnesse, The great Motion, Reason, The Immensitie. . . .

John Holland *The Smoke of the Bottomlesse Pit* (1651)

This extreme immanentism (especially when accompanied by political levelling and 'overturning') makes it impossible to value one material over another. A deal board is as valuable as carved marble. Plain plaster is as good as fine wainscoting. The equation of rhetoric with 'painting' (i.e. with cosmetics) is a standard trope of the sermon-books.[31] The phrase 'painted rhetorical terms' carries the same sense of falsity or disguise. 'Painting' equals rhetoric; rhetoric is specious; *ergo* 'painting' is specious. Materials have to be displayed in their natural unpainted or unvarnished condition; there can be no hierarchy of materials; all materials can be the bearer of the numinous.

It may be thought that here we are at some distance from the ostensible ground of this study – tables and chairs and houses;

but the disorderly radicalism of mid-seventeenth century was a forcing ground of utopian and millennial ideas. The Ranters, Levellers and Diggers (not to mention the Fifth Monarchy Men and The Family of Love) have left us no design, no buildings, no statements of aesthetic priorities other than the common invocation of 'plainesse'. But their immediate descendants – the Quakers, Amish and Shakers were (and are) distinctive builders, craft workers and organisers. Moreover, utopianism, as a guiding metaphor, became through the settlement of the Americas and through the Enlightenment, one of the foundations of modernism.

Though much has been written on the ideologies of utopian thought, and on the relation of these to twentieth century architecture and arts, quite insufficient attention has been paid to the deeper ground of mystical theology from which these phenomenon arose. The radical sects of the seventeenth century were the first to face this undying dilemma; shall Utopia be realised in the mind or in the life. If in the mind, by what symbolic or emblematic scheme can it be evoked and communicated, insofar as it is expressible. And if in the life, then how, and in what forms, shall it materialise? Through what doors shall it enter, in what clothes? In what halls walk and in what chairs sit down? To answer these questions would be to realise heaven's vernacular.

Such a dilemma (given the historical and cultural ground on which it was experienced) induced what I shall come to call a spiritualised functionalism. This is an ugly term for a supremely elegant simplicity of style; to describe it in theological terms we might say, an aesthetic of *esse intelligibile*. Gershom Scholem has written some appropriate words in a related context.

> *If allegory can be defined as the representation of an expressible something by another expressible something, the mystical symbol is an expressible representation of something which comes from a sphere whose face is, as it were, turned inward and away from us . . . the symbol 'signifies' nothing and communicates nothing, but makes something transparent which is beyond expression.*[32]

To attain the transparency, this 'perspicuity' is the aim of the radical puritan when he or she begins to make or build.

*

To maintain a mental life, to pray and meditate without recourse to mental imagery is a difficult high wire to be walking; it requires constant self-scrutiny. Self-scrutiny lies at the very heart of reformation spirituality because it is the logical entailment of the relocation of authority inward, upon the individual conscience. We have a permission to use mental imagery, but the consequence of this is that we must become our own censor. It is hard not to feel, at times, that the reformers were doing violence to their natural imaginative faculties. But any attempt at transcendent experience requires a like discipline. Religious life, and indeed any serious discipline, is full of similar examples of taking a stern attitude toward oneself. The perfect counter-example to the inner iconoclasm of the Reformation will be found in the equally severe, but powerfully pictorial, meditational practice enjoined by Ignatius Loyola who, as founder of the Jesuits, was a prime mover of the Counter Reformation.

The Spiritual Exercises, first officially published in 1548 (the year in which the English clergy were required to take away, utterly extinct and destroy all paintings, pictures and other monuments), specifically promotes visualisation as the first and essential stage in meditation. After a preparatory prayer, each exercise enjoins the reader to form *"an imaginative represent-ation"*.[33]

> *Para.47. Note: for a visual contemplation or meditation, the picture is an imaginative representation of the physical place where the event to be contemplated occurs. By physical place I mean the temple or mountain where Jesus Christ our Lord is, as demanded by the subject matter. Where the subject matter is not something visible, as in the present case of sins, the 'picture' will be the idea produced by an effort of the imagination, that my soul is a prisoner in this corruptible body and is condemned to live among animals on this earth like someone in a foreign land.*

That is to say, where we do not have a given image we must form one from an extended metaphor, for ourselves. For the various objects of meditation there are appropriate pictures. For the contemplation of earthly and eternal kingship, the first preliminary states

> *A picture of the scene. Here it will be to see in imagination the synagogues, towns and hamlets through which Christ*

our Lord went preaching.
For the Incarnation . . .

Here it means seeing the great extent of the round earth containing so many different races; and then I must look at the room in Our Lady's house at Nazareth in Galilee.

For the Nativity . . .

Represent to yourself in imagination the road from Bethlehem in its length and breadth. Is it level, or through valleys, or over hillsides? In the same way study the place of the Nativity. Is the cave spacious or cramped, low or high? How is it furnished?

Nor are all our images to be wholly visual. As for hell,

See in imagination those enormous fires and the souls as it were with bodies of fire . . . hear in imagination the shrieks and groans and the blasphemous shouts . . . smell in imagination the fumes of sulphur and the stench of filth and corruption . . . feel in imagination the heat of the flames that play upon and burn the souls.

In less penitential passages we are asked to look in imagination at our imagined devotional images

meditating and studying in detail . . . listen to what they are saying . . . smell the indescribable fragrance and taste the boundless sweetness of the Divinity . . . touch, by kissing and clinging to the places where these persons walk or sit.

These passages read like prescriptions for devotional paintings, linking internal imagery with actual works, the one drawing upon the other and each feeding the other's invention. I do not think we can understand a great deal of later sixteenth and seventeenth century art without knowing The Spiritual Exercises, because they are the seeds of Counter-Reformation imagery. From thence comes its sense of dramatic, even theatrical presentation, its emotionalism and idealised realism.[34]

Looked at in this light, we can view the struggles between Reformation and Counter-Reformation as a conflict between iconic and an-iconic cultures, in which the religious image was the point of keenest focus.

If this suggestion held good then we would have encountered a useful typology of cultures. In the context of Northern Ireland, to which the first edition of this book was mainly addressed, it seemed to shed light on the notion of 'two cultures', or what I

described in the Introduction above as the underlying geology of European society. But the matter is by no means as simple as this. First, Protestant Europe did not forbid the art of painting, only the use of images in worship. The ban upon religious imagery actually encouraged (after a pause for adjustment) the creation of secular imagery, often of a symbolic or allusive kind, which led in time to great changes in subject matter and treatment. The interior scene, the still-life, the landscape, became for Northern Europe what the altar piece was for the South. The ostensible subject matter of much Dutch painting, for example, frequently masks a religious content, making of domestic space an arena for our encounter with the Divine. Second, the mortification and self-censorship of the visualising faculty for which Reformation spirituality called, is a tribute to the power of that faculty, seeing it as irrational, sensual and even demonic. And third, as I shall argue in the next chapters, the effect of the removal of images from worship was to displace the iconic function of the picture onto workmanship and the display of materials. Thus stone, timber and plaster, plain and unadorned, and above all, space itself, could embody the numinous dimensions of life just as surely as pictures and statues.

We can now enlarge our original diagram, as follows. . . .

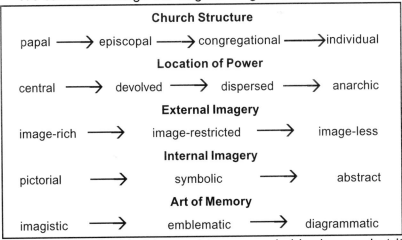

Church Structure

papal ⟶ episcopal ⟶ congregational ⟶ individual

Location of Power

central ⟶ devolved ⟶ dispersed ⟶ anarchic

External Imagery

image-rich ⟶ image-restricted ⟶ image-less

Internal Imagery

pictorial ⟶ symbolic ⟶ abstract

Art of Memory

imagistic ⟶ emblematic ⟶ diagrammatic

I believe this chart holds good to a remarkable degree, but it needs (I repeat myself) to be treated as a servant rather than as a master.

There is a further point to be made here, which tends to the stereotypical but is difficult to avoid. The replacement of pictures

and statues by text and emblem, and of mental pictures by the abstract diagram makes possible a higher level of self-conscious control over the inner life which may not always tend toward human happiness. One effect of being the censor of one's self may well be to rigidify and repress the visualisation faculty so as to release one from the anxiety of constant self-scrutiny. We may conclude that the notion of the repressed puritan is, like other stereotypes, based upon a truth.

The Protestant, and especially the puritan, insistence upon text also raises the contentious question of correct interpretation. Text, to be comprehensible, has a grammatical and syntactical order, and though there are several possible interpretations we can be sure that some are wrong and we may believe that only one is right. The idea of the true meaning is always lurking there. Images, on the other hand, have no syntax and no necessary order; they are frequently disobedient and can never have one and only one meaning. Meaning can be changed by entitling. There is, in the uses of images, always something of a carnival: they lend themselves to, and even invite, alternative, subversive or heretical interpretation. The Catholic tradition, above all, understands this very well, having from the first appropriated the imagery of the classical world and, in more recent times, that of Indian, African and South American beliefs without much trouble. This attitude undeniably frees the imagination for synthesising play and recombination (provided that it always remains within the baggy confines of doctrine and faith). There is a generosity about this, even when it colludes with whatever releases individuals from self-responsibility. This is manifestly lacking in the demanding world of Protestant an-iconism, which always throws the conscience back on its own resources.

The issue is unavoidably vast. We are dealing here with a field of human experience and social practice that far exceeds the limits of this book. At the extreme edges of this field, where Protestant rejection of imagery tends toward an over-prescribed rigidity of expression, the catholic theatre of images tends to infantilise. These extremes are most manifest where social and cultural conservatism are strongest.

*

It seems to me that we are also dealing with a powerful constellation of ideas, in which plain speech and a passion for perspicuous expression overrides traditional rhetoric, creating a rhetoric all of its own; which, translated into buildings and artefacts, issues forth in a direct, even stark refusal of compromise and decoration and a liking for geometrical simplicity. This is a deliberate and ostentatious lack of ostentation which, in the context of the seventeenth century, implied a lack of respect for hierarchy and aristocratic forms of behaviour and manners. There is in this an attitude which is simultaneously spiritualised and utilitarian; and one which is suspicious of metaphor and figurative speech. In Chapter Five I shall relate this to the growth of science through the attitude taken toward speech and toward the design of early scientific instruments.

1. *Institutes,* Bk.1. Ch.8 xi: 8, London (1961)
2. For a discussion of Poole and her book, see Woodhouse, A.S.P., ed., *Puritanism and Liberty: being the Army debates 1647-9,* London (1938). cited by Aston op. cit.
3. From his pamphlet *The Fiery Flying Roll* (1649). See also Morton A.L., *The World of the Ranters: Religious radicalism in the English Revolution* London (1970). Coppe went on to write: *'Thus saith the Lord, I informe you, that I overturn, overturn, overturn. And as the bishops, Charles, and the Lords have had their turn overturn, so your turn shall be next, (ye surviving great ones) by what Name or Title soever dignified and distinguished. . . . Behold, behold, behold. I the eternal God, the Lord of Hosts, who am that mighty Leveller, am coming (yea, even at the doors) to Level in good earnest, to Level at some purpose. . . .'* Bishop Gardiner 102 years earlier, had been right!
4. See Crew, P.M., (1978) pp. 22-38 for discussion
5. Miller, G.E., (1967) p. 211
6. Richard Baxter in 'Three Treatises Tending to Awaken Secure Sinners', as cited by Keeble, N.H., in *Richard Baxter: Puritan Man of Letters.* Oxford (1982)
7. See, for example, Trimpi, W., *Ben Jonson's Poems: A Study of the Plain Style* Stanford (1962) and Gilman, E.B., *Iconoclasm and Poetry in the English Reformation: Down went Dagon,* Chicago (1986)
8. In what follows I am, of course, heavily indebted to Frances Yates' *The Art of Memory* (1966)
9. Yates *op. cit.,* pp. 17 et seq
10. Panofsky, E., *Gothic Architecture and Scholasticism* London (1957)
11. Cited by Howells op. cit. p. 87
12. In *The Art of Prophesying* cited by Aston op. cit. p. 457. See also the dispute that Perkins conducted with the followers of Giordano Bruno at Oxford during 1584, as related by Yates (op. cit. Ch.12 'Conflict between Brunian and Ramist Memory')

13. See Strong, R., *Gloriana; the Portraits of Elizabeth I,* London (1987), pp. 157-161. And also Arnold, J., *Queen Elizabeth's Wardrobe Unlocked: an Inventory of the Wardrobe of Robes 1600,* Leeds (1988), p. 81-82.
14. See Young, A.R., (ed.) *The English Emblem Tradition: Henry Peacham's Manuscript Emblem Books,* Toronto (1998)
15. Roy Strong, in the forward to Holtgen, K.H., *Aspects of the Emblem: Studies in the English Emblem Tradition and the European Context,* Kassel (1986)
16. There is an excellent essay on this topic by Anthony C. Buckley, 'The Chosen Few: Biblical Texts in the regalia of an Ulster Secret Society', *Folk Life,* Vol. 24, 1986-6, pp. 5-25
17. Marlowe, as a Cambridge graduate, was among the firstcohort of scholars fully trained in Ramist method
18. See Ong, W.J., *Rhetoric, Romance and Technology: Studies in the Interaction of Expression and Culture,* Cornell U.P. (1971) and *Ramus, Method and the Decay of Dialogue,* Harvard (1958)
19. And note again Marlowe's *Doctor Faustus.* Faustus, rejecting this concept of logic, opts for magical means of augmenting his power and begins by conjuring up his mental images of Helen etc. Faustus is punished for rejecting Ramist logic! (See note 17 above)
20. Reprinted recently by Science History Publication, New York (1977). There is a debate as to how far the Ramist method was wholly originated by Ramus himself; Dee was probably also learning from Richard Recorde and Ramon Lull. It might be truer to say the 'method' was generally 'in the air' in the 1560s and that several writers, of which Ramus was the most prominent, availed themselves of it, each in their own way
21. Cited in Broadbent, G., *Design in Architecture,* London (1973) p. 326
22. *ibid.,* p. 60
23. *op. cit.,* pp. 250-251
24. Ong (1971), p. 184. And see the whole of his chapter entitled 'Ramist Method and the Commercial Mind.' We note in passing that Ramist typographical inventions are now the commands of word-processing software. . . .
25. Howells, op. cit. p. 206
26. Miller, G.E.P., and Johnson, J.J., *The Puritans: a Source Book of their Writings,* Harper Torch reprint. New York (1963)
27. *op. cit.,* pp. 30-33
28. Rossi, P., *Francis Bacon: from Magic to Science,* London (1968), pp. 40-41, p. 136 et seq
29. See next chapter for an expansion of this idea
30. Cohn, N., *The Pursuit of the Millennium, Revolutionary Millenarians and Mystical Anarchists of the Middle Ages.* Revised edition, London (1970), pp. 318, 322 etc
31. As in *The Golden Grove,* yet another manual on preaching, by William Vaughan (1600),
32. Scholem G., *Major Trends in Jewish Mysticism.* London (1955), pp. 244-255
33. All quotations from the translation by T. Corbishley (1973)

III
THE PLAIN STYLE

I have spent a long time on the issues of inner and outer image-breaking because they seem to be the foundation of any possible 'Protestant aesthetic'. Now we are to examine the world of things; the realm of buildings, furniture and clothing, so as to discover how this aesthetic, which was founded in the expression of worship, manifested itself in materials and spaces. In so doing I shall move outward from design for worship into the secular world of design for the household, and into public life with its rituals of display.

In making these distinctions, however, I imply not absolutely distinct areas of design but rather different aspects of the same manifestation which we can summarise as the spiritualisation of the vernacular; or, viewed in the reverse direction, as the vernacularisation of the spiritual. The special and the everyday intersect; the chapter will describe a spiral of reciprocal interaction between the sacred and the secular. This follows from the general tendency of Reformation liturgical practice, with its use of everyday language and congregational singing; and from the 'bottom-up' location of authority within the Calvinist and 'puritan' wing of the movement. In particular, where we are dealing with the more highly individualised, even anarchic tendencies, the spiral is aligned with the immanentist refusal of hierarchy with respect to materials as well as in society.

Thus the main concern will be directed toward the puritan and anti-Episcopal wing of the Reformation, toward the churches that in time formed the dissenting tradition in Britain and gave the American settlements their distinctive character. It appears at this stage to be neither possible nor necessary to make the fine distinctions in design that were made in theology and liturgy between these various 'separatist' and 'gathered' sects; but the distinctions between them and the Lutheran and Anglican

traditions of building (which stem from the location of authority within the system) are important, and attention will be paid to them in Chapter Four.

*

Design for Worship

A useful conceptual instrument with which to open our topic is provided by a recent Protestant writer on the phenomenology of places for worship, H.W. Turner, who has written that . . .

> We need a theology of space itself, as a basic category or dimension of human existence with the most immediate relevance to a spatial structure such as a church.[1]

From a general discussion of sacred places Turner distinguishes between two types which he calls the *domus dei* or temple-type, and the *domus ecclesia* or meeting house type. This is not an architectural typology but a liturgical category.

> We hope to demonstrate that even at the phenomenological and historical level the meeting house type presents the authentic norm for the Christian tradition.[2]

The *domus dei* is an earthly house of God, mirroring the cosmos in its formal structure and symbolism, thus forming a meeting point between heaven and earth: "*it brings the transcendent Yahweh to an immanent presence at one place in the world*". Typically the *domus dei* contains an inner sanctuary, a Holy of Holies, screened off in some way from the main space where the congregation gathers; and its form language is directed toward the expression of the numinous and other-worldly. It is a clearly sacred space. The *domus ecclesia,* on the other hand, is primarily a meeting place for the congregation, not in itself symbolic or sacred. In this space the meeting of the transcendent and the immanent is created in and by the congregation at worship, not by the sacredness of the place in which they meet.

Turner is at pains to stress that he is not concerned with the technical or aesthetic aspects of church building, nor do his two categories absolutely exclude one another. Both Judaism and Islam have, in the Temple of Solomon and at Mecca, their respective Houses of God, but their characteristic religious buildings, synagogues and mosques, are of the *domus ecclesia* type. He writes of the synagogue that it was

in its beginnings, more akin to the ordinary dwellings of the people and so suggestive of an intimate, personal and 'domestic' relation between God and Man; it could be established with ease wherever the people of God were, in exile or in dispersion or in the smallest community, and so had a kind of mobility about it; the simplicity and plainness of the tent was reflected in the absence of monumental or luxurious features in the original synagogues and expressed the kind of life the Law required.[3]

The mosque too is a secular kind of structure, with its liturgical role designated only by the *mihrab* niche in its eastern wall. This feature was not in itself holy, but served as a directional focus for prayer. In both cases, the function of the building was acknowledged by common observances, the covering of the head, washing and so forth. Actually existing synagogues and mosques might, of course, be glorious buildings; but that was ancillary to their essential character. The history of Christian church building should be understood in terms of the alternation between these two types; but Turner asserts the priority and greater authenticity of the *domus ecclesia* by reference to Paul. Following the example of the first Reformers he quotes from 1. Corinthians; *"For we are a temple of the living God. . . . Surely you know that you are God's temple, where the spirit of God dwells . . . the temple of God is holy; and that temple you are."*

Turner concludes that for early Christians

the essential functions of all sacred places were manifest in a new way, for it was believed that Jesus Christ fulfilled these functions more truly than any temple ever did. [It was thus] no mere literary metaphor to speak of Jesus Christ-in-his-community as the Temple of God, but an ontological statement in which the meaning of the word 'temple' was at last laid bare.[4]

The conclusion of this had to be the adoption of the *domus ecclesia* as the proper architectural expression of Christian worship. *"This setting of the worship in the place of everyday life was matched by a similar transformation in the nature of language employed about worship in the New Testament."* He described this as the transposition from the cultic to the everyday domestic forms.[5] It was to this principle that the Reformers returned, or believed themselves to be re-asserting.

The relevance of this typology and its consequences are clear enough. To this I would seek to add the reciprocal consequence, that the everyday form might equally, under certain conditions, be transposed into the cultic by the spiral of interaction I have suggested above. It convincingly meets strictly historical evidence travelling in the other direction from the realm of social history – that seventeenth century development described by Christopher Hill as 'the spiritualisation of the household' (see below).

But what did this mean in terms of real buildings, their design and alteration?

We recall that the process of Reformation was nowhere uniform or without reversals, second and third thoughts, opposition and retreat. In England especially, the shifts and turns of policy in the early Tudor period, the Marian restitution, Elizabeth's settlement, and the Laudian attempt at the restoration of ritual and splendour, itself followed by the renewed and vehement 'cleansing' of the Commonwealth, makes it difficult to reconstitute the setting of early Anglican worship with any exactness. Modernising or restoration work at all levels of quality and intention have made of the older Anglican churches a unique and curious palimpsest which we read only with great difficulty, so much has been but partially erased and so much overlaid so incompletely.

Ecclesiastical historians have done their best to describe these changes and adaptations. The type of the larger medieval church or cathedral has been described as *'a mysterious succession of self-contained rooms seemingly stretching away into infinity'.*[6] For the Reformation to succeed, these spaces had to be opened out. Martin Bucer wrote (before 1577) that

> *the end of all ceremonies in the Church is the effective building up of faith in Christ, and for this it is necessary that the things said and done in the sacred assemblies should be well understood by all present . . . it is altogether necessary that the ministers of the churches should recite these prayers distinctly and also with clarity, and from a position from which the things said may by all present be apprehended abundantly.*[7]

This is the spatial and topological brief from which Anglican bishops and their builders had to work. Bishop Hooper of Gloucester, in his injunctions of 1551-2 gave orders that *'chapels, closets, partitions and separations'* should be taken down and

churches left without *'closures, impartings and separations between the ministers and the people.'*[8] The principle of intervisibility and audibility between minister and congregation were from then on absolute within the puritan wing of Anglicanism, and the attempts to reinstitute screens, partitions and altar-rails were to be associated with attempts to restore centralised authority. Some sixty years after Hooper's injunctions we find screens being built again (at Cartmel Priory in 1618), or in some cases replaced and then taken down, as happened at Dairsie in Fife where a screen set up in 1621 was hewn to pieces in 1641.

A very similar process was enacted in The Low Countries. Garvan, in a seminal article to which I shall return, describes the results as follows:

Eminently successful in the alteration of existing structures, the Dutch did not destroy the larger Gothic churches, but adapted them to Protestant worship. The churches were stripped of all sculptural ornament but the simplest mouldings, clear glass was substituted for stained windows, the high altar was removed and the chancel filled with seats. Either at the centre of the nave or in the chancel a high pulpit alone attracted attention. In some cases the eastern end of the apse was filled by a vast organ. The result is altogether satisfying, a clear well-lit sense of space broken only by the strong vertical lines of the Gothic structure. In such 'purified' churches, Protestant congregations heard simplified services which centred not upon the ritual of Communion but upon the minister's reading and interpretation of the Bible from his new pulpit in the nave.[9]

In time, these new pulpits became magnificent affairs; the only point in some churches where decorative display is manifested.

We see something of the early state of these reformed churches to this day, in interiors in Holland and Scandinavia, and in Northern Ireland. Those in England have frequently been altered by successive Ecclesiological movements. We also see them in paintings, notably the many works of Pieter Jansz Saenredam (1597-1665). His painting of the church of St. Odulphus, Assendelft, probably done around 1645, is of a middle-sized church nave of unpainted timber, plain stone and whitened

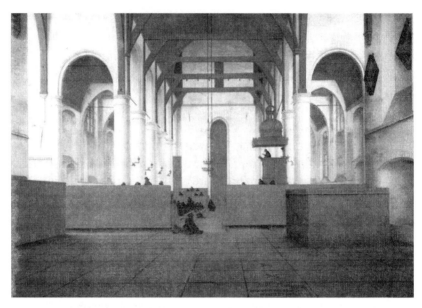

Interior of the Church of St. Odulphus, Assendelft by P.J. Saenredam (1645).
Rijksmuseum, Amsterdam.

plaster. The only ornate feature is the pulpit from which a preacher reads to an attentive congregation. To the sides are two heraldic plaques, but no trace of picture, statue or stained glass can be found. However, this is no simple description. In this and other paintings the artist has skilfully extended and stretched the space, rendering the figures small and the structure disproportionately tall. Every main feature, with the exception of the human figures, can be comprised within a simple geometric scheme – vertical, horizontal, diagonal and circular. The effect is knowingly paradoxical, an iconic image of an an-iconic faith.

The transformation effected in these Gothic structures, which were then fully visible for the first time since their building, must be understood in its full symbolic power. It realised, in visual form, in Ideal clarity, the 'great brush dipt in whiting' that Abiezer Coppe had imagined, revealing the *esse intelligible* of the medieval church. This was a visual demonstration of the catharsis imagined by Wyclif and rationally epitomised by Petrus Ramus.[10]

No such records exist for English church interiors; and granted a certain iconic idealisation in these paintings, I think we must rely on them as being a realistic record of the kinds of visual/ spatial effects desired by Bishops Hooper, Ridley, Grindal and

those of the puritan and Calvinistic wing of the English church in the first years of the new Anglican faith.

These were, however, adaptations of existing structures. What was it like to build a reformed church or chapel anew? What were the models one might use?

Among the first such spaces in Britain were certainly the private chapels of the great Elizabethan 'prodigy houses' and palaces. Unfortunately, some of the greatest have vanished. Nonsuch House, Theobalds, Richmond Palace, Rycote House and the great city mansions have gone. Others – Hatfield, Wollaton, Burghley, Longleat, have been substantially altered (though Hatfield retains some fine original glass on strictly Biblical themes). But we get something of a glimpse of what might have been the intention at Hardwick Hall (designed by Robert Smithson and completed around 1599). Here the chapel was constructed within the space of the domestic stairwell in such a way that the family and guests used the landing of the stair as the balcony of the chapel, and the household servants used the ground floor of the well. The pulpit was ingeniously placed at half height. Exactly how this was done is not fully clear to this writer, nor is it easy to photograph because the stairwell was subsequently floored in and the spaces separated; but even a swift inspection shows the marks of the changes. The principle this indicates very clearly is that the space for worship was not separate from the normal domestic space; the *domus ecclesia* was incorporated into the *domus familia*, at just the most populous circulation point of the house. Something of the same seems to have applied at another (vanished) Smithson building, Wimbledon House; but the story as a whole is as yet unclear.[11]

Where whole buildings are concerned, once the church building is no longer the *domus dei* it is free to share its spatial and topological structure with other buildings, such as theatres, concert halls and every other sort of public meeting space.

A number of precedents existed; Franciscan preaching halls are mentioned by all writers. The friars *'seem to have been unique in their realisation of the importance of buildings designed to accommodate large numbers of people with the maximum of light and spaciousness.'*[12] There was certainly a large Franciscan hall in Newgate Street in the City of London. But another model that meets the demand for intervisibility and audibility was the octagonal centrally-planned church, apparently

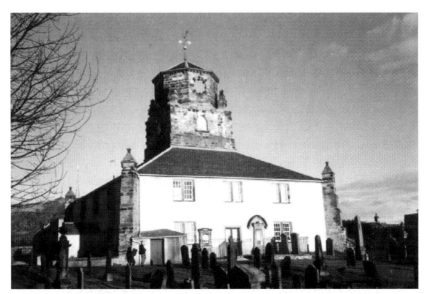

Built in 1592, St.Columba's Church, Burntisland, Fife is a marvellous example of Scottish ingenuity. The tower is supported within by four massive pillars and eight huge arches, creating an cubic interior space that is sombre and powerful. The King James translation of the Bible was first promulgated here.

invented by Brunelleschi in 1434 (S. Maria deli Angeli, in Florence). This certainly permitted many people to focus on one point, and the octagonal plan was taken up quickly by continental Calvinists. A detailed description of one of the first exists, in a contemporary account of the Reformation in Ghent.

> *Both the lower and the upper storeys of the building were lit by numerous windows. These were all glazed with plain glass, except for the lower windows which bore inscriptions from the Ten Commandments . . . looked at from both outside and inside, the temple resembled a lantern or riding school, only much larger. Inside there was an enclosure, a good twenty feet wide, where men could stand or sit around. the women all sat in the middle separated by a partition or parapet against which they had put benches for the men to sit on. . . . The interior of the temple was supported by roof timbers, the work of some master craftsman. The pulpit, recently made of fir in the ancient style, stood at the far end, . . . etc.*[13]

This was probably modelled on a similar 'temple' built in

The interior of St Columba's; newly restored. Dark oak, brass, stone and white-washed plaster; all round balcony, vernacular floral decoration and plaques of ships and trades. The pulpit is just off-centre and raised half-way to the balcony.

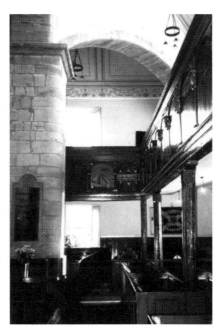

Lyons. It appears to have been the form favoured by French Calvinists. There were also large octagonal meeting houses at La Rochelle (1577) and at Sedan (1593); these seated up to 3500 people. After the Edict of Nantes in 1598, which enabled the Huguenots to worship freely, many more were built. One at Rouen (1601) was dodecahedral, and a twelve-sided building appeared at Hanau in Germany in 1622. Subsequently centrally planned churches were widely adopted by Lutheran builders and by Jesuits who sought to employ the persuasive preaching techniques of Reform in the service of Counter-Reform. One of Christopher Wren's designs for the rebuilding of St. Paul's was of this kind.

This was also, I need hardly add, the basic plan of the Globe Theatre (1599), where similar sight-and-sound lines were required.

However, the octagon type was not the most favoured in the longer run. There were other and varied attempts to modify the cross plan of the pre-reformed church. The most notable was perhaps the square hall with all-round gallery (St. Columba's, Burntisland 1592).

One also notes a nave without chancel or altar (Old Grey Friars, Edinburgh 1612), the T-shaped plan of the Tron Church, Edinburgh (1637), a 'Greek cross' type at the Norderkerk, Amsterdam (1623). Another striking invention was the L-plan, as at Freudenstadt (1601).

The T-shaped plan, perhaps because of its Scots assoc-iations, found favour with Presbyterians in Ulster; one such

T-plan Presbyterian church from the seventeenth century; now relocated
in the Ulster-American Folk Park, Omagh, Northern Ireland. Rustic in the
extreme, half-way between barn and cottage: whitewash and timber within.

is now restored and rebuilt in the Ulster American Folk Park
near Omagh, and there is another later design at
Broughshane (1720?). A rare but very beautiful plan can be
seen in Rosemary Street Non-Subscribing Presbyterian
Church in Belfast (1783); it is a well proportioned oval hall
now a little marred by later additions. A more rustic version
of this plan is the old Congregational Presbyterian Church at
Randalstown a few miles away (1790). The City of London
churches of Wren and his colleagues are a sequence of
variations and permutations of most of these plans, executed
with great inventiveness.

A principal type of Protestant church building or meeting
house, however, was defined by Jacques Perret in the studies
of churches published in *Des Fortificatione et Artifices* (1594,
1602,1613, 1620 etc.). Perret described the interior layout of
seating as being '*en manière de théatre*'. His plans and elevations
for a reformed church consist of a large rectangular hall with a
modest Doric portico, flanked by a bell-tower. This has proved
an enduring invention, with or without the tower. It was favoured
by the Huguenots for their great temple at Charenton. This
remarkable building, by Salomon de Brosse, was completed in
1623. Like the much earlier church at Burntisland it had inner

The First Presbyterian Church, Rosemary St. Belfast. Now squeezed into the narrowest streets of the city, this building contains a perfectly oval hall. It was the principal meeting house of the 'non-subscribing' Presbyterians and political radicals. The hall is now marred by the nineteenth-century addition of stained glass and an organ.

balconies on all four sides. Garvan writes:

> *Abroad it was copied closely. A Dutch engraving of 1623 shows workmen completing the Remonstrance Church in Amsterdam. In almost every detail the Dutch architect followed the plans of De Brosse. In each church two tiers of galleries were carried round all four walls. In each the pulpit stood clear of one end wall so that the preacher was almost at a level of the first gallery and surrounded by his parish. Men and woman sat apart, and special seats were reserved for the elders.*[14]

In the British and American perspective, Inigo Jones's St. Paul's at Covent Garden, London is an equivalent and successful type. A structure of the simplest form, nobly proportioned and fronted with a dignified portico of Doric or Tuscan order, well lit by large clear windows and having normally a balcony, such a structure could and did serve both Anglican and dissenting traditions for the next three centuries.

What we are accustomed to thinking of as the 'Wren' type of

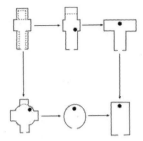

From medieval church to open-plan meeting house. • marks the pulpit.

church takes the Jones/Perret rectangular hall and bell tower, slims the tower down into a spire and sets it over the portico, not beside it. This becomes a standard type of church building throughout the United States. The whole process by which the medieval church became the meeting house can be summarised thus – allowing, of course, for many variations and by-ways.

The interior arrangements of these rectangular halls might differ according to liturgical needs and the available resources, but all normally employed the carpenter's craft to advantage through plain or box pews, rails, tables, panelling and pulpits. Pulpits were often very ornate and splendid affairs, as befitted their role in the service. The absence of painted, glazed or sculpted imagery, and the judicious contrasts between materials – oak, stone, marble, plaster, leather, iron and brass (avoiding wherever possible any kind of fakery and any ostentatious or meretricious effects) all embody the common aesthetic heritage of the reformed churches, despite the wide variety of liturgy and doctrine. In them everything appears as it is; as if the building were naked. *As if the building were naked.* I wrote that sentence without thinking. On revising it seems very apt because the essential form and material of the building is revealed as the human body is revealed when clothes are shed. Painted surfaces, imagery, effects, become, in this trope, mere cosmetics; an analogy that was widely used at the time.

The non-liturgical floorplan, the box pew, the movable communion table, galleries, the two-storey facade, the low ceiling, the elaborate pulpit, all were known to Protestant builders who, by 1630, had striven for almost a century to create a Plain Style of Church Architecture. Carried not only to New England but to other American colonies this aesthetic produced, due to the individuality of the colonies and their poor cultural intercommunication, a variety of church buildings; but none of these . . . failed to follow the fundamental principals of the European Plain Style. In each, space was closely defined, linear and well-lighted; ornamentation was constrained and abstract, and construction direct, simple and

apparent. Here was a lucid shelter within which the rational, literate Protestant might reach his God.[15]

As will become clear below, the rational and literate Protestant is something of a retrospective construction. The Plain Style was more inspired by faith than reason, and the 'literacy', while it certainly grew, was by no means widespread. The reliance was on the spoken rather than the written word, and this did most to determine the spatial form of the new churches.

At the time, most village parsons did as best they could in a changing world. Something of plain Anglicanism at its limpid best will be found in George Herbert's reflection on care of the church.

First he takes order that all things be in good repair; as walls plaistered, windows glazed, floore paved, seats whole, firm, and uniform Secondly, that the Church be swept, and kept clean, without dust or Cobwebs Thirdly, that there be fit and proper texts of scripture everywhere painted, and that all the painting be grave, and reverend, not with light colours, or foolish anticks . . . the books . . . be there and those not torne and fouled, but whole and clean and well bound. And that there be a fitting and sightly Communion Cloth of fine linnen, with an handsome and seemly Carpet of good and costly stuffe, or Cloth, and all kept sweet and clean, . . . etc. [Likewise] He is very exact in the governing of his house, making it a copy and a modell for his Parish . . . the furniture of his house is very plain, but clean, whole and sweet. . . .[16]

In the adaptation of existing buildings, the reformers were trying to reduce the sacral character of the space; to pass from the *domus dei* to the *domus ecclesia*. This was directly related to the location of authority. The Anglican and Lutheran congregations, deeply implicated in the authority structure of the secular state were, indeed, compelled to maintain some of the sacral elements. We might argue that this issue has never been fully resolved within the Anglican tradition. The devolution of authority downward to the congregation contained an enterprise (as Gardiner might have said) to subvert all authority; but it had an immediate impact on the control and allocation of funding and patronage; and hence of design. With each step away from the centre we move toward the vernacular tradition of building and design, for reasons that combine the theological

with the financial and the practical.

Within the non-episcopal churches the issue was between those who advocated a unified and established state religion, with a learned and 'professional' ministry; and those who advocated 'separated' and 'gathered' congregations. The radical alteration of church interiors and the design of new churches, as carried out in Holland and Scotland, was the work of Presbyterians of a Calvinist persuasion engaged in the capture of the established structure of worship and its buildings. This can be distinguished on the 'right' from the partial alteration effected by Anglican and Lutheran authorities; and on the 'left' from the separatists who were disposed to build anew, by reason of their beliefs, and compelled to find their own places of worship, by reason of their exclusion from those established in law.

It was amongst these separatists that the adaptation of domestic and vernacular forms to the uses of worship was most deeply and thoroughly developed; with long-lasting consequences. The unvarying tendency was toward the increasing fusion of the *domus ecclesia* with the *domus familia*. To think schematically, we can return to our original diagram and add another tier. The tendency of reformist architecture can be shown to be. . .

domus dei → **domus ecclesia** → **domus familia**

Organised dissenting communities existed in London and Norwich in the late 1560s, meeting in private houses, in upper rooms whose locations are recorded but not, regrettably, the interior details. These communities owed a good deal – though how much is conjectural – to Anabaptist precedents brought by exiles and migrants from the Low Countries.

Addleshaw and Etchells criticise the *'very inadequate theology of the Eucharist'* in Anglican tradition as a cause of uncertainty in architecture and church fittings and furniture. Radical dissenters had no such problem. If the only offering in the Eucharist is that of the individual and his devotions, the altar (or table) is only one piece of furniture among others. In consequence, the communion table should be arranged and adorned like an everyday table for an everyday meal. Any one table or room might be, like the Ranter's deal board, a bearer of the divine, and an everyday house was as good, in principle, as the greatest cathedral.

In 1568 the antiquary John Stowe recorded the meetings of

separatist groups in 'a *lighter in St. Katherine's Pool', 'in a choppers-house, nigh Wool Quay',* in Pudding Lane, in a minister's house, and in the houses of a carpenter, a goldsmith and a servant of the Bishop of London (then Edward Grindal).[17] These locations were in the commercial and manufacturing heart of the capital city; a gleaning of the records yields a list of the occupations of those who attended the meetings; cobblers, weavers, feltmakers, buttonmakers, glovers, carpenters, goldsmiths, coachmen and glaziers. A later group, questioned by magistrates in 1593, included former clergymen, shipwrights, tailors and schoolmasters, as well as a clerk and a scholar. As we shall note, this class of skilled artisans and educated men was to be at the centre of the scientific and technical revolution of the times; they were in at the start of what Christopher Hill has called 'the intellectual origins of the English Revolution.' W.R. Watts comments on the lack of support given to the separatists by the landed gentry: *'It helps to illumine the chief economic characteristic of early Dissent; its actual or potential mobility.'*[18]

When they came to build, the domestic setting was invariably preserved. Briggs, in his *Puritan Architecture and its Future* (1946) illustrates and discusses a small chapel built at Longleat House during the building of the great mansion (from 1554) for the worship of a team of Scots masons. This is a small cottage, in all essentials; though its original condition is a matter for surmise. Others must have existed. The first Baptist church of which there is any record was a small building in Southwark, made in 1616 by one Henry Jacobs who had lately returned from Amsterdam. No description has survived. Perhaps these buildings were of the class complained about by John Houson in the St. Paul's Cross Sermon of 1598, when (reflecting government concern) he spoke against village churches *'no better than pigsties'* and City churches resembling `a country hall, fair whitelimed, or a citizen's parlour, at the best wainscoted, as though we were rather Platonists than Christians.'*

However, a number of examples exist from a slightly later date, which may be taken as originating types capable of subsequent development and refinement.

One of these is a small chapel at Bramhope near Leeds, dated at around 1650. This example is interesting because of an easily demonstrated relation with village school buildings of around the same time and place (see below). It is essentially a typical cottage,

The so-called 'Puritan' Chapel Bramhope nr. Leeds (around 1650). Of uncertain origin, this is a fine example of the merging of chapel and cottage. It differs from local cottages of the same period mainly by virtue of its finely executed mullions and door arches. The bell-tower is probably more recent.

dignified by its careful attention to stonework and good finish. The interior of plain pews is unlikely to be original, but is congruent.

The cottage type of dissenting chapel is seen throughout Scotland and Ulster, where it was the dominant form of country places of worship until Catholic emancipation. This is so to such a degree

that it is often difficult to tell from without of what persuasion they may be.

There are also some very simple one-room Anglican cottage-churches, and some Presbyterian churches that are barn-like in character, with hipped roofs. Maurice Craig has written of these country cottage churches,

These buildings are undervalued, I fear, because being simple they are not thought to be beautiful. The very circumstances of their creation, the self-denial and self-reliance of farming communities in times much harder than anyone alive today can imagine . . . are, by a sad irony, turned against them. Their unity with the farms and dwell-

A view of the interior of Bramhope Chapel. The prominent central pulpit, the box pews and the lack of ornament show its 'puritan' character; but the font, altar rails and memorial plaques are of more recent and Anglican origin.

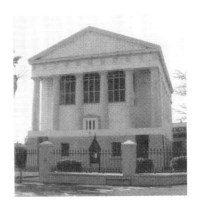

Portaferry Presbyterian Church (1841). This little ferry port contains a wholly unexpected creature: a hall that would not disgrace Glasgow or St. Petersburg. We have now left the Plain Style behind; learning and historicism are no substitute for plainness and perspicuity. Within a decade, Presbyterian churches are being built with neo-gothic complication. Dissent has become respectable and part of the authority

ings of their time, the essential rightness of their relationship to the landscape, the devotion and craftsmanship they embody, the moving dignity with which they testify to an honourable past, are disregarded. . . .[19]

This unity of which Craig writes is that achieved by building as church, an idealised or dignified form of the family house; thus realising St. Paul's insistence 'And that temple you are.'

In the nineteenth century there was a tendency, with rising prosperity, to rebuild with a certain measure of refinement and a nod to 'real' architecture. The exact provenance of many designs is difficult to establish; the continuity is of congregation rather than of structure. This is well seen in the evolution of the grander urban dissenting chapels, from previous unrecorded buildings. The Non-Subscribing Presbyterian Chapel in Rosemary St., Belfast (already mentioned above) is actually the third in its line. Another line-of-succession can be traced in Portaferry, Co. Down where an old T-plan meeting house had to be rebuilt after a storm; the result (in 1841) was a 'Greek revival' hall that demonstrates vividly the existence of that rather curious creature – established dissent.

Indeed, considered sociologically, the progressive magnification of previously modest chapels displays the increasing wealth and power of Dissenting communities in the British Isles. But in Britain and the U.S.A., and indeed throughout the world of the dissenting tradition, plainness and perspicuity remained marks of actual or potential dissidence.

Dissident church societies continued to build the simplest type of rectangular meeting house well into the 19th century. Their simplicity of design became a protest against the elaborate edifices of the established congregational societies, and a rural rejection of urban

ostentation and wealth.[20]
And this remains the case in large parts of the U.S.A. and in Northern Ireland.

<p style="text-align:center">*</p>

Design and the Household

Design and the reformed household meet theoretically in an injunction of 1563, culled from the writings of Thomas Taylor by Christopher Hill:

> *Let every master of a family see to what he is called, namely, to make his house a little church If all families, where reformation must begin, were brought to this discipline, our eyes should see a happy change.*[21]

He quotes Calvin to similar effect, linking piety to livelihood.

> *God sets more value on the pious management of a household, when the head of it, discarding all avarice, ambitions and lusts of the flesh, makes it his purpose to serve God in some particular vocation.* (Institutes 11. pp. 483-6)

In fact, beginning with Luther's Short Catechism of 1529 we find a stream of publications dealing with this homiletic topic – household prayers, books of etiquette and educational manuals. They urged the head of the household to a weekly catechising of the children and young servants, to the habit of daily prayer, to graces before meals and to a new orderliness of behaviour. Hill describes this as the 'spiritualisation of the family', which is being constructed as the lowest unit in the hierarchy of social and religious discipline, rather than the parish. This was not simply a matter of religion, but of social order and policy. Elizabeth's church regulations laid on the heads of households the duty of seeing their children and apprentices went to church, upon payment of considerable fines if they did not. Family religious instruction and observance were imposed as a duty by the Westminster Confession; by this process, the heads of household were formed into a lay clerisy and instructed as such.

> *There was indeed a vast mass of books published in the sixteenth and seventeenth centuries which aimed precisely at assisting laymen of the industrious sort in their semi-priestly duties – a kind of Protestant lay casuistry.*[22]

The physical focus of the household, as well as of the congregation, was the table. Here design for worship and design for household use meet and unite.

The use of a wooden table for the Eucharist (within the British context) was instituted by Bishops Hooper and Ridley in 1550. Diocesan injunctions did not have the force of an order, but they exhorted parishes *'to erect and set up the Lord's Board, after the form of an honest table, decently covered.'* The phrase 'Lord's Board' was conveniently ambiguous in difficult times, but the adjectives are interesting. In Hooper's parish of Ludlow the old stone altar was demolished in 1551 and a 'Board' set up consisting of five planks on a frame. (The wood, nails and wages of the carpenter, Richard Kerver, came to seven shillings and six pence, which suggests good quality materials were used.) The 1552 Prayer Book dropped the word 'altar' altogether. Addleshaw and Etchells assume these constructions to have been trestles, with a kneeling bench; however it was, the Board had to be moveable so that it could be brought down into the nave at Communion.

The royal injunctions of 1559 (at Elizabeth's accession) speak of a *'holy table'* which is to be *'decently made'*, covered during services with a *'fair linen cloth'* that seems normally to have reached the ground. When not in service it was to be covered with a cloth of *'silk, buckram or suchlike'*. A bare wooden table was not permitted. Bishop Bentham of Coventry directed that parishes were to use ' *a decent and simple table upon a frame covered with a fair carpet, and a fine linen cloth upon it, in as beautiful a manner as it was being upon the altar.*'[23] Such tables and cloths were clearly secular in origin; and it seems to have been normal practice (and theologically correct practice, increasingly) to employ domestic tables in religious situations. Cescinsky and Gribble, in their massive survey of early English furniture illustrate a whole sequence of tables which are interchangeably domestic or religious; they are chiefly of the heavy bulbous legged type, deeply carved. They write:

The ordinances forbidding the use of elaborate altars which were reiterated on several occasions during the late 16th and early 17th centuries, led to the use of secular tables as altars. It will be found in nearly every church throughout England, that where simple altar tables have been specially made as such, they are nearly all of modern

construction. In the larger number of instances, the secular tables of the time are used, generally altered or modified.[24]

A study of these tables, alternately or interchangeably sacred and secular, reveals what I shall call a spiral of interaction. We begin with the assumption of a fine domestic table from the manor hall into the communion table of the parish. Perhaps it is the very same table, carried across at the instruction of the squire of the manor (who in 1560 would often have been the Justice of the Peace and so responsible for local church discipline; such a man would have been the only person in the parish with a fine enough piece of furniture). The next stage of

The progress towards lightness . . .

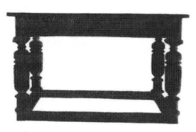

Anglican communion table; 1590's

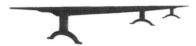

Shaker communal table; 1820's

interaction would be, for the parish to commission a table of similar design, from the village carpenter; he makes one, which is perhaps made consciously less opulent. Now we imagine the carpenter and his household of family, servants and apprentices seated at their own table; their meeting (reinforced by prayers and graces) is an expression of the primary unit of religious discipline and in itself a shadow o_f the communion meal. At the lowest level of all, the alehouse trestle is the first term in a series of which the last is the Idea of the Table in the Upper Room. Depending upon one's belief, the simple trestle might stand as well as the finest design.

Cescinsky and Gribble argue that *'It appears to be almost a fixed law, in the case of English furniture, that development is always in the direction of lighter structure'*. With particular reference to this period they continue *'toward the closing years of the 16th century and during the early part of the reign of James I, both tables and chairs were usually much more richly ornamented than at a later date. It is safe in almost every instance to state that elaborately carved tables are of an early*

period. . . .[25]

Ole Wanscher argues for a similar evolution continuing into the next century.

Generally, English furniture of the 18th century would appear to have been related to ships, carriages and riding equipment, to silverware and other handicraft. This common-sense attitude toward furniture assured a steady progress in regard to utility as well as craftsmanship. . . . English furniture of the period constitutes a by no means inconsiderable aspect of 18th century rationalism.

He goes on to describe this rationalism as follows. . .

A characteristic feature that applies to large groups of English furniture dating from the first half of the 18th century is that each form, regardless of changing styles, would appear to have been developed independently according to its inherent possibilities. In this way, the utilitarian and constructional aspects were incorporated into the aesthetic possibilities.[26]

This kind of analysis leaves a lot to be analysed. It is not at all clear what is meant by 'common-sense'. Are we to suppose that French and Italian designers and clients lacked it, because their furniture was very different? What I think it means is that many things made in Britain at this time had something in common, which was manifestly different from qualities found elsewhere; this included the revelation of the structure and the material as a deliberately desired aesthetic effect. Wanscher ascribes this to 'rationalism', but what he indicates is a common utilitarian approach following from a dislike for display. Then at a third move he appears to argue for an immanentist doctrine of style development 'according to inherent possibilities'; which is surely something else again.

Ideas of this kind are common to many writers on British and early American furniture and design in general;[27] these kinds of characterisations are not actually wrong, but they don't cohere well because one significant feature is missing. It is my contention that we can't understand eighteenth century British design without reference to the Plain Style; it is rooted there, in Protestant spirituality, which both formally and informally enjoined simplicity, the avoidance of ostentatious decoration, a preference for real rather than simulated surfaces and an active dislike of figurative imagery. This was the 'common sense'. This was the

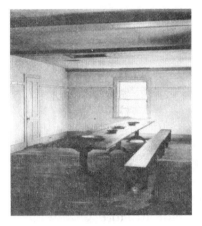

A Shaker table from Mount Lebanon, N.Y. (around 1850). This illustration is printed from one of William Winter's original negatives for the publication of Shaker Furniture (1937 By E.A and F. Deming). It is good to be reminded that these tables and benches were made for real places that might become dilapi- dated, and not for the pristine spaces of a museum and the photographer's studio lighting. (By courtesy of The Shaker Museum and Library, Old Chatham N.Y.)

broad consensus of taste, the visual ideology, of the large mass of clients of middling wealth.

What went with this was a liking for the practicality of vernacular forms at all levels of design, including, as we shall see, the design of such novelties as scientific instruments and machines. This consensus persisted through different fashions and across most social classes. By the 1750s it had become the norm and carried spiritual significance for only a relatively small part of the population.

Within the sects of Dissent, however, and especially amongst those of 'old' Dissent who had inherited their assumptions from the Civil War period, the pursuit of plainness remained a marker of their faith. In the extreme cases – that of Shaker furniture in the nineteenth century, and in certain Quaker and Mennonite interiors – we can see the spiral of interaction continuously raising domestic design toward heavenly design. Where the special case of tables is concerned, some Shaker pieces are best described in Turner's phraseology as *ontological statements in which the meaning of the word table is at last laid bare.* Or, to use Wyclif's hierarchy of Being, we rise from the actual table, to its potency in liturgy and thence to its intellectual essence as the eternal and necessary locus of God's encounter with Man.

*

The *domus familia*

And in what sorts of houses should a reformed household dwell? What did the precepts of the Plain Style mean in domestic

furnishings?

A recent study of domestic architecture in the Commonwealth period has identified a number of guiding ideas, practices and individuals. Mowl and Earnshaw have devised the somewhat anachronistic term of 'Puritan Minimalism' to describe a manner of designing large but not ostentatious country houses, and credit Inigo Jones and Henry Wotton as its principal inventors.[28] These houses, which were frequently in brick rather than stone, were symmetrical and neo-classical in general form, but very plain in their exterior surface detail. Within, however, they were frequently lavish in their use of fine timber and their ceilings were often fantasies of moulded plasterwork. Their furniture, at this early date, had a busy mannerism relating back to Jacobean models. They illustrate British examples, but several can be found in the eastern United States, and I investigate some in the next chapter under the rather misleading title of `the colonial style'.

There would be imagery, of a secular kind, in the form of tapestries and portraits. Here, of course, we are dealing with families of some wealth, and of an orthodox Puritanism which still recognised the difference between secular and religious design, and for whom worldly status remained important.

Within the cities and towns this Puritan Minimalism first appears in Inigo Jones' plans for London's Covent Garden district, though it was only the church there that was built to his original design. It is what was foreseen in these and other unbuilt designs that is most remarkable.

> *Jones's elevations for a modest house and a terrace of houses are so dull in their fine orderly fashion that it takes a moment before their amazing originality is realised. Here, in an almost Corbusier-like stroke, Jones had stripped away the extraneous detail of classical design to expose its essential geometric formalism reasonably organised around a building's structure of floors and roof. The five-bay house is quite simply the Platonic essence of a house. Built even in 1950 it would hardly have been considered old fashioned; built today it would be wholly acceptable. The terrace, equally, could have served as an archetype for city housing for the next two hundred and fifty years.*[29]

What was being invented by Jones and his commercially mind-ed clients was the brick terrace house in its typically 'Georgian'

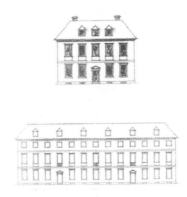

Two drawings by Inigo Jones dating from 1638 relating to the Covent Garden piazza. (Reproduced by permission of The Provost and Fellows of Worcester College, Oxford.)

form – austere to the point of numbness, but achieving elegance by an unsparing attention to the proportions of windows to walls and doorways. The almost total absence of ornament or even incident concentrates the eye onto the very few points at which ornament is permitted – door design and fanlight, and in touches of ironwork and railings which, because they are so exposed, have to be perfect. The austerity and flatness of the brick surface makes us acutely aware of its small irregularities and its material quality. In its Georgian hey-day even the roof line is hidden from the street by the flat plane of the facade; this is a Plain Style with a vengeance, though it often contained delicate plaster-work and exquisite carpentry within.

The terraces of Dublin's squares are amongst the most extreme and the most elegant; but innumerable examples can be seen all over Britain. They also formed a pattern for the New World, especially in New England and in Pennsylvania. Of course, by the mid-eighteenth century the style was a norm that came largely from builder's pattern books, and no longer deliberately signified its puritan affiliations. But if Mowl and Earnshaw are right, then their Puritan Minimalism, an *architecture without kings*, is one of the major and lasting features of the Plain Style and one most appropriate to the New World.[30]

For public buildings a little more ceremony was permitted. The Belfast Poor Hospital (1771), now known as Clifton House is a good example of this later Plain Style as applied to public amenities; it could be removed across the Atlantic and transplanted without any incongruity.

We must, of course, be chary about ascribing building styles pre-eminently to ideas; there are always numerous causes at work. The idea of a Puritan Minimalism is useful, but I think the most lasting endowment that Dissent left to architectural and

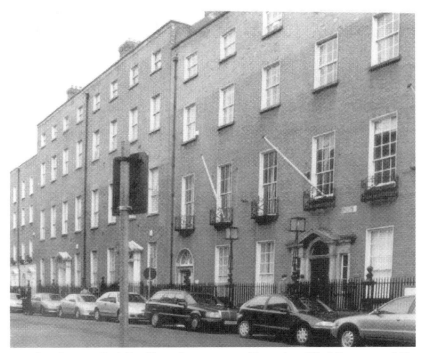

Merrion Square, Dublin. How do we name this style of Dublin terrace? By period – Georgian? By class – Anglo Irish? By ideology – 'puritan minimalism?' No one term is ever enough, because any one design is the culmination of multiple chains of causation. The houses around Merrion Square, Dublin (from 1762) are, modern street signs notwithstanding, the best surviving examples of the urban aspect of 'plain style'. By the 1760's such building had become the norm and was no longer ideologically driven. The iron balconies are later additions.

other design in Britain, and subsequently in its colonies, lies in what it prevented rather than incited. And what it prevented was a culture of conspicuous extravagance and display based around a court style. With the major exception of late Tudor braggadocio, the one attempt to create such a court style – by Charles I – ended conspicuously badly, and one reason for that is that it was perceived as an attempt at a new visual ideology based upon an image-rich baroque pictorialism, the visual correlative of political centralism. Thereafter there never was any sustained attempt to create a court style, and the dominant tone of taste throughout what was to become the United Kingdom was always driven by a middle-class of gentlemen and manufacturers and (importantly) their wives. The major movements of neo-classicism and the Baroque were almost

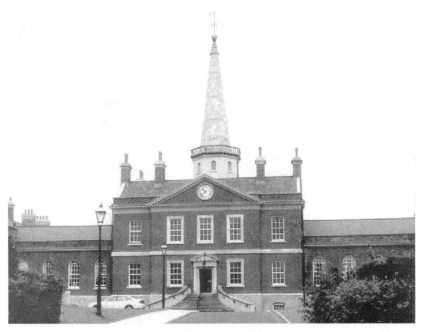

Clifton House, Belfast; formerly The Poor Hospital. By Robert Joy (1771). One of Belfast's best older buildings, with many historical connections to radical politics. The Poor Hospital fulfilled the functions of an alms house, a chapel and an administrative centre. Though much altered within, there are remnants of the original interior, including an entrance hall with black wainscoting against white walls, and black and white floor-tiles. This simplified neo-classicism, that we usually call 'Georgian' and which Americans refer to as 'Colonial' has demonstrable affinities with what has been called 'puritan classicism (or minimalism)'. Robert Joy, the architect, was a leading member of the Presbyterian congregation in Belfast, and family members were prominent in the 'United Irishmen' of 1798.

always modified and domesticated by the local tendency to plainness, modest size and dislike of ostentation. Even in a monarchy, this was an 'architecture without kings'.

What then of the inhabitants of these houses? How did they dress, move and interact with one another? Contemporary prints and portraits give us a good deal of information, but it is of a selective kind and gives us pictures as true to life, perhaps, as we now find in Ideal Home exhibitions and style magazines. But we have one visual source for the visual representation of a reformed household which deliberately attempts to portray a reformed family. In 1633 Abraham Bosse published a series of engravings showing life in a well-to-do Huguenot household.

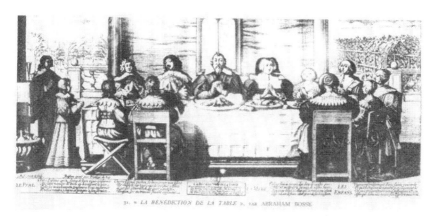

La Bénédiction de la Table, by Abraham Bosse

'La Bénédiction de la Table' shows the family seated at a very large table, covered by a beautifully folded linen cloth. This table seems to be a turned-leg and ball-footed design of some magnificence. The chairs are plain, but sturdy. The head of the house and his wife are at the centre; the womenfolk and girls to the left, the younger men and boys to the right. All are dressed well, but carefully rather than splendidly. On the wall above the father's head are painted panels bearing the Ten Commandments (very like the panels that were displayed in Anglican churches). All have their hands together in prayer. There are thirteen persons present, for this is an emblematic supper table; the text at the bottom concerns the obedience of child to parent and of all to God.

It was families such as this that fled to Britain and Ireland after the Edict of Nantes banished Protestantism from France in 1685. There they acted as the shock-troops of early industrial capitalism financed by the City of London and, in Ulster, joined in powerful political currents that are still with us today.

In 'La Dame Réformée' a young woman (probably the oldest daughter) stands before an open casement with her hand upon a dresser which holds a mirror; she looks away from the mirror and makes an open-handed gesture of welcome to an invisible guest. She is gracefully dressed in a wide sleeved gown in a fashionable cut. She is not without ornament – a small necklace and a bangle at each wrist, and the gown is partially embroidered; but the effect is of a rich austerity. What we see of the room suggests the same – a tapestry and paintings of secular scenes, strong simple furniture and another fine table covered with a heavy cloth (velvet?) and an

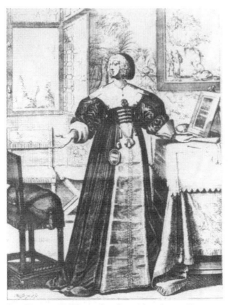

La Dame Réformée, by Abraham Bosse

overcloth of linen with a scalloped lace edging. The verse below speaks of spiritual treasures greater than those of bodily adornment, of nature above art and of virtue above lace.

At first this family seems not unlike any other moneyed family from the period, but a comparison with court portraits slowly reveals differences, and, as we know, small differences in dress can signal major differences in outlook. There is, for example, significantly less lace and jewellery for either sex. Though the tailoring is rather grand and opulent, and the fabrics obviously very good, the lines of these clothes are, by the standards of the early seventeenth century, simple, tending to the monumental. The gestures and groupings are formal, even a little hieratic. There is a seeking after poise, balance and formal dignity.

This is an aesthetics of behaviour as much as of objects. Getting close to the manners, customs and the body-language of the past is extremely difficult and much of it must depend on empathy and intelligent guesswork. But there are some matters of which we can reasonably be certain: in the mid seventeenth century it was expected of a reformed household, and especially of a puritan or Calvinist household, that the members should cultivate seriousness and consistency, rather than graceful politeness, in their manners. William Hubbard, writing in one of the first books to be published in New England, suggested in his *Benefits of Well Ordered Conversation* (1648) that

in a curious piece of Architecture that which first offers itself to the view of the beholder, is the beauty of the structure, the proportion that one piece bears to another, wherein the skill of the architect most shows itself. But that which is most admirable in sensitive and rational beings, is that inward principle, seated in some one part,

able to guide the whole and influence all the rest of the parts, with an apt and regular motion, for their mutual good and safety.

One must, so to speak, *design* one's behaviour as one designs a house, around an inward principle of proportion which regulates the rest. This self-consciousness offered a fair target to the satirist, and for every Bosse or Hubbard there are six Ben Jonsons. But the manner to which the jokes refer seems to have been a real phenomenon, manifested in deportment and body language – an erect, perhaps rather stiff 'unbending' carriage of the body, careful gestures and studied behaviour. Some gestures were openly ideological; removing one's hat and gracefully bowing had always been a mark of deference, very precisely graded to the persons and the occasions. It was just this that Quakers notoriously refused to do; this was not a small matter, for with it went the refusal to swear oaths and both were direct challenges to the central principles of political and social power. It appears – we cannot be sure of this – that the fluid body-language of an aristocratic court was being replaced by something notably erect and measured, perhaps 'stand-offish'. These characteristics seem also to have appeared in tone of voice – a head voice often described as a 'drone' or 'twang'. I surmise this may be the distant origin of an East Coast American accent, and of the preaching voice of some evangelists.

There was a Plain Style in clothing too. Elizabeth Tudor as a young woman affected a quiet style of dressing, mainly in black and white, without adornment or cosmetics, and without elaborate hair setting. This was a typical piece of ostentatious lack of display, meant deliberately to provoke her catholic sister Queen Mary and to serve, as a recent historian has observed, as *'an ocular rebuke to the old religion'*.[31] There is an account of another young woman (probably Lady Jane Grey) laying aside a gift of rich gilt lace from the Queen, on the grounds that *'it were a shame to leave my Lady Elyzabeth, whiche foloweth Gods woorde'*. The same austerity appears throughout the Lutheran party, and especially amongst the educated women of Elizabeth's circle.[32] For men, black jackets and white shirts move from being the formal clothing of the clerisy and learning and the civil service, to a more informal general use; just as clerical clothing moved toward lay clothes. Later, the opposition between City and Court was expressed in dress codes and hair length,

with puritans becoming cropped 'roundheads'. When Cromwell reorganised the Life Guards, the old Tudor uniforms of red and gold embroidery were replaced with black cloak and grey jerkin with a touch of lace at collar and cuff, dark brown boots and wide belt – the ensemble of so many enforcers ever since. On the basis of Bosse's engravings, on the evidence of Dutch paintings, on the anecdotes of diarists and the jokes of satirists it is not too much to describe this serious, restrained but rich style as a kind of 'puritan chic'.

Further 'left', in the seething world of the little sects and the separatist communities, dress codes became fixed and hypostatised by liturgical regulations, most notably the Old Order Amish 'ordnungen', which will be studied further in Chapter Four.

*

Here a short excursion into music is in place. The Reformation required a music-making that, like the Plain Style of sermon and the unornamented church, looked forward to a fully-formed Protestant aesthetic. The dissolution of the monasteries meant the dissolution of the older musical culture. The great cathedral choir-schools, however, were not destroyed; what was changed was the physical location of choirs within the building, and with that their liturgical function and acoustic scope. Exact details at parish level varied from place to place, but certain principles were enforced. The choir was now in the same acoustic space as the congregation, not hidden mysteriously behind a screen. It was now part of the congregation, leading the main body; it was not in a separate or heavenly space. It therefore required a new and earthly music that employed melodies interchangeably sacred and secular, settings that were simple in structure, and words that would be audible. All authorities cite a letter written by Thomas Cranmer to Henry VIII in 1544 in which he writes, apropos of reforms to the Chapel Royal, that

> in mine opinion, the sung that shall be made thereunto would not be full of notes, but as near may be, for every syllable a note: so that it may be sung distinctly and devoutly. . . . The Latin note, as I think, is sober and distinct enough; wherefore I have travailed to put the verses into English, and have put the Latin note unto the same.

By 1548, this had become the official policy.[33]

After the Marian interlude it was felt necessary to reinforce this orthodoxy, so the injunctions for 1571 read:

> Item: that in the choir no more shall be used in song that shall drown any word or syllable, or draw out in length or shorten any word than by the nature of the word it is pronounced in common speech, whereby the sentence cannot be well received by the hearers. And also the often reports and repeatings of notes with words and sentences, whereby the sense may be hindered in the hearer, shall not be used.

The use of well-known secular melodies was encouraged. Queen Elizabeth, however, referred to them as *'Geneva Jigs'* and loathed them. From the Chapel Royal she supported an effective counter-movement to champion complex polyphony.[34] But the 'jigs' were published in the *Certayne Psalms* of Thomas Sternhold (in 1549) and reprinted many times in London and in Geneva; they contributed to the growth of the communal hymn, the chanted or metrical psalm, the anthem and the forms of matins and evensong, and finally the oratorio. Spiritual and secular songs were often bound together in the same books, suggestive evidence for a lay spirituality centred on the home. The stress on congregational singing is part of the process by which the vernacular and domestic is brought into the same realm as the sacred and the learned, and the boundaries between the two made much more permeable.

The great intention of the reformers of church music was for ready comprehensibility of both text and musical structure simultaneously. The one-to-one correspondence of note and syllable embodies an aesthetic principal of importance: both construction and effect are self-evident and congruent with one another. Such an intention fits well with the plain style of preaching, and even more so with an unornamented architecture and increasingly plain furniture in which *'the utilitarian and constructional aspects are incorporated into the aesthetic effect.'*

Where the theatre was concerned, the Reformation lent great power to the arts of public persuasion. Puritan sermons were, indeed, a form of theatre of their own kind. Just how this is bound up in the development of Elizabethan and Jacobean theatre seems to me a very obscure subject despite the efforts of several scholars. The almost total absence of *overt* religious themes and imagery is an index of an increasing secularisation of the formal culture; but

the arts of the theatre, being at every point complicit in the carnival of images, simulation, display and dazzle that the puritan divines had to reject, could not fail to gain their disapproval. As the City of London came under puritan control the Court moved to protect theatre companies by taking them under noble patronage. In all this, as in music, there was a cultural battle taking place. It was exactly in the matter of theatrical display that Charles' court collided with the Calvinists, because it was through the royal masques that the Baroque iconography of the centralising monarch was developed, through which Charles asserted his quasi-divine status.

Where painting was concerned a number of recent studies have addressed themselves to the effects of iconoclasm, concluding that the rejection of sacred imagery encouraged the extension of secular imagery, with many new genres coming into being, all concerned to render what is actually visible to sight.[35]

Design for Education

Before leaving England and Scotland we should touch on design for education. A great expansion of formal education took place throughout both countries in the late sixteenth and early seventeenth century: it was based upon the Ramist textbook and the secular schoolroom. Amongst the first of all was John Colet's foundation of St. Paul's School (1509), which fulfilled the later reformed demand for visibility and audibility. Erasmus noted it as having four main chambers and little more, *the school has no corners or hiding places; nothing like a cell or closet.*[36]

Former monastic sites, however, were often used. Christ's Hospital School, founded in 1552, used building formerly occupied by the Grey Friars. The plan of the original school shows the cloister clearly, and a complex of former rooms and courts. But when new schools were built, the preferred model was always secular. They were houses, not cloisters, and the secular imagery of heraldry and emblems invested the clerical schoolmaster with civic authority. Some of the new 'grammar schools' were large – one at Shrewsbury, housed in a row of converted town houses, had 266 pupils in 1562 and 320 in 1581. This particular school – still existing – had an important state function, linked with the satellite court at Ludlow from which Wales was governed; it provided a flow of educated civil servants. Philip Sidney and Fulke Greville were pupils there. But a similar large school at Guildford was for general educational purposes. This building was purpose built and had a plain

School; Burnsall, Yorkshire (1601). After over four hundred years this fine building is still in the same use. Externally, an Elizabethan manor house, it consists within of a set of large rooms, lit on both sides by ample windows, without 'corners or hiding places'. Next to the parish church, it shares with it a grove of yew trees, which suggests that it was initially built on church land.

symmetrical plan arranged around a small courtyard – a sort of cross between country house and cloister. Seabourne writes that

> The rebuilding of schools takes its place alongside the renaissance of vernacular architecture which began during the sixteenth century. Perhaps the most significant change was the decisive way in which groups of townspeople and merchants now entered the field of school building.[37]

The library of this school was given by Bishop Parkhurst, who had been one of the Marian exiles; it contained commentaries on the Bible by Lutheran and Calvinist writers.

But of at least equal importance was the development of village schools such as those at Ilkley and Burnsall in Yorkshire; these were built as dignified cottages or small manors, distinguished from the other houses of the village by perhaps no more than some better quality stone work, much like the chapel already cited above.

Early seventeenth century cottage type
school; Ilkley, Yorkshire. Compare
with the nearby chapel at Bramhope.

That at Burnsall, combining the schoolroom and school-master's house under the same roof, recalls some Presbyterian chapels in its plan. These are the types of school buildings that were first erected in New England, and are the begetters of much educational building throughout the New World.

Seabourne describes the development of the village school as follows:

Although of modest size and unpretentious appearance, they nevertheless reflect an educational movement of great importance – the penetration of formal education not only into the towns, but into the countryside, with an emphasis on the classical subjects, but also on what may for the first time be called 'the three R's'.[38/39]

The curriculum was, as we have already noted, inspired by Ramist methods and responded to

several new pressures, the most important of which was the Puritan spirit, which appeared in such works as Brinsley's Ludus Literarius or The Grammar Schole (1612), and the new scientific ideas of men like Bacon.[40]

Brinsley was a leading Ramist and his book is an attempt to create a suitable curriculum for the new schools. He particularly advocated the systematic teaching of English

Because of those which are for a time trained up in schools, they are very few which proceed in learning, in comparison of them which follow other callings.[41]

Brinsley's curriculum is related to that of Charterhouse (1611) and Christ's Hospital in which commercial or business topics were introduced; one aim being *'to cipher and to cast an account, especially those that are less capable of learning and fittest to be put unto trades.'*

In these schools and their teaching programmes we may observe in action the Ramist tendency toward the utilitarian and the quantitative. The combination of village school, cottage and

small church comprise a triad of functions for a single basic building type – the cottage as little church, the school as cottage, the church as school. In the light of the foregoing pages the significance of this reciprocal triad hardly needs to be stated. Though education at this time is described as being increasingly secular, we can, through the evidence of design, add that both learning and worship were being domesticised. The interior of these village and grammar schools appears to have followed the models of church interiors – with undecorated white walls, sturdy and comely woodwork, no enclosures, and with texts and emblems in full view.

<div align="center">*</div>

I have criticised above the notion 'common sense' and its application to British eighteenth century design which, as I wrote, 'enjoined simplicity, the avoidance of ostentatious decoration, a preference for real rather than simulated surfaces and an active dislike of figurative imagery. This was the broad consensus of taste, the visual ideology, of the large mass of clients of middling wealth.'

I think we can best characterise this broad consensus in terms of *habitus*. This term has been proposed by Pierre Bourdieu in a long series of detailed studies to account for the stability of some lasting, almost permanent dispositions in a culture or social class.[42] He has used definitions such as *'the set of basic deeply interiorised master-patterns'* and *'mental and corporeal schemata of perceptions, appreciations and action'* to account for these features in the life of societies. It is because the habits of the Plain Style became so deeply interiorised that their foundations ceased to be a matter of discussion or comment.

The perceptual schemata of plainness and the mental schemata of perspicuity have been formative of most of the culture of North West Europe and North America; not, of course, as an exclusive or monocausal 'explanation', but as a major qualitative factor without which we cannot interpret or explicate how such societies *look* the way they do: but also because what something looks like is an index of the interiorised master-pattern of its intellectual constitution.

1. Turner H.W. *From Temple to Meetinghouse,* The Hague (1979), p. 6
2. ibid. p. 11 et seq
3. ibid. p. 101
4. ibid. p. 149
5. ibid. p. 50
6. Addleshaw G. and Etchells F., *The Architectural Setting of Anglican Worship,* London (1948), p. 15
7. Martin Bucer, *Scripta Anglicana,* Basel (1577). See Addleshaw and Etchells (1948)
8. See *Early Writings of John Hooper, D.D., Lord Bishop of Gloucester and Worcester, Martyr, 1555,* Cambridge (1843) pp. 491- et seq
9. Garvan, A., 'The Protestant Plain Style before 1630' in *Journal of the Society of Architectural Historians,* Sept. 1950
10. The whitened ceilings of these Dutch churches were sometimes painted with restrained floral ornament; similar treatment will be found in some Swiss churches. It is not clear to me when these were added or if they are original. In a group of reformed churches in Eastern Hungary entire ceiling and walls may be decorated with folk-motifs. Such semi-abstract decoration were evidently permitted by the Calvinist pastors of Debrecen
11. The details of this topic are presently being researched by Annabel Ricketts, to whom I am indebted here
12. Addleshaw and Etchells op. cit. p. 18
13. Printed in Duke, Lewis, Pettegee (eds.), 1992 pp. 153-4
14. Garvan, op. cit., (1950) p. 6
15. ibid. p. 12. See also Garvan A. *Architecture and Town planning in Colonial Connecticut,* Yale (1951)
16. George Herbert *A Priest to the Temple* (1652). Clarendon, Oxford (1978 ed.) p. 246 p. 241. Herbert's poems are the high point of Anglican plain style
17. Stowe, J. in *Three Fifteenth-Century Chronicles, with Historical Memoranda by John Stowe, the Antiquary, and Comtemporary Notes of Occurrences written by him in the reign of Queen Elizabeth,* ed. by J. Gairdner' in The Camden Society (1880) cited by Watts p. 20 (see next note)
18. Watts, M.R., *The Dissenters from the Reformation to the French Revolution,* Oxford (1978), pp. 73-74 etc
19. Craig, M., *The Architecture of Ireland from the Earliest Times to 1880,* London (1982), p. 24, and see also pp. 212-225
20. Garvan (1950) p. 145
21. Hill, C., *Society and Puritanism in Pre-Revolutionary England,* London (1964), p. 455ff
22. idem. p. 456
23. Addleshaw and Etchalls, op. cit. pp. 25-34, for summary
24. Cescinsky, H., and Gribble, E., *Early English Furniture and Woodwork,* 2 vols, London (1922), vol.2, p. 116
25. ibid., p. 104 and 127 etc. Not surprisingly, this process of simplification was not geographically uniform, 'Carving on chairs or other furniture of home county origin is rare during the years 1645-60, yet the same cannot be said of Yorkshire, Lancashire, Westmoreland, Cumberland or Durham,' p. 187

26. Wanscher, O., *The Art of Furniture: 5000 Years of Furniture and Interiors*, London (1968), pp. 277-279
27. Similar qualities can be discerned in much Scandinavian and Dutch work of the same period, but this has to remain a small book!
28. Mowls T. and Earnshaw B., *Architecture Without Kings: the Rise of Puritan Classicism under Cromwell*, Manchester (1995).
29. ibid., pp. 28-29
30. There is, however, a point of architectural history to be made here. An unadorned or stripped-down neo-classicism of the Jones kind did, in point of fact, precede Jones by some ninety years, in the design of Somerset House, Elizabeth Tudor's city mansion in the 1550s. Drawings of this vanished structure show an austere, unornamented symmetry, which was, without doubt, associated with the Lutheran party in the English Reformation.
31. Johnson, P., *Elizabeth 1: a Study in Power and Intellect*, London (1974), p. 40
32. See Starkey, op. cit., Ch.13
33. See le Huray, P. *Music and the Reformation in England 1549-60*, London (1967) p. 2, 10, 25, 38 etc.
34. In the Act of Uniformity is an injunction commanding that no changes should be made in churches with endowed choirs 'by means whereof the laudable science of music has been had in estimation, and preserved in knowledge'. Using Italian and often Catholic singers, the Chapel Royal achieved the highest standards of complexity and excellence. William Byrd (a Roman Catholic) was at the same time a composer of Latin mass for lordly recusant families, and a member of the Chapel Royal. Oliver Cromwell, a hundred years later, was a notable patron of music; he continued to employ members of the Lanier family which had supplied many of Elizabeth's musicians.
35. See, for example, Haller, B., *Jan van Hemessen: an Antwerp Painter between Reform and Counter-Reform*, Cambridge (1981), Alpers, S., *The Art of Describing: Dutch Art in the Seventeenth Century*, Chicago (1983), Freedberg, D. *Iconoclasm and Painting in the Revolt of the Netherlands*, London 1988). A much older but very useful work is Wencelius, L., *L'Esthetique de Jean Calvin*, Paris (1936)
36. See Seabourne, M., *The English School; Its Architecture and Organisation*, London (1971), p. 12
37. op cit., p. 17. And see also McClean, A., *Humanism and the Rise of Science in Tudor England*, London (1972)
38. op. cit., p. 43 et seq
39. op. cit. pp. 48-49
40. ibid
41. For further treatment of Brinsley, see Howells, op. cit., pp. 265-266
42. For Bourdieu, see *Distinctions*, (1984) and *Sociology in Question*, (1993): and also ed. Robbins, *Pierre Bourdieu*, London 2000; Swartz, D., *Culture and Power: The Sociology of Pierre Bourdieu*, Chicago (1997), and others

IV
HEAVEN'S VERNACULAR

It has been asserted that a Protestant or puritan aesthetic was of importance in the North American colonies. The settlers possessed, we are told, *'a philosophy that was austere and a practical ethic that would not permit indulgence in luxury and the fine arts.'* The outcome was a 'functionalist' approach to design.

> *The principle of beauty as the natural by-product of functional requirement was given additional meaning by the Spartan circumstances of the colonial environment . . . the colonist was obliged to avoid the devotion to rich detail and elaborate adornment . . . aesthetic reward had to be found in the economy of means and purification of form to purpose, and from the soundness of proportion and the clarity of symbolic form that inevitably result.*[1]

Unfortunately for this argument, the colonist was already, before he or she arrived, a person likely to be avoiding the devotion to rich detail and elaborate adornment, and actively seeking out a perspicuous clarity of symbolic form. It was a major aspect of the immigrant's *habitus*, which their new situation reinforced, partly through necessity and partly through choice.

In this chapter I propose to examine the course of the Plain Style in the American colonies; this will be done under two main categorisations. The first will be the manners of design employed by what I shall call the radical Reformation, in which a strong current of utopian intention impelled the participants to push the plainness principle as hard and as far as it would go. The second will be the prolongation of the puritan *habitus* in the New World, as an aspect of a more general approach to design that is usually described under the heading of 'colonial' or 'federal' style. These basic categories, however, are not distinct entities; they are more like different directions that might be taken from the common starting point, which was the general demand for plainness and

perspicuity. I shall take four differing examples of radical or independent dissent, and one of 'colonial style' to compare and contrast with these different directions. It should go without saying that we are here concerned with a major qualifying factor in transatlantic design, rather than a single or unifying cause.

*

I have so far used the idea of 'radical Reformation' and the 'leftward' tendency in reform in a loose way, because it was not necessary to make hard and fast distinctions between the different anti-Episcopalian and Congregationalist groups that existed outside or beyond established churches. But a good deal turns on these differences, especially where concepts of the state were concerned, and the kinds and degrees of individual self-responsibility that accompanied and defined the different kinds of radicalism.

Kenneth Davis has explored these distinctions with particular respect to the Anabaptist tradition, and cogently advances the idea of an 'independent' rather than 'radical' Reformation. The independence is defined as against what he terms the 'Magisterial Reformation' identified with Lutheran, and Calvinist traditions. Yet he is forced to conclude that

It is apparent that as yet there is no satisfactory precise generic term or single set of criteria that can successfully unite the independent dissenters – except in the negative sense of being independent, that is, not being Lutheran or Reformed . . . the differences between the principal groups within the Radical Reformation considerably outweigh any generalised similarities.[2]

If this is so, for my general thesis to stand, I shall need to show that in some measure the theological differences appear in concrete forms and practices (in buildings, artefacts, clothing etc.),and in how these forms and practices changed or remained the same. The generalised similarities, of course, will persist, but whether they are outweighed by the specific differences depends partly upon one's stance. From outside independent dissent, all independent dissenters are likely to appear more or less the same, but from within, the differences between the groups may well be very sharp. Whether or not we tie our coats with tapes or fasten them with buttons seems a Lilliputian quarrel in the greater world, but it was a large matter amongst the

Mennonites, because buttons had come to stand for too great an attachment to the 'worldly', and from this much followed. During the eighteenth century buttons were frequently a marker of fashion and status. Likewise the slow departure from extreme plainness into an accommodation with the 'world', characteristic of the Quakers, needs some commentary. Significant differences also appear in such issues as gender and how it is perceived theologically, and in attitudes to such worldly matters as trade and the problems raised by technological advances.

It will also be necessary to set a distance between the deliberate and self-conscious vernacular styling of the independent dissenters, and the general use of vernacular models common to all the immigrants and colonisers, be they English, Scotch, Irish, Dutch, German or whatsoever, who built the way they did because they knew no other way, and adapted their knowledge to local circumstance and materials. This has a bearing on the study of folk culture. Henry Glassie, for example, has made a lucid analysis of different kinds of farmhouses and barns built by the settlers; from the point of view of the independent dissenters, however, these classifications served as a repertoire of possible models, rather than norms.[3] Some groups, like the Ephrata religious community, deliberately chose a retrospective, European model for their formal buildings, but others, like the Amish, were happy to go along with the general evolution of North American farm building, reserving their differences for other matters.

Moreover, the 'generalised similarities' can be both real and useful. It is possible to list several to which nearly all the independent dissenters would agree. These would include the stress on biblical authority, an ideal of the church as a voluntary fellowship of believers, a baptismal confession of an adult (rather than infant) kind, strong congregationally controlled discipline, a 'Sermon on the Mount' ideal of Christian conduct, and non-violent principles.[4] These were often conjoined with an initial expectation of the millennium, and belief that they were living in the Latter Days. To which I should want to add an absence of central authority structure in favour of decentralised 'meetings'. Whilst Anabaptists, Quakers and others had important leaders in their earlier days, in such figures as Menno Simons, George Fox, Conrad Beissel and Ann Lee, the mature communities had usually little formally structured centralised leadership.[5] This was generally replaced by a hierarchy of levels – some Shakers were more Shaker than others, and there were

recognised degrees of commitment. The Ephrata community divided itself into Solitaries, who were celibate and devoted themselves to religious contemplation and sacralised work, and the 'Householders' who surrounded and supported and worshipped with the central 'core' members. Amish youth are often encouraged to go out into the 'world' for a time; but once they are baptised, they are within the community for good.

What they also shared, of course, was the requirement of 'plainness'. They were all 'plain people' – a phrase that is still in use. They were all 'separated'; though not always in quite the same ways. But, as I hope to show below, all groups found ways in which beauty, visual display and delight in colour could thrive.

The location of authority is, as we have seen, a central issue, for it defined the standing of the 'intentional community'[6] toward the state and the state's requirements for conformity. To build and to make and to dress differently embodied a political intention that was founded on a religious conviction. We should think of independent dissent as being concerned with *Gemeinschaft* – community feeling created by consensus, folk tradition and religion, rather than *Gesellschaft* – order resting upon the rational will and convention and safeguarded by legislation embodied in the state.[7] The communities were attempts to retain, maintain and promote the first in the face of the growing force of the latter. This has been a difficult stance to maintain in the face of modernity; the Amish, in particular, have fought a subtle and sustained campaign to protect their community; this they call 'negotiating with Caesar'. The Amish defence of intra-community values has been studied extensively, like that of the Quakers before them, since it raises matters crucial to individual and group liberty in modern conditions.[8]

There is a further similarity amongst the independent dissenters which is well worth noticing; they did not (and do not) take so harsh a view of human sinfulness and fallen nature as did the more orthodox Reformers. In particular, they tended to reject predestination for a much more merciful and loving conception of the Divine; this did not make them less strict in their congregational discipline, but it seems to have made them less anxious. In this respect, this 'independent' Reformation' (and the imperfection of the term is granted) had a deal in common with some late medieval movements of reform which remained theologically more orthodox. Writers on this topic refer to the Waldensian background of some movements, to the 'Brethren

of the Common Life' and to the devotional tendency known as the *Devotio Moderna* whose remaining monument is Thomas a Kempis *The Imitation of Christ* (c.1420). This is especially the case with the Ephrata Community. A thorough examination of this matter must, however, remain outside this little book.

I propose to take three principal strands in the tradition of independent dissent and to look at them in their general similarity and specific differences, as it applied to artefacts and buildings. These will be Anabaptist, Quaker, and Shaker. All three of these developed first in the Old World before migrating across the Atlantic; all three had a definite attitude to building, personal appearance and group discipline. I shall also be comparing the Shakers to the followers of Conrad Beissel, at Ephrata, who became the Seventh Day Baptists.

I hope it will be sufficiently clear that I am not attempting more than a cursory history of these peoples, nor any kind of detailed social analysis. My concern has been throughout on the wider issues of plainness and perspicuity, and the contribution that the Plain Style has made to forming the broader practice of societies.

<p style="text-align:center">*</p>

The Anabaptists

Anabaptism as an organised body of believers has an obscure origin, amongst the followers of Huldrich Zwingli who brought about the reformation of the church in Zurich and later throughout much of Switzerland.

Some of his followers believed their chief was too willing to make accommodation with the temporal powers. The main question was whether or not pious believers might not set up their own church organisation without respect to the civic authorities; should the reformed worship be 'separated' or inclusive? By 1524 this had led to the foundation of the 'Swiss Brethren' and the declaration that only those who had come to Christ through the reform of their own souls could be said to be baptised '*into a newness of life*'.[9]

The Swiss Brethren were able to make common cause, over the next decades, with like minded groups, notably the Hutterite movements in Bohemia and Austria and a substantial number of Dutch congregations, led by Menno Simons from whom the term

Mennonite was derived. These Dutch in turn had English connections.

Their new life would manifest itself in new, pious behaviour – not only in faith, as Luther had been teaching. This required a turning of the whole will and intention of the soul toward virtue which was hard to square with doctrines of election and predestination. Thus the practice of adult baptism became tied into the principles of free will and of 'separation'. This in turn undermined the structure of civic or state authority by making membership of the 'true' church intentional. On 21 January, 1525, by rebaptising themselves, this group of reforming preachers recreated themselves as an organised separatist church. By such an act, as Davis summarises, they signified the end of a morally mixed society called Christian but obviously not truly Christian, and the creation of a spiritual entity separated institutionally from 'worldly' control whether papal or civil. This separated church could be identified by the conduct of its members as well as by its professions of faith, and that conduct included a rejection of the 'world'. Since this 'world' pre-eminently included civil authority it is not to be wondered that Anabaptism became, in the sixteenth century, a synonym for anarchy, and that Anabaptists were persecuted as a matter of routine, by all and every established church and state.[10] The demand that separation be visible and external as well as internal made Anabaptism *prominent*. Believers had to show in their outward conduct that they were inwardly different. This was true of all of the groups we are to consider.

How far distinctiveness should be pressed was the issue behind the division of the broad Anabaptist movement into its subsequent parts, and the emergence of the Amish sect in particular. The emerging Amish (followers of Jacob Amman) held out for a strong interpretation which included uniformity in dress. The crucial argument was about the scope and force of the *meidung* – the practice of shunning those who went against congregational authority.

Material differences in appearance, clothing and such were never as obvious within Europe as they became later in America, whither large numbers of the now quarrelling Anabaptists migrated in the early eighteenth century.[11] As John Hostetler makes clear, the differences were connected with essentially negative doctrines that stated what the Amish tendency was

against, and the actual practices were important symbolically, as signs of the emerging distinctions. In particular, dress, grooming and personal appearance were the visible and explicit signs of correct belief and social unity.

Such signs had to be maintained, as signs, because the signifier and the signified were one and the same. Without one you could not be the other. This extreme literalism has maintained Amish society with astonishing success, preserving aspects of the dress and folk arts of the Palatine States into the present day, and holding the people together through thick and thin. In Europe the followers of Jacob Amann were mainly reintegrated back into the larger Mennonite community, but in the American Colonies, especially Pennsylvania, they thrived.

They thrived because of their exclusiveness and self-reliance, which were an outcome of their theology. The principle of separation colours the Amish view of reality. The world is divided into two mutually antagonistic spheres – that of 'the world' and that of 'the people'. Because work is seen as a spiritual discipline, 'the people' are obliged to be very industrious.

At their baptism, Amish youth promise to obey the *Regel und Ordung* of the church community; these rules and regulations are not generally written down, nor are they uniform or always unchanging, but they have the character of taboos which are binding on everyone. They are arrived at and emended through a long process of earnest discussion. In detail they may appear absurd – no hats with less than a three inch brim, restrictions on outside pockets, no air-filled rubber tyres, no photographs etc. But considered in their totality they construct, in negative form, something very impressive, stable and dignified. The *ordnungen* have the effect of discouraging competitive pride, slowing down and consolidating social interchanges, and managing the very difficult interface with 'the world' (or, as Old Order Amish are wont to say, with 'the English'). They also regulate the acceptance or refusal of modern technologies, such as telephones, motor vehicles and, most lately, computers. The refusal of many modern conveniences is invariably on the grounds that they break up the web of *Gemeinschaft*.

That there should be no patterned wallpaper, statues or pictures for decorations, nor part-singing, fancy yard-fences, fashionable clothing, nor cosmetics, ensures that aesthetic pleasure is channelled and intensified into those practises that

are permitted – embroidery, communal singing, personal appearance, and building; i.e. all those practises that reinforce or signal group cohesion. All the major pleasures and artistic activities of Amish life are shared. Classically, these include communal embroidery 'bees' for the women, singing for young people, shared building enterprises (most famously, the barn-raising ceremonies), and group appearance. Each of these provides opportunity for individual achievement and leadership within the group.

Needless to say, photography is rejected; not as a technology but as an incitement to vanity. Amish may be photographed, but they may not normally pose to be photographed.

[This raised a problem for the Author. Having spent some time studying these people through history, I gained respect for them and found myself reluctant to take photographs of them and of their possessions. I have come to feel very strongly that their feelings should be respected, lest we turn a living community into a tourist commodity, a process already underway throughout Lancaster County.]

The visual habitus and material culture of the Amish has to be viewed, not as a survival of the past, but as the product of a process of self-definition in difficult circumstances.

Most, but not all, of their distinctive visual culture derives from and shows clearly their Germanic and eighteenth century origins, with the exception of their architecture. The Amish have been content to go along with the general pattern of Penn-sylvanian farmhouse building, but treating the interiors in a very sparing manner. Their lack of architectural distinctiveness probably stems from their avoidance of special buildings. They have no churches or meeting houses since they have taken St. Paul's injunction literally. They themselves, in congregation are 'the church', and their homes are little churches in themselves. Communal acts of worship take place in the domestic setting – the *domus ecclesia* is identical with the *domus familia*.

Only by careful scrutiny can the Amish farmstead be distinguished from its neighbours.

Some Amish artistic practices have achieved fame, notably their richly coloured patchwork quilts. Owing to the exigencies of academic publishing we are not able to show these in colour, but in fact this is less of a disadvantage than it appears. Photography tends to render the quilts as if they were the flat

Amish Farmhouse and field. The splendid large barns, often with ingenious moveable walls for drying tobacco crops, the dairy building, cowhouses and silos, with the neat farmhouse and immaculate garden are hardly to be distinguished from those of their non-Amish neighbours. But no motor-vehicles, telephone wires or electricity cables. Set in the geometry of the field patterns together they produce a landscape very similar to what we might find in lowland Switzerland or Holland; in which everything is in use. Nor should this surprise us, since the cultural project of the Amish is to maintain as best they can the *gemeinschaft* principles of eighteenth century rural life.

abstract paintings to which they are frequently compared. In reality, they are useful objects, thick and textured. The surface pattern of coloured patches is often at variance, or in play with the stitching pattern; this cannot be demonstrated effectively by a flat image, but has to be witnessed and handled.

It would be easy to take these practices separately, but very mistakenly because they constitute an *ensemble* or visual *habitus* in which everything has a part. This is rich and varied enough to provide a bulwark against the encroachment of modernising *Gesellschaft.*

Even in the matter of personal appearance, the very uniformity of dress accentuates individual difference. A group of Amish men walking together down a lane is an impressive sight, because the dark suits, the wide-brimmed straw hats and boots encourage a kind of swaggering gait, each in his own way. A group of Amish women in their aprons and blouses may look initially the same, but personal chic shows through; the neat caps, whose function is to enclose the hair, displace attention onto the nape of the neck, making the carriage of the head more noticeable. Neatness and natural beauty takes on exaggerated power in the midst of apparent sameness.

It would be easy to take these practices separately, but very mistakenly because they constitute an *ensemble* or visual *habitus* in which everything has a part. This is rich and varied enough to provide a bulwark against the encroachment of modernising *Gesellschaft.*

*

The Amish Quilt

Scholars of the quilt agree that the practice of quilt-making was borrowed from the surrounding 'English' after the Amish had settled in North America; the patterns and techniques are all, we are told, based upon British methods. Within Amish practice, however, they acquired a distinctive character. Linda Welters and others have analysed Amish patterns and using the geometric concepts of symmetry and the deep cultural symbolisms of symmetry. The Amish concept of *Gelassenheit*, in which the individual surrenders his or her self-assertion to God and the community, finds its objective correlative in the disciplines of strict symmetry.[1] The patterns of the quilts, as indeed is common in most folk cultures, are based around a selection from the 7 possible on dimensional symmetries (as in borders and hems) and the 17 possible two dimensional symmetries (across the plane): to which it is necessary to add the infinite number of possible finite symmetry designs that are based around a single point. Thus:

1 of 7 possible

1 of 17 possible

finite or point symmetry

Taking only the manageable combination of 7 or 17, the addition of colour adds a further range. Two colours, spread symmetrically across 17 plane patterns increase he range of possibility to 42. More colours introduce further complications. But this is merely to treat the quilt as a plane

surface, like a painted canvas; it is, in reality, a three dimensional, pliable thing, with thickness, even bulk. The patterned front or top plane of the quilt is held to the backing or lower plane by stitch-structures which are independent of the upper plane's pattern. Thus:

pattern layer

filler

base layer

Vertical constructional stitching and horizontal pattern stitching in Amish quilt

Making a large quilt is a feat of organisation; and it is no wonder that it is best done at a communal gathering or 'bee'. There is no structural reason why the stitching together of the two layers has to coincide with the pattern on the top layer; thus we find that a quilt usually has two forms of symmetry working in relation. The constructional stitching has its own pattern. Thus:

The complete pattern of an Amish quilt is formed by the interaction of the colour-pattern layer (l.) with the constructional base layer (r.) and it pattern of stitching.

When the colour-pattern layer is in straight lines, the constructional layer is frequently curvilinear in pattern, or vice-versa. Consequently, the interplay across the surface can be very complicated. The constructional stitching may also have its own colour, so the range of possible patterns

is prodigious: the mathematics I leave to the reader. Indeed a restriction to known patterns and their names – 'log-cabin', 'Tulip', 'Stars' etc. – become established because of their *Gestalt* qualities of recognisability. To depart from the recognisable sector of the immense (infinite?) repertoire would be too 'proud' it would be a refusal of *Gelassenheit*.

The problem of design is not unlike that found in traditional music. The four symmetry motions of pattern composition – translation, rotation, reflection and glide – are like the four transformations of the musical element – theme, inversion, retrograde and inversion of the retrograde. For a music to be 'traditional' it has to work within a selection of the possibilities that are readily comprehensible: this is clearly seen in hymn tunes and folk songs. We can thus liken the quilt, and the making of the quilt, to something like the practice of communal singing; with this important difference. In Amish communities, singing follows the original Protestant injunction of 'for every note a word', and the taking or parts and 'repeatings' is not encouraged, because it is too 'proud': but the Amish quilt can be, and often is, an object of virtuoso colour 'polyphony'.

The polyphony is comprehensible because of its symmetry, but the peculiar glory of the Amish quilt is that the symmetry is so often interrupted or modified by variations of colour – either knowing or incidental, when a piece of patterned or faded cloth has been used. The dialectic between the complex disciplines of symmetry and the quirks and improvisations of material make the quilts into emblems of 'plain' living. They are then, literally, em*bed*ded into family life.

In their making and their design, the quilts have a dionysiac function comparable to Shaker dancing or Ephrata's singing.

Amish culture is not by any means confined to quilts and clothing. There are examples of painted and decorated chairs in a manner very similar to that which can be found in

Southern German and Alpine folk styles to this day, made very sturdy with painted motifs of flowers (stylised roses and tulips). Chests, tables and dressers are less 'ethnic' in character.

Two birds in a fruit-bearing tree dated 1844, a common theme in the art of Fraktur, here meaning, perhaps the friendship between the two women whose names appear below it; but in Ephrata, two souls perching in the fruitful tree of life (?)

Tulip motif, from a bookmark dated 1845. This somewhat frenzied example if closely linked to the art of Ephrata and the erotic mysticism of the Song of Solomon. Made for the bible of Bishop David Beiler.

D and K McCauley, in their *Decorative Arts of the Amish of Lancaster County* (Intercourse, 1988) illustrate a range of toys which include miniature quilts for dolls; these dolls are without facial features 'in keeping with the Amish taboo against graven images'.

There is also an extensive range of graphic emblems drawn in the 'Fraktur' style adapted from German folk arts and widely used by the Amish and their 'Pennsylvania Dutch' neighbours. These are formally very similar to the graphic arts of the Ephrata community discussed below, with the very important distinction, that they do not seem to have had precise religious significance, and were treated as 'decorative'.

Drawings of this kind are intermediate between visual decoration and the specific religious emblem.

1. In Smucker, J., Crews, P.C., and Welters, L., *Amish Crib Quilts from the Mid-West: The Sara Miller Collection*, Intercourse, Pa (2003)

The Ephrata Community

Within the broad Anabaptist tradition we would also want to enlist the followers of Conrad Beissel who settled in Ephrata, Pennsylvania, in 1730. They, like several other overlapping sodalities, represented and epitomised a second stage of Reformation, pietist in inspiration and German in origin. These, like the Shakers whom we shall look at soon, had a strong proto-feminist element in their theology, and a celibate or 'solitary' aspect. They took their separation from the world much further than did the Old Order Amish, for they did not engage in trade or manufactures. As a consequence, the settlement was unable to maintain itself for long enough to regenerate. In some very interesting ways they were reasserting monastic ideals of an almost medieval character, with a brotherhood and sisterhood of celibate Solitaries, supported by a married order of Householders. The Solitaries normally wore a simple robe that was usually white. Their building, their graphic symbolism and their involved, intense musical life are all markedly pre-Enlightenment German/Swiss in character.

Conrad Beissel was an irascible and charismatic leader, and the community was frequently divided and quarrelsome; it nevertheless sustained itself for long enough to provide a powerful starting point for the widespread Seventh Day Baptist movement, which has adopted itself to the ways of the world with some success. This transformation is signalled by an abrupt change in architectural style, and in such matters as gravestones.

A comparison of their buildings reveals a great deal of their inner character and demonstrates their difference from other settlers in Pennsylvania.

Their graphic art, however, from similar sources, has a poignancy and symbolism that is all its own, being esoteric and even hermetic in its symbolism. A visitor in 1835 reported that

The walls of all the rooms, including the meeting room, the chapels, the saals, and even the kammers or dormitories, are hung and nearly covered with large sheets of elegant penmanship of ink-paintings . . . in ornamented gothic letters, called in the German Fractur-schriften.[12]

These sheets were always composed of religious texts, richly embellished with emblematic flowers, fruits, doves and sometimes human figures. Here and there the Sisters make an appear-

The Ephrata 'cloister' in early spring. Both the construction and the form of these houses are deliberately late-medieval in character (from 1734).

ance, clad in the white nunlike cloaks that they wore for most occasions. One especially splendid sheet depicts a labyrinth – a sort of 'Pilgrim's Progress' of the soul toward heaven. The iconography is rooted in the folk-decoration of central Europe; the tulip motifs, for example, are very close to similar tulip-based decorations that we find in Hungarian folk art, but the significance is almost certainly part of the secretive world of Ephratan beliefs. Secretive, because only fully transparent to the knowing believer; but not hidden, because roses, pomegranates, vines, and doves are part of the common visual language of mystical ecstasy. We are never very far from the Song of Solomon.

Jeff Bach, in his *Voices of the Turtledoves* (2002) has made the most complete study so far of this American offshoot of the *theologia deutsch* and concludes that the most important single influence of Ephrata was the mystical writing of Jacob Boehme, particularly as transmitted through Georg Gichtel and the spiritualist movements of the first years of the eighteenth century. In this long-standing tradition of expression, highly figurative and obscure language was normal, as a way of deflecting the sceptical away from core beliefs. But there were other currents

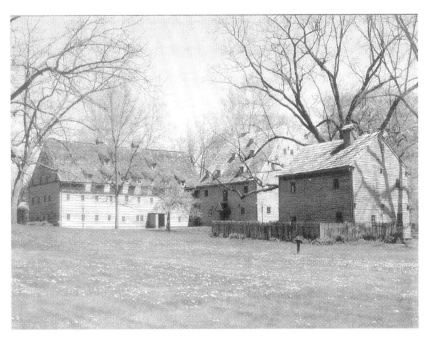

The meeting house, known as 'Peniel'(1741) and the sister's house, 'Saron' (1743); Ephrata. The two main surviving buildings of what had been a more extensive settlement of houses and work buildings which underwent several changes. The vernacular style of these buildings is more apparent than real; it is probable that the dimensions of Peniel in both plan and elevation reproduce and embody the number symbolism of Christian cabbalism, through the teaching of Jacob Boehme. 'Peniel' is the name that Jacob gave to the place where he had wrestled with the angel. 'Saron' (signifying the end of marriage) contains a series of cells and a 'farmhouse' style of kitchen and eating area. Other large communal houses were 'Bethania' and 'Mount Zion', now vanished; but the main buildings were surrounded by others in a genuinely vernacular style, such as the small house to the right.

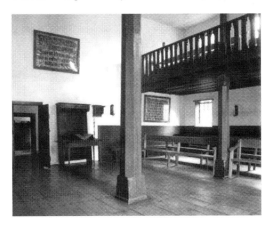

The interior of 'Peniel', the meeting house. Balconies and floor plan strongly recall early Presbyterian chapels, such as Burntisland. On the wall are manuscript placards in the 'fraktur' style of German folk tradition, with biblical and other religious texts, and floral emblems.

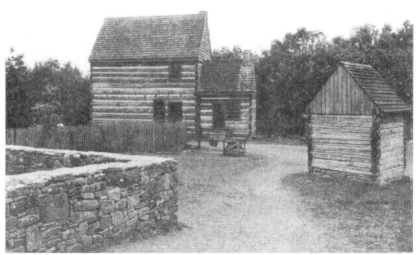

Houses in massive timber, shingles and whitewashed daub; of the kind usually termed Pennsylvania Dutch, but generally built upon German/ Bohemian models. A stage beyond the log-cabin, on the way to the American vernacular of the framed and plank-clad farmhouse, rectilinear in form and very 'tight' across the surface. The lesser buildings of Ephrata are in this style, though these particular examples were transported across the Atlantic from Pennsylvania to Ireland, where they can be found in the Ulster-American Folk Park, Omagh, Northern Ireland.

The Academy: Ephrata (1837). Built after Conrad Beissel's death by the Seventh Day Baptist Church, the lineal inheritors of the Ephrata Community, who by this time had made a more complete accommodation with 'worldly' normality, if the evidence of this little building is to be believed. It is fully within the idiom of 'federal style'; a stripped and simplified neo-classicism. The curriculum offered here included chemistry, surveying and astronomy.

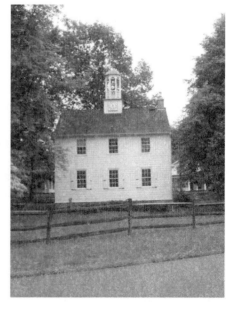

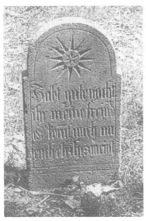

Ephrata Gravestones. To the left, in the early period (1750?). Abstract emblem of the sun or divine light(?) and German language inscription. To the right (1830?) A pictorial emblem: married love and death and English language inscription; Ephrata normalised.

of thought and feeling in Ephrata, including the rosicrucian revival, studies in Christian Cabballism and even alchemy.[13]

Of one belief we can be certain; that Beissel and his followers took up the Boehmist belief in a female principle, the Divine Sophia, which was in parallel with and complementary to the figure of Christ. The encounter with the divine, for men, was to encounter this inward female principle, as both mother, sister and lover; and for women, the parallel and appropriate experience was sought in the person of Jesus. For either sex, this mystical marriage with the internal figure signified a moment which unified the soul in its original androgyny. This highly charged eroticised mysticism underlies the graphic art of Ephrata.

Closely allied to the graphic art was the printing of books – often highly embellished. The most splendid of these is the *The Martyr's Mirror* by Thieleman van Braght (1748), reprinted by Ephrata for their Mennonite neighbours; this volume of 1500

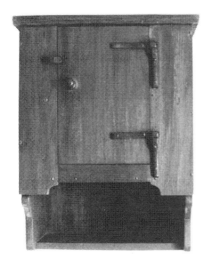

Ephrata furnishings. The interiors and furnishings of the Ephrata community were derived directly from European peasant traditions, more or less untransformed, with sturdy wooden furniture, whitewashed brick and low ceilings This heavily built cupboard, probably original, is typical of the 'farmhouse' fittings of the Brother's and Sister's houses.

An emblematic lily from an Ephrata manuscript.

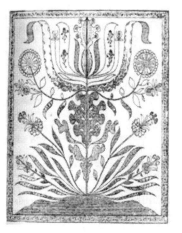

pages is for the wider Anabaptist tradition what John Foxe's *Acts and Monuments* is for the Anglican tradition; the heroic foundation epic of martyrdom and opposition to the Caesars of the world. Several other important devotional works were produced for the Mennonites. But important also was the publication of dissertations, hymnals and music books of devotional songs. There are many of these, printed or in manuscript presentation form.

The musical life at Ephrata has been long recognised as having especial interest for musicologists. Beissel's treatise of 1747 entitled *Songs of the Lonely and Forsaken Turtle-Dove* was the first music manual published in the American colonies. It set out the prescriptions for religious singing that the 'Solitaries' were to follow. Ephratan music had no clear melodic line, but rather a *cantus firmus*, normally song by the men, over which the female voices improvised. Before performance, the choir was expected to fast severely (with consequent effects upon the voice), to stand with face down, and to maintain a steady tone. Just what it sounded like has to be partly conjecural: there are reports of ethereal beauty. Recently, attempts have been made to interpret the '*Songs*' in contemporary performance; this has been done with great care and scholarship. The present writer (though cheerfully admitting his lack of deep musical knowledge) wonders if the resulting sound is not rather too smooth and 'spiritual': a sound that would be more bodily and more odd might be closer to the original. This music, that required training, practice and a severe regimen, was for the celibate 'Solitaries'; 'Householders' and visitors participated in the more vigorous and lively communal singing that the community shared with the various Mennnonite, Amish, Moravian and other communities in the region.

Much of the Ephratan community remains imperfectly understood, being both difficult and insufficiently documented. In some respects it is the 'wild card' of the intentional settlements, for it had a definite retrospective quality in its utopianism. Its

ideal image of itself was of a quasi-monastic order, of a very ancient kind. Its architecture and visual expression was congruent with this idealism. But the gendered theology that Beissel and his fellows embraced reappears markedly in Shakerism and elsewhere and is influential to this day.

<div align="center">*</div>

The Quakers

The Quakers provide a striking contrast with the Old Order Amish; beginning from similar initial starting points but steadily diverging to embrace the 'world' that the Amish rejected, and even to form it in such significant and world-changing sectors as banking, iron-founding and food-processing.

The Society of Friends took its origins amongst the unruly sects of the British Civil War period, but seem to have had, like the Anabaptists with whom they had much in common, older antecedents in the *devotio moderna,* and in the secretive Family of Love.

The original Family of Love was formed by the followers of Hendrick Niclaes; they numbered merchants, scholars, printers and courtiers amongst their members. Through the publishing concerns of the Plantin and de Bry families we find them connected with the highest levels of intellectual culture and political influence, and it has recently been discovered that several of Elizabeth Tudor's private bodyguard were Family members; nevertheless, in England at least, the adherents included *'weavers, basketmakers, musicians, bottlemakers and other such lyke which by travailing from place to place do get their living.'*[14] Though accounts of their aims and beliefs are suspect, being largely derived from hostile sources, it seems that their leading concept was the *vergottung* or descent of the Holy Spirit into mankind, cancelling former sins. They allowed themselves to practise dissimulation in 'the world', whilst remaining 'separated', and it is reported that they taught that:

there should come a time shortly when there should be no magistrate, prince or palace upon the earth but all should be governed by the spiritte of love.[15]

Not surprisingly the Family was intensely mistrusted by magistrates and judges; to be accused of a 'familistical' temper was a standard prosecution ploy. After the restoration of the

monarchy, this was to prove a problem for the Quakers who now, reorganised by George Fox into the Society of Friends, were trying to distance themselves from the Ranters and Levellers and 'familists' from whom the judiciary could scarcely distinguish them. For radical dissent to survive, it had to lie low.[16]

But this was very difficult for a group of believers whose plainness was ostentatiously obvious; it showed distinctly in manners and speech, because the Quakers took plainness to the point of rudeness by openly refusing all honorific forms of address, the raising of the hat, and of course such worldly practices as bowing or bending the knee. The political correlative of this was the refusal to take oaths of any kind.

It is difficult for us, to whom something like Quaker manners have become slackly habitual, to grasp the significance, even the social violence, of not using such terms as 'Sir' or even 'Mister' in ordinary conversation; but it signified (to Quakers) the intention of speaking a pure and truthful language in every matter. It was coupled with the use of plain speaking in disputations and preaching, a sense of the revelatory strength of plain utterance, and strict injunctions as to the use of terseness and piercing succinctness of phrasing. We can get a good sense of what this was like from the *Journal* of George Fox, and from works such as *The Pilgrim's Progress* (though Bunyan was not a Quaker). There is extensive evidence that, like other sects of the time, they believed that it was possible to rediscover something approaching the pure speech that Adam used *'when all things had their names given to them according to their nature and virtue'*. They obeyed a general instruction – *'Let your words be few'*.[17] This was an attack on the principles of social hierarchy and civility as developed in speech. But the refusal to swear oaths was a dagger aimed at the heart of legitimate government. As a result, Quakers were disbarred from a vast range of legal and contractual arrangements which they had to develop in and amongst themselves. They were forbidden from appointment to public office as a matter of course, and faced great difficulties in the law courts where they often found themselves. They were seen as a deeply subversive and dangerous organisation by the magistracy.[18]

They were no less disliked by Calvinist ministers, for their refusal of the very idea of a ministry and their rejection of Reformed doctrine. Ministers were several times responsible for

the arrest and imprisonment of Quakers,[19] and in Calvinist Massachusetts Quakers were the subject of particular legislation that fined any sea captain who brought them on shore, the Quakers themselves being banished on pain of death (three were in fact executed in 1659). The first fifty or so years of their existence was sustained under conditions of severe persecution. It is not surprising that many began to see the New World as a possible escape into freedom.

The refusal of worldly forms of speech or behaviour included the practice of 'going as a sign', in which an individual would perform or enact a metaphor; notoriously, by going naked one revealed the nakedness of civil authority, or embodied the prophetic threat that all would be revealed. In 1659, one Friend *was moved to go to the Parliament and to take a pitcher in her hand and break it to pieces, and to tell them so should they be broken to pieces, which came to pass presently after.'* The most striking of all was James Naylor's entry into Bristol, riding upon an ass, attended by followers; he was challenging the local religious leaders to play the part of the High Priest, and the magistrates to impersonate Pilate; which they did, very thoroughly. Naylor was lucky to escape with his life. The meanings of these performances might not always be so clear, and require expository sermons or other demonstration. But a degree of ambiguity forces upon the audience the moral responsibility for the interpretation, which is the core moral intention implicit in radical or independent dissent – *you are a responsible agent before God and your fellows. You are absolutely revealed in your actions.*

Early Quaker worship was often ecstatic and revivalist in character; preachers gave impassioned sermons, with convulsive shaking, tears and fainting: hence the pejorative name they received. After George Fox called the Friends to order in the 1680s, this emotionalism was slowly repudiated in favour of the silent meeting and social quietude, though the drive to social radicalism has never faded.

We have no firm injunctions as to what sorts of buildings Quakers should build (or at least I have found none from that period), but when The Society of Friends began, as part of their social consolidation, to construct permanent meeting houses, a definite type was established very early on, and we may wish to speak of 'building as a sign'. Such structures can be found at

Adderbury (Oxfordshire 1675) and Briggflatts (Yorkshire 1675) and several other sites. These are, externally, cottages in the local manner, well but simply built, consisting within of a single large rectangular room. In these and many cases, a small balcony or 'loft' runs round three sides of the room reached by an interior (or sometimes exterior) stair. Along one wall, often the longest side, there would be a low raised area or 'stand' railed in with a simple balustrade, for the elders of the meeting. Furniture consisted, and still consists to this day, of long wooden benches, in an unornamented manner. Walls might be panelled or wainscoted up to window height, but there was to be no fancy plasterwork. White walls were *de rigueur*. Wood was generally left untreated, since varnish and polish were counted as vanity. Nor were there cushions, a practice that, happily, is not now regarded as essential.[20] William Alexander, in his often cited *'Observations on the Construction and Fitting up of Meeting Houses'* (York 1820) advised that the benches be unpainted and treated only with hot water and soap; but if they were to be treated, it should be like the wainscoting. Quaker plainness, we should add, was in no way a transformation of the necessities of poverty; the Quaker meetings were, from the first, supported by men and women of means and property. But, like all the groups under discussion, they were trying to find that simplicity which early Christians were held to have followed.

There was often a further smaller room, under the loft or adjacent to the main room, which was regarded as the 'women's meeting'; not that women had separate meetings, for Quakerism was remarkable for its attempt at gender equality in all things, but to signify that there was a feminine sphere of life that deserved its own spaces; these rooms later became known as the 'small meetings' and ceased to be gender specific.[21] In the earlier meeting houses these rooms are often separated off by removable screens of shutters.

The degree to which early Quakerism had a specific theology of gender is not clear; they asserted, through their doctrine of Inner Light, that *'there was that of God in every man'*, which included every woman too. Women frequently spoke in meeting and were recognised leaders. In some measure, and in ways that are partly obscure, Quakerism also maintained links with the pietist movements in Germany.

In the illustrations that follow I have stayed with these early

buildings, out of a love for their dignity and democratic spirit. They formed the template for later buildings in the New World and beyond; and as the status and acceptability of Quakerism increased, such simple buildings might easily be translated into the simplified neo-classicism that became the norm of eighteenth-century Dissent.

Some larger urban meeting houses from the eighteenth century onward came to resemble reformed churches, with porticos, columns and lobbies; but ornament was always very restrained, if not totally absent. I know of no examples in which anything remotely neo-gothic appeared in meeting house building.

Going as a sign was also extended informally into everyday appearance. Simple undecorated clothing, of a rather old-fashioned cut, appears to have been adopted very early on. A palette of black, brown and shades of grey became a standard marker of adherence, though it does not seem ever to have been codified. There was something very canny about the adoption of grey in the early half of the seventeenth century, since it lay between the black and the white of clerical authority. Whilst the lack of bright hues set the wearer apart from the main mass of the 'world', it could have a certain appeal of its own. The predominant effect could be smart and rather chic. And as we have had chance to note already, the avoidance of ostentation can be itself an inverted form of display.

Within their houses Quakers also adopted a plain style, though it seems never to have been enforced by instructions: rather the general quality of Quaker domestic life was reinforced by hints and suggestions from the Meetings. We read of the Leeds Meeting recording (in 1706) that

it is the general sense of this meeting, that at least all such as buy any furniture into their houses, that it is plain as becometh the truth.[22]

Plain, as becometh the truth. This aesthetic assertion can be compared to Keat's much later assertion that *'Truth is beauty, beauty, truth'.* If we wish to reconcile each of the three terms we have to produce a syllogism something like this . . .

The plain is the truthful
the truthful is the beautiful
the plain is beautiful

Habits of plainness in social behaviour were expected and

Swarthmore Hall: a Tudor manor house near Ulverston, Cumbria. The home of the Fell family who were amongst the earliest adherents and supporters of George Fox. The building contains a remarkable collection of seventeenth-century furnishings and fittings: it is now a conference centre and retreat for the Society of Friends.

Brigflatts Meeting House: near Sedbergh, Yorkshire (from 1675). One of the very earliest purpose-built meeting houses, in cottage form, with the typical wainscoting, balcony and elders bench within, and with a beautiful secluded garden without. The little room above the porch, another typical feature, was probably reserved for any visiting preacher.

The interior at Brigflatts, with elders bench and balcony. A rather dramatic little hall, somewhat resembling a theatre.

Colthouse Meeting House: near Hawkshead, Cumbria (1688). A slightly later and more developed design, with the high eighteenth century windows looking in on a plain hall with a balcony at one end. Under the balcony is the smaller 'women's meeting' that can be opened up by the lifting of wooden screens. The porch opens into the two spaces through separate doors.

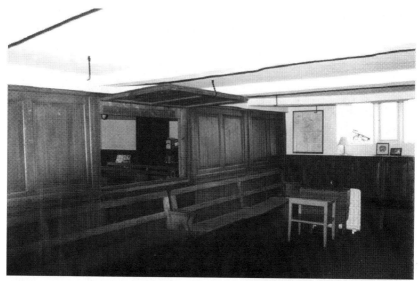

Inside Colthouse. The main meeting.
Unvarnished deal and whitewash. The
windows above the stand are recent.

Colthouse Meeting contains some
excellent benches; originally very plain
indeed, in a forgiveable departure from
primitive austerity, back rests and arms
were added at some unknown time in the
past. And today there are cushions! But
still no varnish.

The graveyard at Colthouse.
Originally the outdoor meeting
place of the Friends, there are
still stone seat set in the wall.
The simplicity and dignity of
Quaker graveyards never fail to
move the visitor.

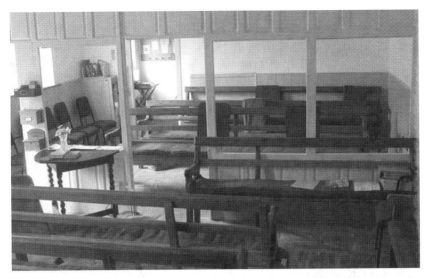

Old Meeting House, Skipton, Yorkshire. (1693). In an urban setting the building type is less like the rural cottage/barn structure, and closer to the worker's cottage. A single space within, divided by a removable partition wall. Stone floor, unvarnished wooden benches, white-wash and white gloss paint. The custom of having a table with flowers as a central focus of the meeting is of unknown origin; it also includes, in some Meetings, the custom of leaving the flowers, fallen petals and all, from one Sunday to another before replacing with fresh.

The garden at Skipton. A carefully tended garden functions, unofficially, as an extension of the interior space.

Early nineteenth-century Quaker meeting house at Adel, Leeds.
A much more substantial but still plain building, which has a
particularly fine graveyard beside it.

pursuits such as card-playing and drinking parties were positively frowned on; but the most striking characteristic that emerges is not the austerity, but the use of an overt loving-kindness and rather formalised tenderness of address, correspondence and social intercourse. This arose directly out of their theology of the Inner Light, and also, we must assume, from self-protective habits generated by decades of persecution. Mutual assistance became the norm, fortified by extensive intermarriage. A significant result was the creation of an extensive business and technical network amongst Friends that in time came to include banking, chocolate trading and several other major eighteenth century business and proto-industrial activities, notably iron-founding. In the eighteenth century Quakers found that, willy-nilly, they were coming to prominence in a wide range of domestic manufactures that a growing population of growing wealth demanded. The story of the Society of Friends in relation to the first Industrial Revolution does not need to be repeated here.[23] The Society was, in effect, compelled to become part of the 'world' which it formally rejected; a distinction came to be made, in the later eighteenth century, between the 'plain' Quakers who kept to the old ways and were unobtrusive in social practice, and the 'gay' Quakers who were hard to distinguish from the rest of the entrepreneurial class, except in their avoidance of the armed services and their dislike of titles.

Most remarkably, Quakers, through the agency of William Penn, became major participants in the foundation of what was to be the State of Pennsylvania, where they actually constituted the world of the judiciary and administration from which they had hitherto been forced to flee. The *Charter of Fundamental Laws of West Jersey* (1676), with its notable stress on religious toleration, the right of jury challenge, and concern for the legal equality of Native Americans stands as redress against the legislation of the Quaker Act and the Clarendon Code.[24] It is one of the great documents of political liberty. And it is in keeping with that constitutional position that great swathes of social reform, liberal practice and advanced legislation bear the stamp of Quaker influence.

With the founding of Pennsylvania, and other Quakerly settlements on the Eastern Shore,[25] a way was opened for legally recognised religious dissent to make its way in safety across the Atlantic. The Plain Style, suitably translated to a new and harsher environment, became normative for succeeding

generations. It was thus a significant former of the 'colonial' and later 'federal' environment.

<div align="center">*</div>

The Colonial style

The term 'colonial' style has been widely used to describe the furniture, fittings and the housing of the early American period. New housing developments may be described in brochures as being fitted out in the 'authentic traditional colonial style'. But the main critical objection to the use of 'colonial' in this connection is that it appears to be explanatory. The early settlers built, it suggests, made and dressed themselves in these ways because they were colonial subjects, under some other authority than their own. Or, as cited above, that they built the way they did because they were so constrained by circumstances. This, as must now be clear, does not fit the case.

Nor is it possible to speak meaningfully of one colonial style: in the southern colonies, pretensions to an agrarian aristocracy created rather different cultural conditions and a greater reliance upon Old World style and fashions. In a complete account we would also want to contrast Spanish and French influences. However, since it is the Puritan tradition with which we are concerned, 'colonial' here means, mainly, from Pennsylvania northward.

The style of the northern colonists, after the first few years of settlement, was that of the broadly puritan Plain Style builders and designers from Britain and Holland, with additional German influences. It was not constrained upon them by circumstance, poverty or hardship, but was part of the *habitus* they brought with them.

The life of eighteenth-century Americans, moreover, was notably prosperous, and there was a continuous demand for skilled craftsmen in wood, iron and brick. As early as 1629, a letter home from Salem in Massachusetts declares that *'Of all trades, carpenters are most needful; therefore bring as many as you can'*[26] . . . and they should bring their tools with them. By 1700 New England's population had grown to around 100,000 and had doubled three decades later; a complex system of internal trading was soon established and a full range of small-scale industrial enterprises. By 1750 an English traveller remarked on the quantity of 'artificers' to be found in Boston *'as cabinet makers, chace and coach makers . . . watchmakers, printers, smiths etc. . . .'*[27]

The architecture that developed in these circumstances was

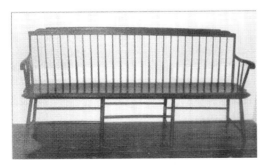

A Windsor-style bench: the Courthouse, New Castle Delaware (date not known). Furniture, typical of its kind: an English domestic object lightened and refined to an altogether higher level.

recognisably that of the 'Puritan Minimalism' initiated by Inigo Jones and others in the Stuart period. It was hard to distinguish from British work in its overall form, being based around neo-classical symmetries, and employing similar simplification of detail. The furniture, however, rapidly developed out of the heavy and rather mannerist furniture of the period into something notably lighter and more 'rational'. In this, of course, it was following and then leading the general tendency of English furniture design which we noted in the previous chapter – always toward a greater lightness of construction. This reaches its apogee in Shaker furniture; but it is well worth looking at the development of such standard pieces as the Windsor chair. The amount of material used in these chairs steadily reduces until some early nineteenth century designs are so attenuated that it is a wonder of sound construction and stress management that they can support an average adult. The best have a wonderful lightness of feel and handle, and are yet robust.[28]

Vernacular furniture of this kind came to provide a model for fashionable furniture in the 1860s. In Britain, the firm of Morris and Co. took country work and gave it what Morris's first biographer called 'trifling improvements'. Though William Morris and his collaborator Philip Webb made some fine pieces in their 'Sussex' range of furniture, beside a Shaker bench their improvements look effete.

The continuity between English design and that in the American colonies is also observable in portraiture. The shallow 'playing card' space of early American picture-making derives not from the naive incapacity of the artist to make a perspective, but from the prior model of the Tudor secular icon, in which the image is a sign rather than a representation. (This, at least, is an hypothesis worth the researching.)

To illustrate the American extension of the Plain Style in what we must call ordinary circumstances, having no special affiliation,

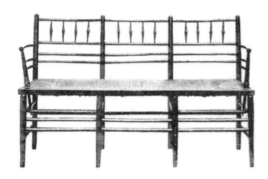

Developments out of the vernacular: a settee from the Catalogue of Morris and Co., ebonised beech and rush weaving .

a number of sites suggest themselves. Most of the older towns of New England have streets or parts of streets that demonstrate my argument, and there are many houses which would serve. But a convenient location is the small town of New Castle, just south of Wilmington, Delaware; this has the additional interest of being the place where William Penn came ashore to assert his right to Pennsylvania. In the nineteenth century it became a fashionable adjunct to Wilmington with an important ferry and it contains several streets of good houses from that period, but the central part of the town remains much as it was in 1750, allowing for a deal of restoration and careful repair. Notable buildings are the Court House and jail, the Episcopal Church, a meeting house, and a number of houses.

There were three principal places of worship in New Castle in the eighteenth century: a fine and typical Presbyterian meeting house (not illustrated here), and a Quaker meeting house (now vanished); there was also an Anglican (Episcopal) building, Immanuel Church.

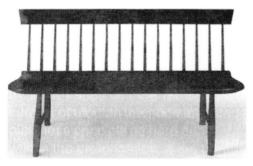

Though the parish dated back to 1689, there was no permanent church until 1703; the present building was erected in stages with several alterations; At one stage it had many nineteenth-century features, which were removed in the 1920s to uncover some of the original 'colonial' character. Its present condition is the result of extensive and

A bench from the Shaker village at Canterbury, New Hampshire from around 1840: beech. (Photograph by Michael Fredericks, courtesy of the Shaker Museum and Library, Old Chatham N.Y.

very careful restoration after a serious fire. What we have, in effect, is the result of a receding series of ideals.

*

The Shakers.

We now come to the apogee of plainness and perspicuity; the buildings and furniture of the Shakers.

The history of the Shaker movement has often been described, and we must continue something of that repetition here. They were followers of Ann Lee, an uneducated woman of considerable gifts, who led her small group of followers from Lancashire to America in 1774. Originally described as 'Shaking Quakers' they came to rename themselves as the 'United Society of Believers'.

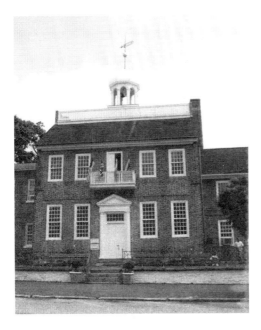

The Court House, New Castle, Delaware, from late seventeenth century with later additions. The building has gone through several stages and additions over the two hundred and fifty years of its existence but is unmistakably 'Georgian' in its general plan and elevation, with interesting differences. The most important of these being the treatment of the surface details; window-frames are almost flush with the brickwork , and the glass only very slightly recessed. The texture of the brickwork is created by alternate orange/yellow and dark bricks, a decorative variation of English bond coursing. Whilst these features can be found in similar buildings in Britain, here it is a definite quality, that results in a particular surface tension, as if the building were covered with a tight skin of stretched woven cloth. The tight surface accentuates the geometrical simplicity of the whole structure.

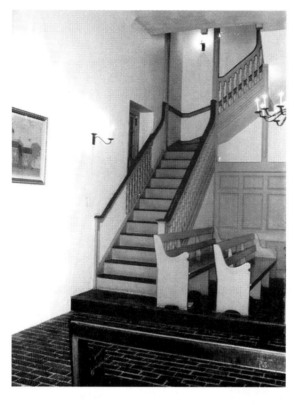

The interior of the Court House, entered directly from the portico. Brick floor, whitewashed walls, plain wood with minimal fuss. This is, however, heavily restored, after being, amongst other usages, a restaurant. One of the first public readings of the Declaration of Independence was held in this room.

Upstairs is a repaired, but unaltered, jury room, with spindly (original) 'Windsor'-style chairs. Off-white wash on the walls, dark oak floor and original stone fireplace. Other rooms in the building are painted light cyan yellow (also original).

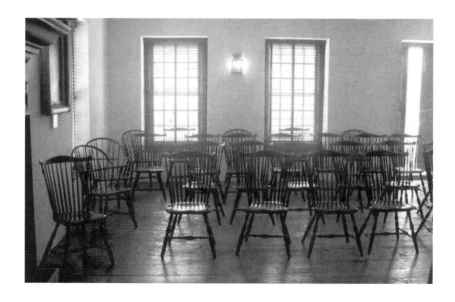

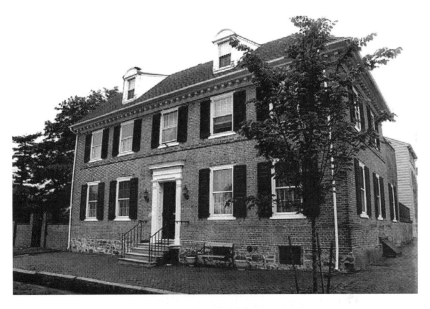

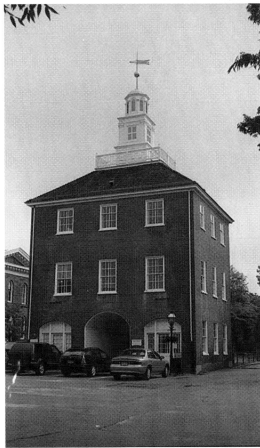

A house in New Castle. early eighteenth century? This is very much in the style that Mowl and Earnshaw (1995) refer to as 'puritan classicism', an 'architecture without kings'. Restrained and block-like, with minimal decoration, it is nevertheless richly coloured in variegated brick, red shutters and white painted details. Houses like this set a norm for much later building.

The Town Hall, New Catsle. When in the 1830s the citizens decided they needed a town hall, they stayed rigorously within the bounds of cubic simplicity.

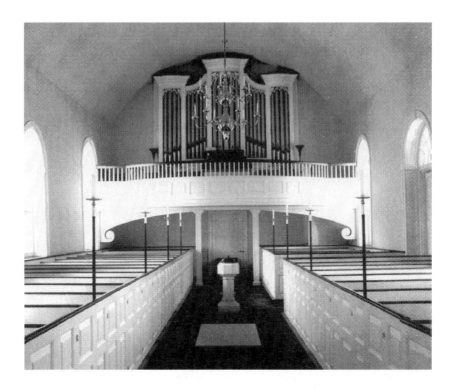

The nave of Immanuel Church, New Castle, looking towards the west end from the sanctuary. Brick floor with inset gravestone. White painted wood with varnished maple rails. Ebonised wood, silvered brass and wax, Marble memorial and off-white plaster. Brass candelabra. The organ was acquired in 1857.

This interior is a restoration of an interior that was itself a restoration of the colonial original, which had been extensively modified during the nineteenth century. Every restoration is always in some measure, no matter how scholarly, an idealisation. So here we have an interior which is a complex and very sensitive look back to what was itself a look backward; first to the supposed 'colonial' style and then beyond that to the 'original' building, which itself had been modelled on what the Reformation thought was the proper style of original Christian worship.

I interpret this interior as a statement of belief in what a Plain-Style church should be rather than what it actually was. (Also see George Herbert's essay 'A Priest to the Temple' of 1652)

By the end of the eighteenth century they had established a series of small settlements in a federation across New England and parts of New York State.

Their theology, though not learned, was striking; perceiving Ann Lee as in some sense the sister of Christ, they posited a male/female dual principle of Divinity. They repudiated all the sacraments, embraced communal property, pacifism, and a form of celibacy in which men and women continued to live side by side. In this they much resembled the Ephrata community, with one important difference: Beissel and his followers were theologically sophisticated, and their thought contains much derived from Jacob Boehme and German language mysticism. The Shakers, on the other hand, rejected sustained intellection and theological speculation as lacking in the essential simplicity.[29]

Shaker recruitment was by conversion or by the adoption of children; as a matter of course they were pacifist and 'separatist'. Their form of worship was, notoriously, vigorous dancing and enthusiastic hymn-singing; but worship was also embodied in a rigorous work ethic and a distinct attitude to making and materials summarised in their aphorism *'Hands to Work and hearts to God'*. Indeed, the United Society thought of itself as a 'living building'.

Leap and shout, ye living building
Christ is in his glory come,
Cast your eyes on Mother's children,
See what glory fills the room!

Hymn from *Millennial Praises* (1813)

In so figuring the congregation, the Shakers , like all the groups we have considered, were taking into full effect St. Paul's saying that the congregation is the church, and the church is the congregation.

Their strong communitarian sense has led commentators to see these people as utopian socialists. Friedrich Engels certainly thought so, in his *Socialism; Utopian and Scientific* of 1880. Other contemporaries were more concerned about their supposed midnight orgies. Others again, stressing the strictness of their internal regulation, have portrayed them as revivalists. Admiration for their design has caused a widespread assumption that, because their tastes appear 'minimalist', they are in some sense forerunners of 'Modernism' and 'functionalism'; whilst at the same time preserving a 'craft ethic' that owes a great deal to 'simple traditions' and so have some relation to the Arts and

Crafts movements. But these may be apparent rather than real contradictions; looked at from the perspective offered by this study, Shaker building and design follow naturally from the spiritual and intellectual tradition of independent dissent. Nor, in their actual locations, do Shaker buildings and artefacts stand out markedly from the general plainness of American rural life. Where building and design are concerned, they were in the true sense, normal; providing exemplars of style, ingenuity and economy.

A recent substantial study, *Shaker Life, Art and Architecture: Hands to Work, Hearts to God* by Scott T. Swank (New York, 1999), attempts to locate the Shakers as *'agents of change, active and enthusiastic participants in the modernisation of American society'*. Far from being

> *a folk culture steam-rollered by American modernisation . . . they formed a revolutionary social movement as well as a new religion, and it was through a series of social inventions that they hoped to achieve their millennialist goal. Chief amongst these inventions was the Shaker village, the communal society where religion, village planning, and community behaviour were constructed as a harmonious whole.*[30]

The difficulty with this account is that it is not easy to see how a separatist sect that rejects the 'world' for millennialist goals can be at the same time a revolutionary social movement, except as an unintended consequence; nor was the communal settlement a Shaker invention, though they advanced it very far.[31]

Fully to understand Shakerism and its design we have to recoup it back into its origins within the independent or radical Reformation. When we do that, the contradictions between the different interpretations of Shakerism are seen to consist largely in the ideological agendas of the successive scholars, rather than in the actual activities of the real historical United Society. But Swank is certainly right in insisting that Shaker design cannot be understood in twentieth century terms *'because it is primarily an expression of the larger social structure of Shaker order.'* The design expresses and embodies that order, and it is not primarily the product of individual designers or architects, though of course we have names of some leading figures. The Shaker movement was, in fact, good at recruiting and retaining skilled people, because it encouraged the exercise of great skill.

A central aspect of this order was the general pattern of Shaker building and settlement planning; this was sanctioned by the 'Central Ministry' in the New Lebanon settlement, on the basis of the 'Millennial Laws' established after Ann Lee's death to guide Shaker conduct. Where the details of buildings and appearance were concerned, the 'Millennial Rules' reiterated the well established principles of the Plain Style, prohibiting *'beadings, moulding and cornices, which are merely for fancy'* and anything *'odd or fanciful* [which] *may not be used among believers.'* Varnish was for use on moveable items only. Novelty was to be avoided unless sanctioned by the Ministry. Ann Lee's salty aphorisms provided the guide: of personal ornaments, *'Let the moles and bats have them'*, of cleaning; *'Good spirits will not dwell where there is dirt. There is no dirt in heaven;'* of work, *'Do all your work as though you had a thousand years to live, and as you would if you knew you must die tomorrow.'* There was a tendency always to look to New Lebanon for the basic model, which was referred to as *'The pattern from the Mount'*. In the case of the Canterbury meeting house, built by Father Job Bishop:

[he] *would allow of no variation in the style of dress, in the form of a building, in the colour of the paint, or in the attachments or capacity of anything that was manu-factured, beyond the pattern shown in the Mount.*[32]

The Millennial Laws were frequently revised in response to new circumstances, but without departing from the injunction that

All work done or things made in the Church for their own use ought to be faithfully and well done, but plain and without superfluity.

Nevertheless, the Shakers used the world when it could learn from it. Unlike the Amish, Shakers were not averse to modern technology, and buildings were modified to include modern plumbing, electricity, telephones, and even the automobile. They are indeed credited with many inventions, and held several patents for such devices as early washing machines. Far from being rural and agrarian, there was an industrial spirit in both their methods and their products. Yet the innovation inherent in industrial capitalism had to be watched carefully, lest it break up the uniformity of the United Society. A circular of 1829 reads:

It is of essential importance to the maintenance of union and good order, that Believers, in all their labours for new

improvements whether in machinery, dress, manners or customs, should be careful to proceed in union; and by no means to introduce new things into the Society without the consent and approbation of the Ministry and leading authority of the Church.

In a circular, 'Concerning the Dress of Believers' of 1864, the same point is made in more striking language.

To the adoption of real improvement, we have no objection; but in this, Zion should revolutionise centrifugally and not centripetally; that is, whatever reformations are introduced, would be done in order, and proceed from Zion's centre, outward, and not from her circumference inward.[33]

Shaker meeting house complexes were a building type of some originality, matched only by their communal dwelling houses. The form was mainly determined by the need for an extensive dance floor that was large and strong enough to contain the whole community in lively, synchronised movement. The communal dwellings that had to accompany them were also original in character, being houses for men and women living in celibacy, in close practical contact, and with a distinct children's area. This enforced a principle of strict bi-lateral symmetry on many buildings; most particularly the elders houses in New Lebanon and Hancock settlements and elsewhere. Some parts of the dwelling houses were shared: kitchens and dining spaces were for all, and there was often an area in which to receive visitors. The general outward form of the buildings was that of a stripped down and simplified combination of the vernacular barn or large farmhouse, with classically regular fenestration and a neo-classical porch; this was the manner into which the Plain Style had crystallised by the end of the eighteenth century. Bell lanterns were a feature. (The Ephrata Academy, illustrated above, might almost have been built by the Shakers.)

Scott Swank offers a survey of architectural ideas that have been suggested as formative of Shaker building. From very general sources such as monastic and utopian institutions, to much more specific influences as the design of halls of residence at Harvard and Yale Universities, which predate the origin of Shaker communal houses at New Lebanon (in 1788), his list of possible sources includes hospitals and asylums of several kinds (some of which had Quaker inspiration), and very interestingly,

the industrial mill villages and improved dwellings for industrial workers that were being developed, in both Britain and the United States. Shaker villages have some obvious features in common – clear planning ideas, communal facilities, mutual responsibility, and a characteristic plainness of building style. They also have a deal in common with non-Amish Mennonite settlements, and with Moravian villages, and Quaker settlements. But the conclusion has to be that, whatever models for such settlements were 'in the air' in the late eighteenth century and available for synthesis, the complete Shaker village was an original invention.

All writers on the Shakers, from their early contemporaries to the present day, have remarked on the uniformity and repeatability of their designs, in houses and in fittings and furniture. It is generally seen as being 'industrial' in character, *'of spare efficiency and potential replication'*.[34] This is seen especially in their maximum use of available space, storage units and interchangeability of parts. The effect, of course, as Swank observes, is to reinforce and facilitate communal discipline. We also have to point out that the belief that Shaker design is primarily 'functional' totally misses the point. Under the condition of late eighteenth century America, the Shaker passion for perfection demanded extravagant expenditure of time and labour far beyond what the world would regard as common sense. It was a prodigally indulged fetishisation of craftsmanship and ingenious design as a form of prayer.

The really important question, however, is 'why was this communal discipline felt necessary'? It is one of the common grounds between the groups we have under discussion, from which the Shakers depart in one crucial respect.

I propose we consider Shaker discipline, and that of independent dissent in general, as a response to an over-whelming sense of *anomie*, of living in a normless world, a search for a revived *Gemeinschaft*. For all the participants in the primary stages of the Reformation, the lack of normative principles followed from the assertion of independent judgement in religious matters, and the reciprocal demand for a 'return' to the putative values of the early Christian Church. It was a search for a new (or old) form of solidarity. The psychic shock, the *'terror and amazement'* of conversion, the destruction of consolatory ritual and imagery *'as was in my heart terrible'*, and the need to escape

from the City of Destruction at least some way toward the Celestial City, impelled those who sought to escape from institutionalised religion to create their own norms and to embody them in socially enforced taboos. These had the psychic function of consolatory ritual, but in the case of Shakers particularly, an economic function; they made best use of their resources.

But these several disciplines were also restitutive. The Amish, as we have seen, reconstructed a version of their former lives in Germany and Switzerland, into the *Regel und Ordnung* of the Old Order; their particular City of Destruction had been their persecution, their martyrdoms, and the religious civil wars of Europe. The Via Dolorosa of the Society of Friends had been the enforcement of the Test Acts and the Clarendon Code, and the fifty years of persecution that began during the Commonwealth period. From this they had formed themselves into a quietist but deeply stubborn and pertinacious counter-culture. The Ephrata community sought its validation in the forms and patterns of medieval eremitism and small scale monastic settlements.

The Shakers had a later and different origin, and this has bearing on the character of their design. They evolved, first in Northern England and then in the United States, in a religious culture of small sects and movements in which plainness and a degree of separation from 'the world' was the norm. Moreover, the principles of Shaker-like design can be seen throughout large areas of British design, but not taken so far. Instrument and furniture design in particular exhibit a spareness and increasing lightness of construction (already noted), which, under the force of religious conviction and the fetishisation of work, became what we now recognise as Shakerist rigour.

Mother Ann Lee was the daughter of a blacksmith, and her husband was a blacksmith; her early followers in England seem all to have been drawn from the skilled manual workers of Manchester and district, then a centre of the technical developments that were to lead very soon into the industrialisation of the textile industry. The normal household of the area was that of mixed occupation, part farming, part productive in weaving, metal working and other crucial trades. This ambience was typically one of radical dissent (both religious, and increasingly, political), technical invention and specialised division of labour.[35] (I touch on this again in Chapter Five.) The

technological connection was sustained and nurtured in the United States by a surrounding culture of Yankee ingenuity, self-help and the growth of industry all around them.

The Shakers took as their origin a conversion experience in which Ann Lee, suffering deeply from the loss of her four children in infancy and estrangement from her husband, began to preach a new gospel, very much in the vein of the many little cults of the time and place, but which rejected marriage, proclaimed the sinfulness of sexual relations, and preached the assertion that when Christ made his imminent return to this world it would be as a woman. I think we should see in this an attempt at the restitution of sexual dignity which the normlessness of early industrial development was tearing apart, as it was tearing apart the households of mixed occupation, beginning the process by which working men and women, toiling with some measure of autonomy, were being turned into 'hands'. The longing for the mixed household occupation, the skilled proto-industrial trades, and the restitution of sexual dignity were the foundations on which Shakerism grew. All come together in Shaker design and discipline.

The notion of a 'skilled trade' is not simple. We want to begin by distinguishing between a 'skill' and 'having a skill' (that is, a noun-phrase), and 'being skilled' (a verb-phrase). The progress toward industrialisation and away from the land, which was well under way in the North of England by the 1770s when the Shakers emigrated to the United States, rendered many skills vulnerable and sometimes redundant. It makes sense to speak of the creation of a 'de-skilled' class of newly industrialised 'operatives'; typical amongst these were the domestic loom-weavers of Lancashire. But the times also required special new skills and rapidly developed enclaves, with protective habits and self-managing arrangements, which in time became what were known as the craft or skilled unions. In the process, the state of being a skilled person was socially constituted on another footing; its skill content (as noun phrase) has been changed and a new social formation had come into existence. Charles More, however, has indicated a third aspect of work

> which can be subsumed under the heading of skill; that is, the possession by the worker of the opportunity to plan his work. The amount of opportunity he has to do this might be referred to as the 'discretion content' of work, and the degree to which the worker possesses or lacks

discretion can be related to the idea of the division of labour.[36]

In either case, the degree of discretion is clearly part of the broader concept of autonomy in work and life and the capacity to pursue a mixed pattern of work. Approached from this point of vantage, the Shaker villages provided an opportunity to prolong a way of life that was being destroyed by mass industrialisation, in the world at large. The order of the Society actually required that the brothers and sisters worked with a multiplicity of skills, learning as they changed their roles and tasks from year to year.

It was the defence of this mixed way of life that can be traced in all the labour disturbances of the early nineteenth century, and in such very different texts as William Blake's prophetic books[37] and William Morris's *News from Nowhere* (1891). The scrupulous attention given to the design of tools, implements and practical objects of many kinds (such as spinning wheels) expresses the honour to be given to the trades.

The feminism of Shaker theology arises, I hypothesise, from similar roots. The vast anonymous, ubiquitous realm of fine house-keeping rises into religious apotheosis in Shaker interiors and songs.

I have come
and I've not come in vain
I have come to sweep
the house of the Lord
clean, clean, for I've come
and I've not come in vain
with my broom in my hand
and my fan and my flail
this work I will do
and I will not fail
for lo! I have come
and I've not come in vain.

New Lebanon. Saturday evening 21 February, 1845.[38]
Such a fine song is in the direct line of George Herbert's plainest of plain verses. . . .

Teach me, my God and King,
in all things thee to see
that what I do in anything
to do it as for thee.

A servant with this clause

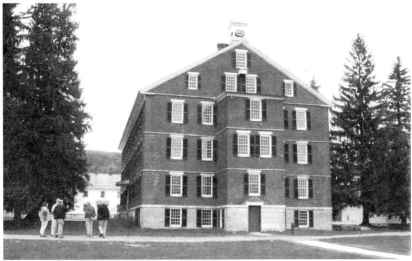

The Church House, Hancock Village, Massachusetts. After Ann Lee's death in 1784, the varied Shaker communities were 'called to order' by her successor James Whittaker, and the movement began to found a series of villages. Hancock was among the first of these, after New Lebanon. Built over the next fifty years, today it consists of this communal dwelling house, a workshop and laundry building, farm buildings including the remarkable Round Barn. The Church House is rigorously symmetrical within, with separate doors and stairs and rooms for the brothers and the sisters, but with a large dining room in common, and 'conversation rooms' for meetings and a little nursery for children – the Shakers cared for many orphans. (By courtesy of Hancock Shaker Village)

> *makes drudgery divine.*
> *Who sweeps a room as for thy laws*
> *Makes that, and the action, fine.*
> The Elixir, 1633

The ordinary is made transcendent.

The number of illustrations could be increased but would not make the point better: which is that Shaker design and building should be seen as rooted in the much older demand for a plain style in everything. Under the particular conditions in which Shakerism evolved into a substantial sect, it realised and embodied the transformation of the vernacular into the heavenly, through a religious discipline of communal work and perfect craftsmanship.

However, the plainness of independent and radical dissent was always balanced by an ecstatic or dionysiac aspect, communal in expression. This was usually overtly religious in

The Dining Room at Hancock. Polished woods in different hues, black iron for the stove, off-white for the walls. Note the careful formation of the pillar and its very modest neo-classical detailing – so discreet as to be hardly there!. (By courtesy of Hancock Shaker Village)

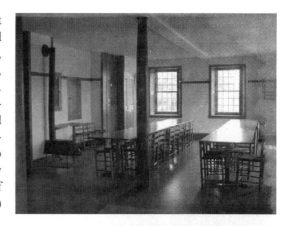

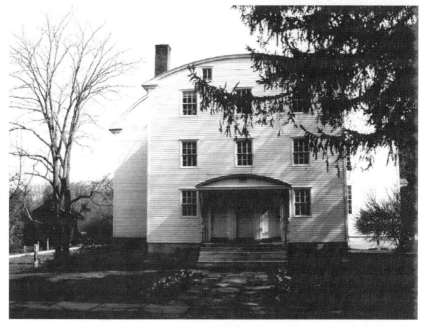

The Meeting House at New Lebanon (1824). It was the custom to paint the meeting house, the most important and prominent building, white. The New Lebanon settlement is nowa large private school who have treated the original buildings with great care; the new buildings erected have been designed in a contemporary version of the style, and are exemplary. The Meeting House is now the school library. Note the three doors – for sisters, brothers and visitors – in the middle. The erection of a meeting house was a solemn event. It had to be done by members of the United Society only, without outside help. The most important were designed by Job Bishop and Moses Johnson, but erected by communal labour in a prayer-meeting atmosphere of exhortation. The trees are recent; a photograph of 1870 shows the settlement with trees not more than ten feet high.

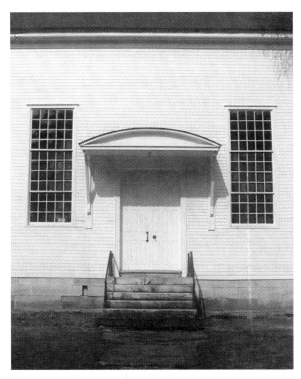

One of the side doors of the Meeting House. The curve of the porch perfectly matches the curve of the main roof. The neat masonry footings are a characteristic of Shaker buildings. The very flat or tight surface of the building, an habitual feature of American timber building, is here taken to the extreme.

The Laundry and Workshop at Hancock: another typical Shaker solution – a water-mill powered wash-house and workshop, full of ingenious ways in which work could be speeded up. Painted a rich dark red, the building is mainly of timber supported on rough-hewn marble columns. Industrial vernacular in its early stages. (By courtesy of Hancock Shaker Village)

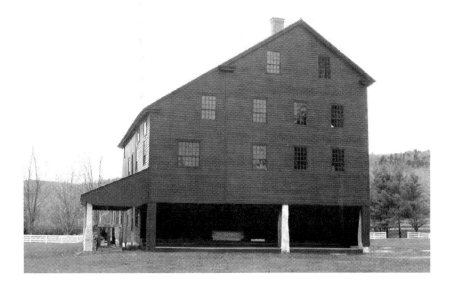

The ironing room in the Laundry, Hancock. With classical Shaker designs in situ.; the stove, the three-post table, the chest of drawers. The conical cabinet is a steel cabinet/stove for heating many irons at once. The clothes were washed in a tumbling washer powered by a belt, taken up into the loft to dry in the heat from stoves by means of a lift, and dropped back down a chute into the ironing and sewing area. the garment is one of the typical Shaker women's cloaks, which were often made for sale to the public. This one is dark blue, but those for sale were frequently scarlet red. (By courtesy of Hancock Shaker Village)

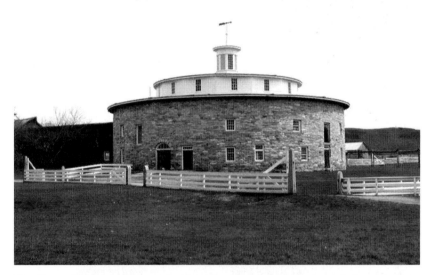

The Round Barn at Hancock. Usually described as a barn it is actually a milking parlour. The cows were driven in on the left at a higher level along a ramp from the barns; they were processed in circular fashion into adjustable stalls for milking. Their dung fell through into the lower floor into which a cart could be driven for its removal. The entire design arises from the need to cope with many cows quickly – an early example of factory farming, indicating the Shaker's practical and financial acumen, as well as their clear, strong sense of structure and design. The railing in front is of typical sturdiness: a shaped handrail, and solid stone end-posts.

Inside the Round barn: the extra-
ordinary circular and adjustable
timber cage which could take up
to twelve cows at a time. After
milking the cows were herded
around the circular path once
again and returned to the barns.
(By courtesy of Hancock Shaker
Village)

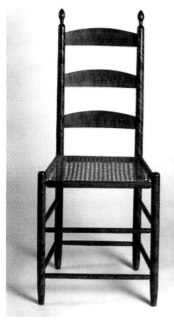

A high-backed chair in maple and
birch(?), with a woven seat, Mount
Lebanon, c.1850. Shaker furniture is so
well known that it seems to need no
further commentary, but a piece like this
challenges the notion that it was done
with no ornamentation. Though this
chair has no decorative motifs beyond
the pine-cone tops to the rear posts,
which we can also describe as useful
handles, the wood has been chosen with
exquisite care to take full advantage of
the rich grain and subtle shifts in colour.
It is, in fact, a self consciously beautiful
object. As a general principle, the Plain
Style indicated that, where possible, the
qualities of materials remain visible. The
decorative qualities derive from the
attention to materials and fanatical
pursuit of the simplest form. But note
the practical touch at the foot of the rear
posts – two tilting metal feet to enable
one to lean back without slipping.
(Photograph by Michael Fredericks, by
courtesy of the Shaker Museum and
Library)

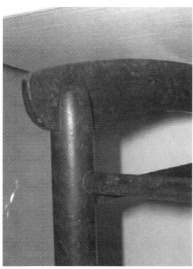

Shaker furniture is full of felicitous details,
such as this joint on a rocking chair.

A spinning wheel; Mount Lebanon (1830s). The most traditional of craft devices, interpreted in the industrial formal vocabulary of classical Shakerism. As James Nasmyth wrote of machine design, 'I have always endeavoured to attain the desired purpose by the employment of the fewest parts, casting aside every detail not 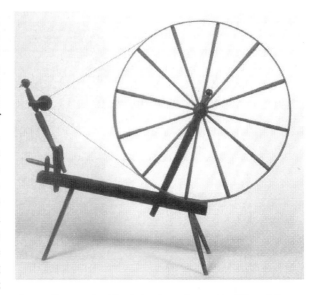 absolutely necessary, and guarding against the intrusion of mere traditional forms and arrangements. The latter are apt to insinuate themselves and to interfere with that simplicity and directness of action which is in all cases so desirable a quality in mechanical structures. Plain common sense should be apparent in the general design . . . and a character of severe utility pervade the whole.' (See next chapter). (Photograph by Michael Fredericks, by courtesy of the Shaker Museum and Library)

A barn near Chatham, N.Y. I have included this typical farm building as a reminder to myself and to the reader that the Shaker virtues of aggressive plainness are, in point of fact, more or less canonical throughout the United States, at all stages and sizes from the silo to the skyscraper, but especially in traditionally built structures such as this.

character, and always included hymn singing and preaching of a very expressive and emotional kind; but amongst the Amish we have to include the making and use of quilts (which I have already described as a kind of part-singing in colour). In the Ephrata community, musical life was a central part of life, and evolved to a high and original level. Music too was important to the Shakers, who had many stirring and lively hymns particular to themselves; but the religious practice by which they were mainly known and from which they received their popular name, was dancing. If the Quakers quaked before the Lord, the Shakers shook.

Shaker dancing was evidently a variant of line-dancing, which included circular movements and distinctive steps. The brothers and sisters danced in separate lines but to one another or in concentric circles. Most of these movements are probably formalisations of the ecstatic whirling and spinning and shaking that often accompanied religious revival meetings; they were a recognised (and scandalous) aspect of Shakerism before Ann Lee led her people across the ocean. During the general 'call to order' after the founder's death, the personal was assumed into the communal, and dancing was formalised. A single document from the time remains: 'Sister Julia Briggs Manual', which sets out a number of dances, according to the settlements from which they originated. Their names recall the names given to Amish patterns; not surprisingly since we are dealing with archetypal abstract forms of expression – 'Mother's Star', 'Double Square', 'Cross and Diamond', 'Finished Cross' etc. Scott Swank has looked into the common practice of setting out meeting house floors with inset lines of pegs, which the Shakers used as their 'marks', just as chorus lines to this day use squares of coloured tape for the same purpose.[39] He describes Shaker dance in terms of its communal bonding function:

> To dance in a church crossed an unequivocal threshold from mainstream Protestantism . . . to bring marching, clapping and whirling into a sacred space and to elevate it above the word of God spoken by ordained ministers was simply heretical. . . .

Here again, Swank misses an important point; meeting houses were not sacred spaces. The sacred space was created in and by the dance. Sacredness inhered not in the place, nor even in the personal prayer, but in the communal acting out of sacral

activities such as work, dance, and song; the very notion of community – of the United Society – was the definition of the sacred. Thus *Gemeinschaft* had become a theological concept.

At this point, as in other cases, radical dissent creates a fundamental challenge to the *Gesellschaft* of the state and of contemporary civil society.

There remains another topic which is not peculiar to the Shakers, but is part of all those aspects of the radical Reformation which we have looked at. I mean colour.

Radical Protestantism is widely portrayed as a black and white affair. The removal of imagery from churches meant the removal of colour from built space, and the plainness of domestic style implied a reduced palette. The typographer's restriction to black and white was taken up by the Anglican parson and the Calvinist minister alike (though Queen Elizabeth I, ever alive to the politics of spectacle, insisted that Anglican bishops wore fine robes). Nor should we be surprised. Colour is a disobedient matter, falsifying surfaces, diffusing form and masking the ugly.

If the visual sense had to be mortified, that meant colour, too, which had to be disciplined.

The Plain Style with which we have been concerned valued unadorned and unpainted materials but this is not the same as chromophobia. The aim was always to control colour, either with the strict geometry of the pattern, or by employing a code for the appearance of things. The Shakers, in their Millennial Laws, proposed that Meeting Houses should always be painted white without, with some shades of blue permitted within. This seems always to have been followed. Houses, barns and mills could be painted in descending order of brightness; thus the workshops at both New Lebanon and Hancock are the same deep red widely employed in agricultural buildings of all kinds. Houses, however, might be ochre yellow or a delicate grey. The Shakers had the problem everyone with a wood-clad house has to face – the wood must be treated to preserve it. Most published photographs stress the unpainted and waxed treatment of wood in the Shaker interiors, but when we enter them, we soon see this is by no means a simple case. In fact, we suspect that some rooms were actually cleaned of their colour in order to bring them into agreement with what the first curators and historians of culture thought they should be. The less formal parts of the houses – inside the cupboards or in the attics, are frequently painted in a

bright but limited palette of ochre, white, grey and mid-blue, with touches of red. Floors, when they are not of bare wood or brick, are frequently of dull red or orange painted boards, and touches of bright red are reported. In Hancock Church House, some cupboards have unmistakable traces of bright yellow. Thin stains were also frequently in use during the 1830s.

This palette, which is also that of many 'Georgian' interiors in Britain, is the basic palette of the available distemper paints of the late eighteenth century ; it demonstrates that the Shakers – and perhaps the other groups we have considered – used the full range of colours available to them. Some buildings were clearly very bright; the Church House at Hancock (in 1832) is recorded as being stained within a bright orange colour, with outer doors in green and the brickwork painted a uniform deep red in four coats, though the plastering within was still finished in white. A Shaker settlement was a colourful place. Nor did the Shakers, as the nineteenth century progressed, reject the wider demand for pattern. But it is clear, from the documents available, that issues of colour and finish were frequently discussed.[40]

1. Pulos, A.J., *American Design Ethic*, Cambridge, Mass. (1983), p. 7
2. Davis, K.R., *Anabaptism and Asceticism: a study in intellectual origins*, Scottdale, Pennsylvania (1974), p. 22
3. See esp. Glassie, H., *Pattern in the Material Folk Culture of the Eastern United States*, Philadelphia (1968)
4. See Torsten Bergen, as cited by Davis, op. cit., p. 23
5. Details of how organisational structures evolved are hard to study. We know that both Quakers and Shakers had a 'call to order' after their first leaders died. The Ephrata community split and, so far as I can understand, the Seventh Day Baptists emerged from the Householder part of the Group when the Solitaries (unsurprisingly) deceased. The Amish largely referred back to their Ordnungen for decisions, but had a structure of 'bishops', who were acknowledged leaders. The location of authority in the radical reformation could never be other than problematic.
6. The idea of an intentional community derives from Nordhoff, and has come into wide use.
7. As defined by Ferdinand Toennies
8. See especially *The Amish and the State*, Essays Edited by Donald B. Kraybill, Baltimore (1993, 2000). This book contains a comprehensive bibliography
9. See Davis, op. cit., Ch.3
10. Amongst the very few executed for heresy by Elizabeth I were four 'Anabaptists'
11. I am here much indebted to Hostetler, J.A., *Amish Society*, 4th ed., Baltimore (1970)

12. William Fahnestock, cited by Bach (p. 141.)
13. The reader is referred to Bach (2002) for many interesting pages, and to the excellent bibliographies that he includes
14. See Hamilton A. *The Family of Love*, Cambridge (1981), p. 117 et seq
15. ibid. p. 123
16. There is a curious account of this process as it occurred in Alison Coudert's' A Quaker-Cabbalist Controversy' in the *Journal of the Warburg and Courtauld Institute,* Vol.39 (1976) pp. 171-189. Some Quakers, of the more learned sort, had taken up with hermetic studies under the influence of J.M. van Helmont, who was promoting Quakerism as the true universal church. Fox wrote a minute of concern to the General Meeting of the Society urging them to reject these ideas
17. For an extensive and fascinating study of Quaker language see Bauman R. *'Let your Words be Few: Symbolism of Speaking and Silence among Seventeenth Century Quakers,* Cambridge (1983)
18. See Bauman and other sources for an account of the trial of John Crook, himself a judge, brought to court to answer for his Quakerism. His judges' attempt to entrap him into refusing the Oath of Allegiance; thus making himself into a felon; he skilfully refuses them. op. cit pp. 105-107
19. There are some lively writings against the Society by Puritan pamphleteers; a notable example being Francis Higginson's *Brief Relation of the Irreligion of the Northern Quakers*. Higginson was pastor of Kirby Stephen near Kendal; he had arranged for the arrest of James Nayler and others, whom he described as 'Satan's seeds-men'. Higginson is an interesting figure who had returned from Massachusetts (where his father had been a pastor) to Leyden in Holland where he studied for the ministry before settling in the north of England. For this and other contemporary sources, see *Early Quaker Writings 1650-1700* ed. H. Barbour and A.O. Roberts, Grand Rapids (1973)
20. The author, having had a Quaker education, has sat many long hours on hard benches
21. There is a useful survey of these early meeting houses in Lidbetter H. *The Friends Meeting House,* York (1961)
22 Cited by Gilbert C. in *English Vernacular Furniture 1750-1900,* Yale (1991) p. 199
23. A standard work on the subject being *Quakers in Science and Industry* by Arthur Raistrick (1950, 1968)
24. Major excerpts are reprinted in Barbour and Roberts ed. (1973) p. 422 et seq
25. See esp. Carroll, K., *Quakerism on the Eastern Shore*, Maryland Historical Society 1970
26. cited in Garrett W., *American Colonial: from Puritan Simplicity to Georgian Grace*, London/New York (1995), p. 12
27. ibid. p. 23
28. Readers may have seen the film 'The Patriot', in which, for all its crass politics, a lovely care has been given to the art-direction. A comic sub-theme is the hero's interest, between slaughtering red-coats, in designing and making ever lighter chairs, which do not always support his weight
29. The possibility of shared sources should not be overlooked. Behmenist ideas of a feminine divine Sophia who acted as the sisterly counterpart to Christ were common in English pietist circles such as the Philadelphian

Society, during the later part of the eighteenth century. But material on conscious elaboration of thought in early Shaker history and belief will be found in *The Complete Book of Shaker Furniture* by T.D. Rieman and J.M. Burks, New York (1993)

30. Swank, op. cit. p. 13
31. Swank's position appears from the standpoint of this book, to render the Shakers as a particular kind of entrepreneurial group: which of course they were, but this leads him to neglect the millennial origins and aims of the group. His book is full of the most telling and interesting detail about the actual conduct of a Shaker settlement and emphasises the evolution of the first into the second
32. H.C. Blinn 'Job Bishop' in *Shaker Manifesto* 22 No.5 (May 1882), as cited by Swank
33. See Rieman and Burks (op. cit). p. 29
34. Swank op. cit. p. 40
35. The towns around Manchester, which had grown with amazing speed in the later years of the eighteenth century, were well-established enclaves of political dissension. The social background from which Ann Lee and her followers sprang has been thoroughly explored by E.P. Thompson in *The Making of the English Working Class* (1963). The Shaking Quakers were only one of a myriad of such sects that combined religious and political radicalism
36. More, C., *Skill and the English Working Classes 1870-1914*, London (1980) p. 22
37. *Then left the sons of Urizen the plough and harrow, the loom*
 The hammer and the chisel and the rule and the compasses
 and all the arts of life they changed into the arts of death
 the hour glass condemned because its simple workmanship
 was as the workmanship of the plowman and the water wheel
 that raises water into Cisterns, broken and burned in fire
 because its workmanship was like the workmanship of the shepherds
 and in their stead intricate wheels invented, Wheel without wheel . .
 . . . that they might file
 . . . and polish brass and iron hour after hour, laborious workmanship
 							Wm. Blake, *Jerusalem* Ch.3. (1804-20)
38. cited by E. Andrews. *The Gift to be Simple: Songs, Dances and Rituals of the American Shakers*, New York. (1940). The Shakers attributed several of their songs to spiritual beings and birds
39. Scott Swank has some fascinating pages, based on the records of the Canterbury, N.H., village. See Swank (1999) pp. 58-63
40. See Rieman and Burks (1993) pp. 60-62, and Swank (1999) pp. 49-54 etc

V
THE TECHNICAL CULTURE:
Prolegomena to Modernity

In this chapter I want to raise a question rather than propose an answer; I mean to sketch out and suggest the links between the Plain Style and the development of early industrial design as exemplified in British machine-making and mechanical drawing in the earliest stages of the Industrial Revolution. Since this is largely a speculative matter, a provocation to further research, it will be a short chapter.

The topic was first studied by Herwin Schaefer in *The Roots of Modern Design* (1970).

> *The peculiar social and artistic climate in late eighteenth century England resulted, for a brief moment, in an almost perfect fusion of the inspiration of the high style and the quiet self-assured utilitarian and functional forms of the vernacular. This created an environment of such refinement and, at the same time, such convincing fitness and sound validity that its qualities and forms were admired and eagerly copied and imitated all over Europe and America . . . the vernacular was given the refinement that raised it to the level of 'high style'; 'high style' on the other hand, was designed with a purity of form, a noble understatement, and a careful fitness for purpose that lent it the anonymity and timeless quality of the vernacular and made it the model for the world . . . not only were (vernacular) forms happily adapted to machine production, but, more importantly, it also proved a point of departure for new forms peculiar to machine mass production, so that we may speak of a traditional vernacular and a vernacular of industrial forms.*[1]

Schaefer brings in evidence a wide range of goods, including carriages, scientific instruments and silverware, at all levels of cost. The visual evidence does indeed make his argument.

Unfortunately he then attributes (as others have done) this happy coincidence of high and vernacular style to something he calls *'English common sense'*. I think it was made abundantly clear in the preceding pages, that far from being that occult property of 'common sense', the qualities on display are much better considered as the product of *habitus*, or as *visual ideology* which found expression in the Plain Style. These qualities are the consequence of definite and analysable habits of mind, values, ideas, and dispositions of character, which have their origins in the different degrees of religious reformation, in the pursuit of imageless thought, and in the relocation of authority. Such matters, unquestioned, only become 'common sense' when they have been thoroughly absorbed; that is, retrospectively and uncritically.

To understand these questions we need to look back again at the Reformation in general, and in England and Holland in particular. When we do so we see the formation of what I shall call a 'technical culture'. I mean this term to stand as distinct from a 'scientific culture' because it is based on practical knowledge gained from making, rather than from experiment and hypothesis; and it is technical rather than 'technological' because it does not involve a theory of technics. The argument that emerges may be seen as lending support to the 'Weber Thesis' (see Introduction) and to its associate the 'Merton Thesis'. The degree to which it does in fact support the broad direction of those debates – that modern capitalism and its associated science and technology owe a great debt to the Reformation – I have to leave to others because that would be to write a different book from this one. The problem seems to be, in its baldest form, one of the relation of technological modernism to the Plain Style. Is it a question of the immanence of the former within the latter, or are we dealing with circumstantial evidence only and a chain of more or less unintended consequences?

*

Christopher Hill has estimated that out of all the titles published in England between 1475 and 1640, ten percent deal with the natural sciences and of these, nine out of ten are written in English. *England seems to have been unique in its vernacular scientific literature, and in its level of popular scientific*

understanding . . . with the doubtful exception of Italy, no country had anything like so high a proportion of popular scientific books at this date (1640) . . . consciously aimed at a public of merchants, mariners, gunners and surveyors.[2]

John Blagrave's Mathematicall Jewell (1585). A device that enabled one to arrive at trigno-metrical calculation by manual and visual means – not unlike a slide rule, though clearly model-led upon a navigator's astrolabe, or a portable sundial.

Another survey lists 172 titles on 'mathematical arts'.[3] Prominent are Richard Recorde's titles, especially *The Grounde of Artes* (a maths textbook addressed to the general reader, 26 editions from 1540 to 1620), the work of the Digges family (seven titles on astronomy, surveying and the use of instruments) and William Bourne's *Properties and Qualities of Glasses for Optical Purposes* (1572).

Most of these books are simple manuals, organised on Ramist principles, with epitomies for easy comprehension. Many of them promoted new instruments. Indeed, to be a mathematical 'practitioner' was usually to be the designer and maker of devices. These ranged from basic surveying, navigational and astronomical instruments, to clocks and novelties, to the development of purely mathematical gadgets such as 'jewels' for calculation, slide rules, micrometers and the like. John Blagrave's 'Mathematical Jewel' (1585) is a good example. It is described in the dedication (to Lord Burghley) as

a jewel, not wrought of Mineralls or set with stately stones or broughte home from beyond the seas by sundrie our country men, in the venterous and worthie voyages late performed. But a Mathematical Jewel, of no small vertue and efficacie, to furnish the willing wits of this our age for the like enterprises. Containing in sum, a reduction of the

Arts Mathematike tending thereunto, and to divers other good uses, wherewith hitherto they have been sequestered and closed up as it were in severall, only to the learnedest sort; unto an easy, methodious, plaine and practique discipline, lying wide open to every ingenious practiser.

The jewel was, in fact, a set of movable discs, rings and hinged rulers on which to work out the *'whole art of sphericall triangles'* (i.e. trigonometry). . . .

without any whit of that great toyle by synes supplementes, tables, proportions, Arithmeticall calculations, and such like . . . here performed by ocular inspection with surpassing facility.

The ambition to open and make plain hitherto obscured topics and practices is something we have met already. Here, however, it is linked to a concern for innovation,

whence I presume, many singular inventions, and notable commodities in time shall ensue and spring, yea a number yet unthought of, even from the common sort of handie craftsmen and travailers.

The crown and pinnacle of this publishing and inventing effort in the early years of Elizabeth's reign was John Dee's *Mathematical Praeface* to Billingsley's edition of Euclid (1577), which we have already encountered.[4] As noted above, this long essay was addressed to

common artificers . . . who by their own skill and experience, already had, will be able (by these good helps and informations) to find out and devise new works, strange engines and instruments for sundry purposes in the Common Wealth.

According to one scholar, the *Praeface 'remains one of the most comprehensive and important statements on learning ever written by an Englishman.'*[5] Here I draw attention to one of its basic assumptions; that its function is not to instruct artificers, who already have *'skill and experience'*, but to help them find out the new. Like Blagrave's dedication, it imagines a prospect of innovation based upon wider circulation of knowledge. In it the idea of the designer first gets an English formulation, and architecture is described as an intellectual and imaginative activity that precedes mere construction.

The intellectual basis of the *Praeface* is a typical combination

of mathematics, early technology and a magical Neo-Platonism.
*Oh comfortable allurement, oh ravishing persuasion, to
deale with a science whose subject is so ancient, so pure,
so excellent, so surmounting all creatures, so used of the
Almighty. We may both winde and draw ourselves into
the inward and deepe search . . . and also farther arise,
clime, ascend and mount up (with Speculation's wings)
in spirit to behold, in the Glas of Creation, the Form of
Formes, the Exemplar Number of all things Numerable
. . . (and know) the infinite desire of knowledge and
incredible power of man's search and capacity.*[6]

For Dee and for many of his contemporaries, practical
geometry was the meeting point between a magical *mathesis*
and a means to command the natural world through technical
invention. Mathematics was the mediator between the lower world
of matter and the super-celestial realm of Platonic essences.
Yates writes that Dee's religion was that of

*a mathematician who believed that the divine creation
was held together by natural forces. If we substitute
mechanics for magic as the operative force used by the
Creator, Dee's religion was perhaps not altogether unlike
that of Isaac Newton.*[7]

It is the magical/NeoPlatonic aspect of this early stage that
prevents us from describing the cultural ambience of Dee and
his fellows as being scientific in our modern sense. But it is the
basis on which a science might and did arise. Dee's mystical
enthusiasm for geometry, which used to be viewed as negatively
related to the growth of science, is balanced by the practical
enthusiasm for geometry demonstrated in the textbooks and in
the precision instrumentation of the day. These were increasingly
perceived as formative of knowledge itself.

Paolo Rossi lists three propositions as the foundation of the
technical culture, each identifiable as early as 1580.

*1. The procedures of artisans, engineers and technicians
have a value for the ends of the progress of knowledge.
2. Such procedures are recognised as having the dignity
of cultural facts.
3. Men of culture must give up their traditional contempt
for operations or practice and discard every concept of
knowledge that is merely rhetorical or contemplative, to
turn to the observation and study of techniques and the*

arts. . . . The men who toiled in the workshops, in the arsenals and in the studios, or those who had dropped their disdain of practice, considered the operations conducted on these premises as forms of knowledge. . . . What is certain, is that the idea of knowledge of construction, the postulation of the model machine for the explanation and comprehension of the physical universe, the image of God as clockmaker and the thesis that man can truly know what he fashions and constructs and only what he fashions and constructs, are all assertions closely connected with the penetration of the philosophical and scientific world by that new mode of considering practice and operations to which we have referred.[8]

The men who toiled in the workshops and arsenals of London and Amsterdam were, without doubt, part of that social formation that was, in the 1580s, forming 'separated' congregations. Dee's association with Raleigh and the trading companies, Leonard Digges' imprisonment under Mary, the dedications of Richard Recorde's numerous publications, all confirm these connections. Gresham College, the intellectual centre of the new science in the later part of Elizabeth's realm, was a stronghold of London Puritanism. There is, in fact, a firm, but circumstantial, connection between Puritanism and precision technology and science.

For scientific and navigational instruments to be made, a prior level of precision tools was required: screw cutters, lathes, accurate rulers, levels, compasses – together with some degree of standardisation within the workshop if not between workshops. The design of the instruments is often subtle and elegant, for precision has positive aesthetic values peculiar to itself. We find a loving attention to the properties of brass, walnut, silver, polished glass and engraved iron. Where ornamentation exists it is normally in the form of miniaturised architectural detail. The existence of such precision instrumentation and the means for making it is a precondition of both science and industry; all three are mutually enmeshed.

These qualities are not, of course, peculiar to the design of instruments in Britain or Holland; they are part of a wider, burgeoning, European technical culture, which has many links to the Arab world. They follow from the growth of rational enquiry at large. The aesthetic values of precision are, however, more than rationalism and functionality. Their elegance is iconic of

John Dee's geometric cosmology, powerfully informed with a Platonising theology – '*so used of the Almighty*'. Within such a scheme of ideas, a device that plots the heavens, measures the earth or gives us the logarithmic tables is more than utilitarian. It records and celebrates the operations of God the Designer Himself; and it can only do so in abstract and diagrammatic terms, because (in this scheme of ideas) the Divine can only properly be thought of abstractly and diagrammatically, without pictorial imagery.

An hypothesis begins to suggest itself. It was because of the habits of plainness and perspicuity, because of the training in imageless thought, that it was possible to effect the connection between theology, geometry, instrument design, the design of everyday objects, architecture and ultimately the design of early industrial machines and their artefacts, which makes British eighteenth-century design so striking and important for the future. Only in a society in which the Plain Style had become *normative* could the aesthetic values of precision technology and science help to form a dominant canon of taste and pass over into buildings, furniture, silverware, clock design and clothing. This more or less unconscious connection, which was *habitual* to the puritan and dissenting traditions of Great Britain and other Protestant societies, was exported and developed further across the Atlantic. This hypothesis goes some way toward expanding upon Herwin Schaefer's account of eighteenth century design, without recourse to the notion of 'common sense'. More than anything else, it offers a further perspective upon notions of 'functionalism', especially in relation to Shaker design.

More widely, it may lead us to reconsider the very notion of 'functional' design, and the truistic aphorism, that form follows function. For the classical as well as for the modern functionalist, the principal is a fundamental precondition of beauty. This entails a linkage between the useful and the beautiful. As one notable American theorist put the matter, "utility is the parent of beauty and any increase in fitness is an increase in beauty".[9] As Edward de Zurko showed in his *Origins of Functionalist Theory* (1957), however, the idea of function as the basis of an aesthetic theory is severely compromised by three kinds of analogy, which are of categorically distinct kinds. There is, he argues, buried within functionalist arguments, mechanic, organic and ethical analogies that do not easily yield themselves up to analysis.[10]

Much of the work at which we have looked, especially in the last chapter, meets most of the classical requirement of functional beauty: but the primary or originating concepts behind The Plain Style were 'plainness' and 'perspicuity', rather that 'utility': their functions were revelatory rather than useful. This may appear to add to de Zurko's three layers of analogy, a fourth – a theological. However, simply to thicken the plot, I propose what is nearly the reverse: that the argument (that utility is the parent of beauty) is essentially and historically a theological argument, no matter what layers of analogy and secularisation have been wrapped around it: and that this is a pre-eminent example of the way in which nearly all aesthetic theory, of whatever kind, is a sort of secularised theology. The inability to recognise this, or even to see that it might be an issue, makes a critical understanding of the arts of the present and the past more difficult than it need be.

For those readers who may think that aesthetic theory is an insignificant matter, let them reflect that their position is an aesthetic theory itself; and that what we idly call 'common sense' is merely the uncritical dross we have picked up, like the chewing gum that sticks to the soles of our shoes.

*

The connection between theology, plainness and science is well seen in the supposedly utilitarian 'languages' of early science.

The way in which early science began to define its common language was a way which chimed in well with a Platonist natural theology. For Galileo,

Philosophy is written in this grandest of all books, forever open to our eyes (I mean the Universe), but which cannot be understood if we do not learn first to understand the language and interpret the letters in which it is written. It is written in mathematical language; the characters are triangles, circles and other geometrical figures, without which it is impossible to understand a single word. Without these there is only aimless wandering in a dark labyrinth.[11]

Where the language of science was not mathematical we had to choose our words very carefully. The founders of the Royal Society, frustrated by literary style, sought to fashion a prose that was as strictly denotative as could be. A passage in Sprat's

History of the Royal Society (1667) is often quoted to this effect, but it does not seem to have been much noticed how close the effects sought were to those recommended during the previous hundred years for sermons. Members of the Society were

> *to reject all the amplifications, digressions and swellings of style, to return back to the primitive purity and shortness when men delivered so many things almost in an equal number of words. They have exacted from their members a close, naked, natural way of speaking, positive expressions, clear senses, a native easiness, bringing all things as near the mathematical plainness as they can, and preferring the language of artisans, countrymen and merchants before that of wits or scholars.*

With the exception of the one adjective *mathematical*, this might well have been written by and for a Presbyterian readership or appeared in a manual of style for preachers. Note, for example, the connection made between primitive purity and shortness, or the idea that nakedness is natural. It is exactly what Quakers sought to practise in everyday life. We should speak as Adam spoke in Eden. With this went a further demand, that scientists purge their speech and writing of figurative expressions and metaphors. Locke's *Essay Concerning Human Understanding* (1690) contains, in Book 3, a sustained attack upon any kind of figurative speech. It exists, he writes

> *for nothing else but to insinuate wrong ideas, move the passions, and thereby mislead the judgement . . . in all discourses that pretend to inform or instruct, wholly to be avoided.*

Once again we have to remind ourselves that such ideas were European wide, wherever science began to form; the significant difference being that in England and in Holland, they coincided with a religious reformation that stamped the ideals of plainness and perspicuity right through public speech and rhetoric and into the material culture, for specifically theological reasons. If we employ the ethnological concept of a speech community to the members of the Royal Society and then to such bodies as the Society of Friends we cannot fail to observe a considerable overlap.

By the time of Christopher Wren the combination of plain un-figured treatment and simple geometry had become a truism of aesthetic theory in architecture, and by extension, generally.

There are two causes of beauty, natural is from geometry,
consisting in uniformity (that is, equality) and proportion.
Customary beauty is begotten by the use of our senses
. . . the true test is always natural or geometric beauty.
Geometrical figures are naturally more beautiful than other
irregular; in this all consent as to a law of nature. Of
geometrical figures, the square and circle are most
beautiful, next the parallelogram and oval. Strait lines are
more beautiful than curve; next to strait lines equal and
geometrical flexures. There are only two beautiful
positions of a strait line; perpendicular and horizontal; this
is from nature and consequent necessity, no other than
upright being firm. Oblique positions are a discord.[12]

This is Platonic fundamentalism; Wren's natural beauty is, to
use Wyclif's terminology, the *esse intelligibile* of design, which
perspicuously, therefore beautifully, reveals the fundamental
structure of Being.

The connection between science, Platonic geometry and
design was, in fact, made through the activities of Wren and
Robert Hooke and their colleagues when Wren undertook the
construction of The Royal Observatory (1675). The designers
and users of that building were, in their persons and their work,
the finest flower of the technical culture that had begun to evolve
some hundred years previously. Hooke said of his colleague
that *'Of him I must affirm, that, since the time of Archimedes,*
there was scarce ever met in one man, in so great a perfection,
such a mechanicall hand and so Philosophical a mind.'

In a different and much larger book one might explore the
steps by which instrument design and the practice of science
contributed to other aspects of manufacture, as an aspect of
eighteenth century natural theology. An important work to study
would be Paley's *Evidences* of 1802.[14] Famous for the example
of a watch used to demonstrate a teleological argument for God's
existence, it is now mainly important as a survey of the life-
sciences in design terms. Everywhere in the text, 'Nature' is
described analogically in terms of human technology and
contrivance, rendering the laws of Nature and the 'laws' of human
design transposable. Important examples would be taken, in the
manner of Schaefer's work, from the evolution of the telescopes
and chronometers used at the Royal Observatory (and still on
display), and from clock, furniture and carriage design. As it is,

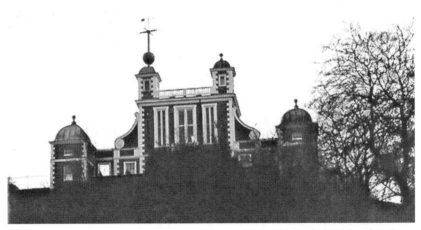

The Royal Observatory, Greenwich; the seminal building of modernity, from which all space and time were to be measured. I do not think the oddness and originality of this building has been sufficiently studied. It is not unlike a piece of much enlarged domestic furniture, or stage decoration, with oversized decorative scrolls and flourishes; the plaster decoration of roses suggest its 'Stuart/rosicrucian' origins.[13]

we must present this chapter as a possible prolegomena to the study of technological modernism.

A part of our putative study would require an exploration of the idea in natural theology that God was the supernal Designer, and look at the way that, as Calvinism slowly receded, it was slowly succeeded within the Anglican world by a more openly Platonic conception of the world which, though tolerant and 'Arminian' in ethical tradition, was no less opposed to images, pictoriality and display. The Cambridge Platonism of Henry More and others would be drawn into these philosophical under-pinnings, which in turn would be connected to developments in music which reach their peak in Handel's choral work and perhaps particularly 'Theodora' (1749) in which the heroic martyrs go to their death expecting to meet a platonised Christian heaven, consisting of '*Objects pure of pure desire*'.

From the perspective of this study, which of course admits of other interpretations and does not pretend to completeness, I do not think we can understand the visual and plastic language of the City churches, of a good deal of British neo-classicism, and even such matters as the sobriety of clothing and Augustan language without reference back to the confluence of science and theology that I have been sketching out.

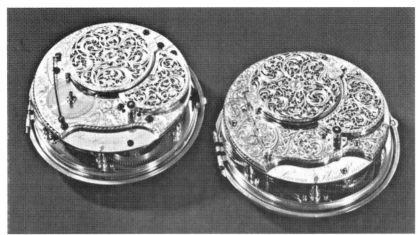

Harrison's Timekeeper No. 4 (1759), by which John Harrison won the vast prize awaiting anyone who could devise a reliable navigational chronometer; and a copy (from 1769). The intense and magnificent engraved decoration is an emblem of the circular energies within the watch, itself seen as emblematic of the circular energies of the cosmos. Compare with Blagrave's Jewell almost 200 years earlier. (Reproduced by courtesy of the National Maritime Museum, Greenwich)

In architectural practice this meant, as ever, restrained and abstract decoration and an avoidance of illusion. Wherever possible, materials are real, not simulated; and there is a characteristic rich but modest palette of colours and surfaces in those City churches where

the walls of Magnus Martyr hold
inexplicable splendour
of Ionian white and gold.

In everyday design, such as we find with silverware and furnishings, similar principles apply. The silver tankard or bowl is so well proportioned that it needs no more than its own shape to hold the eye; the lip or the details of the handles are judged to a nicety. Even the hall-mark acts like a motif.

In the design of furniture, the evolution toward 'rationalism' which Ole Wanscher describes was interrupted for a while by the Restoration and the Court's attempt to restore French models of decorative style, to counteract the plain norm,

court furniture was primarily to reflect purely decorative
styles incorporated in pieces whose measurements and
architectural details might well be quite crude . . . the
Versailles style left little scope for displaying the natural
surface of the wood.[15]

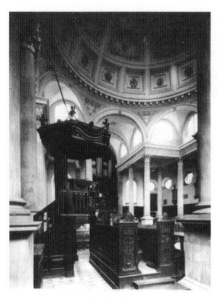

Christopher Wren: The interior of
St. Stephen Walbrook (RIBA
Library Photographic Collection)

*

As we approach the aesthetics
of early industrialisation we
would want to investigate in
great detail the development
of technical and mechanical
drawing and the structures of
ideas that underlie its
conventions. Within a strictly
British context we should need
to return to Dee's *Praeface*
once again. In the pages of Dee, or of Rosicrucian writers such as
Robert Fludd, the expansion of the point to line, plane and solid
was given a mystical significance as being emblematic of the
unfolding of the manifold creation from God's original 'Fiat!'. The
capacity to 'frame' lines and geometrical diagrams was part of a
natural magic that was almost indistinguishable from the utilitarian
drawing of masons, carpenters and architects. But the capacity to
make drawings and 'frame' lines made the difference between
the one who knew and the one who made, between workman
and designer.

*The hand of the carpenter is the architect's instrument
. . . the whole feate of architcture in building consisteth of
lineaments and in framing. And the whole power and skill
of lineaments tendeth to this; that a right and an absolute
way may be had of coapting and joining lines, by which
the face of the building, or frame, may be comprehended
and concluded . . . the form and figure of the building may
rest in the very lineaments, etc. And we may prescribe in
mind and imagination the whole forms, all material stuff
being secluded.* [To which Dee adds in a marginal gloss
. . .] *The immateriality of perfect architecture.*[16]

The 'frame' for these writers meant both the plan and elevation
of the building, and its abstract and mathematical scheme as
depicted in 'lineaments'. Thus when they spoke of the frame of the
Universe (or building), they meant its geometrical configuration

A drinking bowl in silver, by Thomas Pantin of Newcastle (1732). 4 in. diameter. The Plain Style comes to the table. The apogee of this plain silver is around 1720, by which time all surface decoration from the previous century had been purged and for about twenty years the metal was treated almost as if it were liquid. (from a private collection.)

shown in number and line. This was not possible in pictorial drawing. This process from picture to diagram can be caught on the wing in such publications as John Smeaton's *Narrative of the Building of the Eddystone Light etc.* (1786). Smeaton found it necessary to write about his illustrations, to justify the curious mix of mechanical drawing and picturesque scenery:

They are little more than geometric lines drawn to explain geometric and mechanical subjects. Is any of them put on the appearance of anything further, it is to render it more explanatory and descriptive. They are, in reality, not meant as pictures. . . .[17]

The impassioned and semi-magical discourse of Dee, in which the utilitarian and the Neo-platonic are inextricably mingled, goes some way to explaining the austere beauty of early mechanical drawings and the visual language in which technical operations came to be communicated. The 'general arrangement' and presentational drawings of ships and, later, locomotives and other engines, have often been recognised as 'works of art' without this ideational background being taken into account.[18]

<p style="text-align:center">*</p>

The combination of a sort of reduced Platonism and instrumental purpose (characteristic of Ramism) appears strongly in the manuals of drawing that, appearing in the first years of the nineteenth century, form part of the first industrial curriculum.[19]

Drawing is an activity fundamental to human action; it belongs with counting and speaking as being a primary form of human cognition. How drawing is conceived and practised reveals a

great deal about the fundamental assumptions of those involved. This is even more the case when drawing is offered as something to be taught; the ideological skeleton is at once laid bare. This can be seen in the methods of drawing, in the self-teaching manuals, and in the curricula of schools and colleges that came into being with the advent of industrial society.

The first industrial revolution required new graphic conventions to communicate and teach its demand for precision and repeatability; within a decade or two of 1800 many books and pamphlets on drawing were written with these aims in mind, as part of the perceived need for a newly trained workforce.[20] The majority attempted to treat drawing in a systematic manner, and a smaller number try to treat it as a science, presenting a set of axioms to use in analysing a drawing problem. This literature was part of the wider project of mass education that the new society then coming into being required. Central to this project was the inculcation of instrumental rather than metaphorical thinking; the process that had hitherto been the concern of scientists had now, in some manner, to be infused throughout the whole population. Likewise, the habits of precision and manual dexterity had to be taught, and drawing was perceived as one of the means by which this might be done.[21]

The manuals were, almost without exception, based on the assumption that all drawing is founded on a set of primary or elementary lines. The ability to form these lines, freehand, must be imparted before any attempt is made to produce images. These linear elements are the *a priori* conditions for the production of any kind of drawing. A characteristic formulation appears in the pages of William Robson's *Grammigraphia* (1799):

Lines are four; perpendicular, horizontal, oblique and curve. All variety of appearance in nature are presented by a combination of these four lines placed agreeably to proportion and position.

The production of a line should be considered as,

properly the continuation of a point. A point can proceed in four ways only . . . and from these we derive a mathematicall account of all the common figures: angle, square, circle, allipsis, oval, pyramid, serpentine, weaving and spiral.

The student was expected to use a line *'as distinct and determinate as possible.'*

The *Grammigraphia* does not seem to have been widely read, but its thinking was widely shared.[22] For George Field,

from the direct, reflect and inflect motions of a point are generated the three primary figures: the right line, the angle and the curve. [From this] *it follows that all graphic art consists elementarily in the ability to form the three primary lines – straight, angular and curve.*[23]

These elements were also conceived as being expressive of ethical qualities; thus their learning was also an acquisition of an expressive grammar.[24]

From such beginnings students were expected to progress to the drawing of regular solids, simple perspective and, finally effects of light and shade. Some books encouraged students to draw from wood or plaster cubes and cylinders, and some books came with a kit of wooden blocks. A sharp distinction was made between this 'pedagogical drawing' and the 'artistic drawing' of the Academies. In Germany this teaching method was particularly favoured and was developed by Pestalozzi, Froebel and other educational pioneers, and encouraged by the Prussian state as part of its drive toward modernity.[25] One of Pestalozzi's disciples described the new pedagogical drawing as '*a new art that should precede the usual, old-fashioned, well-known ideas of art-culture*'.

The pedagogy was intrinsically algorithmic, organised upon Ramist principles, setting forth in a new guise what was essentially academic, neo-platonic lore such as Christopher Wren would easily have recognised; but it is a Platonism without affect; a kind of instrumental Platonism, such as we have already encountered in the Ramist textbooks. Similar ideas were circulating in the United States, where the self-teaching manuals were found very useful in the relative absence of a stable educational system.[26]

In neither Britain, Germany nor the United States was pedagogical drawing regarded as an attempt at art education; it was to be a useful mechanical skill attainable by all, similar in character to writing. A typical apologia was provided by the *Encyclopaedia Mancuniensis* (1813), which, under 'Drawing' states that:

It should be learned by every person as answering the same purposes with writing . . . we are convinced that it is of the utmost importance to society that this would always form part of common school education, in the same manner of writing.

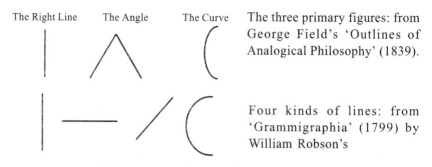

The Right Line The Angle The Curve The three primary figures: from
 George Field's 'Outlines of
 Analogical Philosophy' (1839).

 Four kinds of lines: from
 'Grammigraphia' (1799) by
 William Robson's

It is instructive to compare the attitude then taken to pedagogical drawing with that now taken toward information technology; the two were and are promoted for much the same reasons.

The practical outcome of this instrumentalised method of thought and drawing (the two being identical) can be seen in the words and products of the great machine designers of the early nineteenth century. James Nasmyth (1808-1890), the inventor of the steam hammer, wrote,

> *Viewing abstractedly the forms of the various details of which every machine is composed, we shall find that they consist of certain combinations of six primitive or elementary geometrical figures, namely the line, the plane, the circle, the cylinder, the cone and the sphere; and that however complex the arrangement and vast the number of parts of which a machine consists, we shall find that all may be, as it were, decomposed and classed under these six forms; and that, in short, every machine, whatever may be its purpose, simply consists of a combination of these forms.*[27]

Nasmyth himself was addressing the practical problems of precision machining, but he was also making a statement of aesthetic intention, about the visual grammar suited to that stage of technology.

> *In mechanical structures and contrivances I have always endeavoured to attain the desired purpose by the employment of the fewest parts, casting aside every detail not absolutely necessary, and guarding carefully against the intrusion of mere traditional forms and arrangements. The latter are apt to insinuate themselves and to interfere with that simplicity and directness of action which is in all cases so desirable a quality in mechanical structures. Plain common sense should be apparent in the general design . . . and a character of severe utility pervade the whole.*

In our extended book we would also investigate the continued

Three plates from J.D. Harding's *The Guide and Companion to The Lessons in Art* (1854) illustrating the use of wooden blocks for self-instruction. Harding wrote several 'how to draw' manuals, mainly for amateur artists: *The Lessons in Art* (1835, 1849, etc.) was his most pedagogical. See also his *Drawing Models and Their Uses* (1854).

importance of Dissenting society in the growth of science and technology and it might well conclude with the advice of Nasmyth's mentor. Henry Maudslay (1771-1831) (to whom all machine designers stand in debt) was prone to give this Shaker-like advice to his apprentices:

Keep a sharp look-out upon your materials; get rid of every pound of material you can do without; put yourself the question 'What business has it to be there?'. Avoid complexities, and make everything as simple as possible.[28]

Such words, and the machines made by Nasmyth and his colleagues are, in their massive and impersonal power, perspicuous of the '*grandest of all books, forever open to our eyes . . . written in mathematical language.*' What much early machine design reveals is the diagrammatic conception of Nature, and indeed of Creation, which made the theoretical constructs of power engineering realisable.

This industrial aesthetic, and the wider technical education in which it was located, was not, of course, in any formal sense 'Protestant', but within Britain and Germany it was, without doubt, linked to Dissent and to particular strains of pietism. The role played by the 'dissenting academies' in England and the state education in Scotland were crucial in the

Steam-hammer form of steam engine.

development of science and early industrial technology. Froebel and Pestalozzi and their transatlantic followers were taken up by the transcendentalist movement.[29] In view of this we can return to Max Weber and describe our task in his terms; *'we are to find out whose intellectual child the particular form of practice was'.*

A coherent answer (which would perhaps require a more cogent and limiting rephrasing of the question) would be a further stage in the development of the 'Weber' and 'Merton' theses. But that would be a task for another kind of book. These pages are already over-freighted.

I may, however, be permitted to close this chapter with a quotation. The ship's engineer, MacAndrew, leaning over the rail in the tropical night, contemplates the power and perfection of the engines he has in his charge.

From coupler-flange to spindle-guide I see Thy hand, O God;
Predestination in the stride o'yon connectin'-rod.
John Calvin might ha' forged the same – enormous, certain,
 slow.
Ay, wrought it in the furnace-flame – my 'Institutio'.

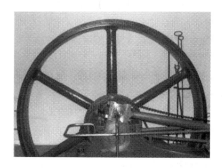

The aesthetics of mechanical precision: horizontal steam engine and detail (1890): Ulster Museum, Belfast. 'Interdepence absolute; foreseen, ordained, decreed.' (R. Kipling 'MacAndrew's Hymn')

1. op. cit., pp. 67-69
2. Hill, op. cit., p. 16
3. Taylor, E.G.R., *The Mathematical Practitioners of Tudor and Stuart England,* Cambridge (1954). See also Rossi P. *Philosophy, Technology and the Arts in the Early Modern Period,* New York (1970), MacLean, A., *Humanism and the Rise of Science in Tudor England,* London (1972), etc
4. The *Praeface* has been reprinted, New York (1977)
5. MacClean, op. cit., p. 138 (and see above Ch.3.)
6. Had Marlowe read the *Praeface* before writing *Tamburlaine* 'still climbing after

knowledge infinite . . .'?
7. Yates, F., *The Theatre of the World,* London (1969), p. 14. There is now an extensive literature on Dee
8. Rossi, op. cit., p. xxi.
9. Claude Bragdon in *Six Lectures on Architecture,* Chicago (1917). Bragdon seems to be largely forgotten except by aficionados of the Chicago School; there is a strong transcendentalist/spiritualist aspect to his thinking that aligns him with contemporaries such as Sullivan and Wright
10. de Zurko, E.R., *Origins of Functionalist Theory,* New York (1957), p. 9
11. Galilei, G., *Opere VI* (trans Brophy and Paolucci), New York (1962), p. 232
12. In *Parentalia* (1750) For discussion see Bennett, J.A., 'Christopher Wren; the natural causes of beauty' *Arch. Hist.* Vol. XV (1972) pp.5-22
13. See Yates, F., *The Rosicrucian Enlightenment,* London (1972), esp. Ch.13 'From the Invisible College to the Royal Society'
14. Paley, W., *Natural Theology: or Evidences of the Existence and attribute of the Deity Collected from the Appearances of Nature,* London (1802)
15. Wanscher, op. cit., pp. 144-145
16. op. cit. I have simplified Dee's erratic spelling
17. op. cit., 2nd ed. (1813)
18. See, amongst other sources, Booker, P.J., *A History of Engineering Drawing,* London (1963), and Baynes, K., *The Art of the Engineer,* London (1983), and the quantity of material cited in Brett (1986)
19. See Brett (1986), 'Drawing and the Ideology of Industrialisation' in *Design Issues,* Vol.3 No.2, Fall 1986, pp. 59-72, reprinted in Doordan, D. (ed.), *Design History: an Anthology,* M.I.T. Press (1995)
20. I have surveyed and studied these in some detail in Brett (1986); and see also work by Ashwin, Korzenik and others
21. For a more detailed study of this topic see Brett (1986)
22. Robson, W., *Grammigraphia or the Grammar of Drawing,* London (1799)
23. Field, G., *The Outlines of Analogical Philosophy,* Vol.2, London (1839), pp. 92-95. See Brett, D. (1986), for a survey of Field's unusual career as colourist, dyechemist, friend of artists and speculative philosopher
24. This notion is especially strong in George Field's 'Analogical philosophy', and it gets an artistic importance in continental writers such as Humbert de Superville, whose *Les signs inconditionels dans l'art,* Leyden 1828) is part of the prehistory of abstract painting
25. Of particular importance is the research of Clive Ashwin published in *Drawing and Education in German Speaking Europe 1800-1900,* Ann Arbor (1981), inter alia
26. See especially Korzenik, D., *Drawn to Art: A Nineteenth Century American Dream,* Hanover N.H. (1986). This contains a wealth of research. into an obscure but rewarding topic
27. In pp. 394-395. Nasmyth's *Autobiography,* New York (1883), cited by Schaefer. op. cit.. See also Robertson and Buchanan *Practical essays on Mill Work and Other Machinery,* 3rd ed., London (1841). Nasmyth was the son of a noted Scots artist and his family circle was linked with that of the Aesthetic Club of Edinburgh. (See Brett, 1986 etc.)
28. Quoted in Gilbert, K.R., *Henry Maudsalay: Machine Builder,* London (1971)
29. By far the most well known knot in this network is the Froebel-inspired education of F.L. Wright, and the writings of Louis Sullivan

6
DEEP STRUCTURES:
The Geology of Culture.

I began this book with the assumption of a metaphor, that cultural phenomenon such as buildings and clothing and the like are the consequences of some deep underlying structures in much the same way as the landscape depends upon the underlying, but largely unseen, geology. The rocks that support the surfaces of earth largely determine what will grow on it, how the waters run and where it is safe to dwell. There are fault lines and earthquake zones.

As it stands, such a metaphor is mainly a device to thicken the plot; it sets up a theme to be investigated, tormented, argued and perhaps rejected. The bedrock in question (as far as this book is concerned) is Protestant theology and its secular consequences as they appear in the Plain Style: the effecting force being what Weber refers to as psychological sanctions originating in religious belief. The danger is always to suppose, or to appear to argue that ideas and psychological sanctions can be a sufficient cause of the forms of objects. Where we are dealing with such matters as design, monocausal explanations have to be rejected. But any large scale argument has to have recourse to metaphors of this kind, which help us to summarise their scope and suggest their complexity. Yet, when we come to explain matters, then metaphor has to be held at a distance, even if it can never quite be avoided.

I find myself in strong sympathy with neo-Marxist apologists who find themselves arguing in the opposite direction:

I shall regard the Marxist theory of historical process and social development in a specific way. I accept, of course, the main Marxist concept that being precedes consciousness, but I hold reservations concerning the thesis that the productive forces, or the socio-economic relationships or even both together, are the sole forces of human history.

Neither technologism (absolutising the means of production) nor economism (absolutising the property relations) does justice, as is well recognised, to the original ideas of Marx. And even taking the two factors together, there remains the often repeated warning of the classic Marxist texts that the basic social phenomena are moulded in turn by the super-structure and, let me add, by the social consciousness, which includes the cultural heritage, the utopian line of thought, and so forth.[1]

It now seems to me that my topic raises just such problems.

It will be clear enough that psychological sanctions, along with utopian lines of thought and cultural heritage, and so forth, are parts of that super-structure which helps to mould the social phenomena from which they arise. They do so because, in Bourdieu's terms, they are *basic, deeply interiorised master patterns* which persist in cultural situations and within societies over time.

That the master patterns persist through time, even after the originating situation has dissolved, is what permits us to speak, meaningfully, of the existence of different cultures and different tendencies within cultures, and of contemporary distinctions within societies, and to treat them as historical topics; though the danger, once again, will be of 'absolutising' the notion of a master pattern into a mode of explanation. The pattern is as much a symptom of a cultural situation as it is its nature or cause. This is why I have preferred to describe the combination of psychological sanctions, cultural heritage, utopian line of thought (etc.) as *qualitative factors*. These are contributive rather than causal.

It is clear enough that the Reformation generally (and in England and Scotland in particular) took the route it did, with the aesthetic consequences I have been investigating, because of the particular range of factors involved. These manifestly included economic factors such as the shift in property relations which virtually created a new class out of the sale of monastic lands – a class that was determined to hang onto its economic gains whatever the religious requirements of the state. (This is shown by Mary Tudor's failure to restore monastic lands to their original owners; she was herself dependent on the new owners.) We can also discern technological factors at work which included as a distinct social consequence, the growth of a skilled, mobile artisanate that was not beholden to

any established propertied class and so could seek out and make its own religious institutions.

One must conclude that the Plain Style is a clear case of a phenomenon wide open to Marxist interpretation, of a fairly obvious kind. But this could only be upheld over time if the property relations, means of production and so forth remained in something like the same relations with one another and with their cultural consequences. In fact, the persistence of the Plain Style in the North American colonies, in significantly different material and property conditions, seems to me difficult to explain in orthodox or 'vulgar' Marxist terms. We are, in fact, dealing with a feature of the superstructure which has 'relative autonomy'. Without 'absolutising' the explanatory powers of ideas (especially theological definitions of authority), I think we may conclude that the qualitative factors that helped to create the Plain Style had their own normative momentum.

*

The question then arises, in a concluding chapter, as to the persistence of that momentum. Can we still speak in some useful way of a 'Protestant aesthetic' that has its own continuing autonomy, albeit in some contemporary inflection? Or has it been dispersed or dissolved into modern culture as a whole so that it can't be taken out and looked at as a separate element? If this is so, then what remains of the historical reality of the Plain Style is something that is shared by anyone who participates in the modern world, in no sense unique to anyone and guaranteeing no separate 'identity'. We would, in that case, be rather like fish, who cannot see the medium in which they move. This, in fact, is what I take to be the case. Whoever participates in modernity does so within terms initially defined by aspects of the Reformation, which have now diffused themselves all through the modern world even when that is now a post-religious world. Because it is a post-religious world, the religious origination has become very difficult to see and think about.

Of course, much of the original aesthetic still exists within religious practice. Meeting houses and churches continue to be built in some places, without adornment, and plain-spoken sermons continue to be addressed to the congregations that built them. We merely have to glance at a Quaker graveyard to

see the Style in action. And whoever passes along the byways of North America sees small independent chapels built as they have always been built.

A powerful suspicion of imagery continues to hold sway over some social and religious groups. A distrust of central authority remains deeply rooted in many Protestant communities; and it is a central fact of political life in the United States, where it supports features that are at the same time amongst the best and the worst of their polity.

But the unavoidable fact is that religious belief and practice no longer play a leading role in the general culture of modernity, and have not done for well over a hundred years. We live in its long, withdrawing roar. And it is difficult to see that it can ever be otherwise, since religious belief has been detached from the other domains of life, except where it remains as a kind of label of other loyalties. In such cases, religious affiliation is a marker of other differences, rather than the substance of those differences. Within Western Europe, Northern Ireland is one such region, as are parts of Belgium and Switzerland. Usually the differences are absorbed or cushioned by democratic governments, a reasonable degree of equity, and by the drive of late capitalism to erode local distinctions.

In those parts of Europe that are imperfectly modernised or in which ethnic boundaries are challenged by political frontiers, this comfortable picture has never held firm. In the Balkans, religious difference within Christianity and between Christianity and Islam have lately been contributing factors with disastrous consequences, reviving an old Europe of ethnic frenzy and bloodlust we had hitherto thought confined to the past. And considering the world at large, it has become a truism to say that the international polity is challenged by various forms of religious fundamentalism (a glance at today's newspaper gives instances of Christian, Jewish, Islamic and Hindu malignities). This fundamentalism arises amongst those who have failed to make an adjustment to modern conditions, who feel themselves forlorn and normless in a world of perpetual innovation. A post-religious world is, for them, a kind of death, even when religious conviction has been worn away almost to nothing.

In the first edition of this book I was concerned to relate this forlorn condition to the growth of identity politics in Ireland. The desire amongst loyalists to assert a 'Protestant identity' was, I

concluded, an attempted adjustment to the feared likelihood of subordination and abandonment. And that, under modern conditions, they were chasing a chimera.

Of course, people do so designate themselves, in harmless ways. In Belfast we might say of someone's housekeeping that 'She keeps a very Protestant-looking sort of a house.' (And we think we know what we mean by this; we imagine, perhaps, a kind of prim neatness. We are not sure if this is praise or not, but it usually is.) There are popularly supposed to be other differences that surface in the minutiae of social behaviour and body-language, none of which, in themselves, are malignant. Many of these are of a kind that in the United States we would probably describe in ethnic terms. At this level we are in the realm of existential culture, which we live in whether we like it or not, more or less unexamined, until the consequences are revealed.

Then walking through the different parts of the town or passing from village to village, we have no difficulty in identifying their religious and therefore political loyalties by glancing at their gable-end paintings and street regalia. We see how the 'loyalist' cause is proclaimed in flat, playing-card icons and emblems, some deriving directly from the Reformation, that stand in marked contrast to the 'republican' tendency to a visual language of dramatic gesture and sentiment drawn largely from the prints and plaster statuary of Catholic piety.[2] Here we enter a world of real distinctions, because changes in visual conventions, are always and everywhere markers of equivalent deep changes in basic, deeply interiorised master patterns. Where political structures and institutions do not enable neighbours to accommodate these deep difference, but actually feed upon them, civil conflict is never far away.

At these boundaries, to use the geological metaphor again, we can feel the shift of the tectonic plates beneath.

*

The question then arises if these master patterns can still be discerned in the formal material culture of historical traditions; that world of architecture, design and the arts with which this book has been mainly concerned.

Where the visual arts and especially painting are concerned,

we can begin by asking why there were no Catholic abstract painters. It is an interesting – and largely unremarked – fact, that of all the great pioneers of non-representational painting, not one was from a Roman Catholic background. Without asserting the priority of the biographical, it is interesting to follow some cases. Wassily Kandinsky, to take a leading example, was devoutly Orthodox, and this certainly informed his thinking about the nature of a painting; it gave him, as we say, permission to disregard Renaissance pictoriality. Kasimir Malevich drew upon Russian mystical traditions of the same provenance; and it is well established in scholarship how deeply the revolutionary movements of early Soviet Russian art were informed by theories of the icon that were anti-pictorial. Most salient of all, Piet Mondrian was brought up in a distinctly Calvinist Dutch family. His artistic career actually reiterates, with some exactness, the course of the visual imagination of the Reformation, as I have described it. His paintings moved, over the years, from the pictorial landscape tradition of the Hague School, through a symbolic or emblematic stage, to the mature abstract or diagrammatic style with which he is now generally identified. Moreover, his particular concept of vertical and horizontal axes as the foundation of a universal pictorial grammar (and its pre-history in artistic theory, touched on in Chapter Five) is characteristic of that pedagogical tradition which, beginning in Ramist epitomes, comes to fruition in the drawing manuals of the early nineteenth century which combined the utilitarian and the Platonic. But reiteration is not the same as identity and we ought to be very chary of claiming this or any other work for a vaguely defined 'Protestant' tradition of painting. Mondrian himself never made any such claim, but maintained all through his life an allegiance to theosophy.

One important study has linked the development of Modernism in painting to the traditions of Protestant pietism[3] and, more generally considered, if religious assumptions and traditions have any contemporary cultural meaning we might reasonably enquire whether or not the Modernist refusal of pictoriality is historically and theoretically related to the Protestant and Judaic suspicion of picture-making. As I noted in the introduction, New York painters such as Mark Rothko were conscious of Jewish religious thought in relation to imagery; though at any one moment it is always hard to cite exactly how the relation works. And still more

recently, something of the same may be said of some conceptual art in which retinal pleasure has been ousted by cerebral challenge. The way in which the formal visual culture of this last fifty years has usually been displayed – in empty, white-painted rooms, judiciously supported by text – is also suggestive of the themes I have been exploring.

To take this a further stage still; the performance artist who uses his or her own body as the site of enacted metaphors is, like the seventeenth century Quaker, 'going as a sign'. But perhaps all this is does no more than to thicken the plot still further by suggesting that the last resort of philosophical theology in modern culture is in the practice and hermeneutics of the avant-garde.

In the domain of architecture and the decorative arts, the twentieth century was marked by a sustained refusal of decoration often loosely described as 'puritanical'. The difficulty here is that writers give us, once again, symptoms rather than diagnoses. A good example is provided in one of the best books on the architecture of Le Corbusier. Charles Jencks has written;

> When Le Corbusier wrote 'Precisions – the Present State of Architecture and Urbanism' in 1929 he must have been alluding to the meticulous ingenuity of his watchmaking ancestors whose survival often depended on their mechanical ability, for these were a persecuted sect of French Huguenots who fled to Switzerland in the sixteenth century. . . . He continually spoke of the persecution of his ancestors, the Albigensian heretics, and he apparently was fascinated by the fierce Manichean religion of the Cathars, with whom he directly identified.[4]

Later the architect is described as creating 'a sober, even Puritanical aesthetic', and of one of his salient ideas – the so-called Law of Mechanical Selection – 'One can see how this form of economic determinism would appeal to the Calvinist strain in Corbusier'. Suggestions of this kind are easy to make, but very hard to turn into argument; they are also confused, as if all these sects and persuasions were somehow the same, or even similar. But anyone acquainted with the buildings and the writings may well sense that something germane is being said here, even when we don't quite know what it is.

I have already noted the ways in which North American design has been interpreted as rooted in 'Puritanism' – correctly,

perhaps, but not always as clearly as it might have been. But more developed arguments have been made that in modern American literature we can trace *'the Calvinist roots of the Modern Era'*. These arguments trace the transformation of religious doctrine into social ideology, until in the twentieth century *'Calvinism appears as a psychological construct, a cultural institution or artefact, a habit of mind, or a socio-political structure'*.[5]

This thesis fits well, I believe, with my proposal that the Plain Style was *normalised* in the United States as the dominant visual ideology or aspect of habitus of the Colonial period and later. My criticism would be, that Protestantism, of which Calvinism was but one aspect, was from very early on inscribed in all those things as construct, institute, artefact, habit and structure, and it was because of that we are now able to speak consistently and meaningfully of a Plain Style and a Protestant aesthetic.

These writers show how this late 'cultural' Calvinism was defined and clarified by the opposition to it, either from within or without. They stress what they take to be a growing convergence between Calvinism (in its American context) and Modernism. However, their view of Calvinism is at some distance from the sect as social practice:

> *Both Calvinism and modernism encourage introspection, a heightened self-consciousness that reflects anxiety over an inability either to affirm or alter one's place in the universe. A paralysis of will and a failure to act, especially for one's own well-being, may equally affect the Calvinist and the modernist. Indeed, one might argue that modernism is a kind of Calvinism manqué; it maintains Calvinism's harshness and despair without its visionary idealism, and its suffering without salvation.[6]*

This passage, too, seems to me both usefully suggestive and historically wrong; it is a very harsh view of Calvinism, which evidence suggests was experienced, at least initially, as strenuous rather than despairing; and Calvinist communities have been notable for their intellectual energy and 'can-do' attitudes. Moreover, Calvinist organisation, as realised in Presbyterian principles of dispersed authority, is without doubt one of the foundations of contemporary democracy and the American Constitution. The visionary idealism which here is held to be absent from 'modernism' is an essential, almost defining

characteristic of much Modernism, not least that of Calvinist' Piet Mondrian. The most useful suggestion refers to the stress on introspection and heightened self-consciousness.

The habit of self-scrutiny, which was so important a part of Reformation spirituality and which was encouraged in all the reformed churches and sects, irrespective of doctrinal differences, is undeniably closely related to the relocation of authority which I have taken to be a key element in the aesthetics of the Plain Style. Self-scrutiny and self-responsibility are two sides of the same coin. I think I have sufficiently argued in the previous chapters that, in the historical circumstances under discussion, both pointed toward plainness and perspicuity. Whether or not they do so in all circumstances is clearly another matter for a different study, but if we go back to the beginnings of this argument and reconsider some of its premises, and the historical evidence of the Plain Style, then we might be able to distil from them groups of questions which are worth putting afresh in contemporary conditions.

In this sense, by making the underlying strata of the landscape more comprehensible, we are understanding our environment better.

The first group of questions will be seen, initially, as political and ethical. Where should power lie? The Protestant, and particularly Presbyterian concept of devolved or dispersed authority fits well with the retreat of state power. As state power retreats with the decline of the economic power of the nation state, a void is being left which is now being filled by global commercial interests that owe allegiance to no peoples and no institutions, which exist only to perpetuate themselves. The history of the Protestant churches afford many possible models for constructing forms of community politics that make participatory rather than baldly majoritarian democracy feasible. The defence of human variety and autonomy well come to rest on some of these.

The second surrounds the main aesthetic consequence of the Reformation – the removal of images. As never before we live in an image-saturated culture. Since the wood engraving was first reproduced in hot metal and incorporated directly into the print-form, and since the reproducible photographic negative was first invented (both in the 1840s), systems for the reproduction and broadcasting of imagery have interbred with

one another at ever increasing rates until, with digital technology melding all together, there seems to be no end to the variety, range, dispersion and penetration of imagery into every part of life and mind across the whole of the globe. This serves, as ever, the interests of power, and more especially, of commercial power as demonstrated in consumption and the ideology of the market. This image-mass, which is the defining characteristic of the culture in which we live, is produced in and by an immense and self-sustaining 'factory of idols'; whose function is the fetishisation of the commodity and eroticisation of consumption, information and the spectacle of politics. It is ubiquitous and inescapable. It is the water in which we swim.

The puritan divines and theologians feared the power of imagery to enchant the beholder out of his or her self-critical scrutiny and sense of responsibility. They attributed great persuasive power to pictures. They inclined to the view that imagery had demonic force. This is an idea that might be worth revisiting. The point has been well-taken by the propagandists of unrestrained consumption and the supposedly 'free' market. Any critical attempt to emancipate the mind and life from the habits of thought and the forms of consciousness into which they are cast by the self-perpetuating nature of this image-saturation is likely to return, in some form or another, to the kinds of questions asked in the sixteenth century. How this would be done today is difficult to determine and not the business of this book, but it seems to the writer that any attempt to bring consumption within globally sustainable demands and any attempt to look critically at the construction of our own *habitus* through imagery, will need to create an equivalent body of theory and commitment.

The matter is closely bound up with the issues of consumption and of liberty, and such an enquiry might help us to separate the two and to make it absolutely clear that high quantities of one do not equal high qualities of the other. What might be a new ethics of production? What would be a truly contemporary Plain Style? How can the market serve civil society rather than replace it?

It also touches on how we perceive our histories. I have written elsewhere on the construction of 'heritage' and of the importance of popular history.[7] A main theme in that work is the complicity of the image-industry in the spectacularisation of the past; and of

the relations of that enterprise to contemporary political understanding. The reduction of history to contrived spectacle is on a par with the fascist 'aestheticisation' of politics (of which so much has been written.)

A third cluster of questions concerns education, literacy and the kinds of learning and the kinds of knowledges that societies create and are created by. We have seen how the Reformation went hand-in-hand with a reform of the curriculum and teaching methods based upon the spoken word, the printed text, and the diagram. The aim was to emancipate the mind from the snares of actual or virtual imagery, to inculcate plainness of expression, directness of thought and methodical habits; and thereby to encourage a temper that was both practical and idealistic. In this it was formidably successful.

It is a truism to say that we have been living through a communications revolution similar in kind and scope to the typographical revolution of the sixteenth century. We assume that printing was a major factor in the growth of science, democracy and liberty; we expect the electronic revolution to perform equally far-reaching changes – though what and how we are still merely guessing.

It is not at all clear how formal education should respond to these developments. The fear would be that the strengths of typographic learning, the intense concentration, the systematic development of independent judgement and the predisposition to debate, would be lost in an affective, non-judgemental mist of 'interaction' (which at present, in practice, actually forecloses on the options of unassisted thought). To describe the problem in that way, of course, is to repeat the sixteenth century opposition between puritan plainness and baroque extravagance; it is more likely that the problem lies somewhere else, uncategorised and even unimagined, and that we have not yet spotted its location or even what it might look like. But it does seem urgent to decide just what sorts of knowledges and skills are best taught by whatever means. Text, for example, though very good at conveying compressed and edited information and chains of argument, is astonishingly bad at describing even the most simple practical operations, leading to the persistent down-grading of technical and artistic intelligence. Imagery, on the other hand, having little in the way of grammar or syntax, has great difficulty in developing argument and logic. Electronic means of data

retrieval and recording has resulted in floods of redundant and unedited 'information' becoming available to students (and others) who have not yet learnt to manage a sub-ordinate clause, let alone speak it aloud without stumbling. To sort out these questions would be to look at the process of reformation, and the Reformation, through new eyes. A start was made on this task by McLuhan, Ong, Eisenstein and others in the nineteen sixties, but it has been overtake by an enthusiasm for the new communications media which has more or less extinguished intelligent criticism.

The attitudes to authority, aesthetics and knowledge, and to consumption that I have been studying here seem to make a good starting point. The original questions provide a basis for a contemporary critique of citizenship, the use of resources and the means and limits of education. There might be much to be said for reconsidering the idea of a Plain Style.

1. Stefan Morawski, 'Marxist Historicism and the Philosophy of Art' in Porphyrios, D., On the Methodology of Architectural History, London (1981)
2. This question has been raised in different ways in the pages of CIRCA magazine (esp. No.26, Jan/Feb, 1986), and in various writings by Belinda Loftus, Sean McCrum, Bill Rolston, and others
3. See Robert Rosenblum, Modern Painting and the Northern Romantic Tradition, London (1975)
4. Jencks, C., Le Corbusier and the Tragic View of Architecture, London (1973), p. 17, 27, 53, etc
5. See esp. Barnstone, A., Manson M.T., and Singley, C.J., eds, The Calvinist Roots of the Modern Era, Hanover N.H. (1967). This book regrettably does not address itself to the most obvious example of all – the appearance of the buildings!
6. idem. p.xxii
7. See Brett (1996). See esp. Ch.4. 'The Technologies of Representation'

BIBLIOGRAPHY

Not included in this bibliography are such basic sources as the works of Calvin, Luther, the Tudor Royal Proclamations, John Foxe's *Acts and Monuments* and similar material. Most of the books cited have extensive bibliographies of their own.

Addleshaw, G., and Etchells, F., *The Architectural Setting of Anglican Worship*, London, 1948

Andrews, E., *The Gift to be Simple : Songs, Dances and Rituals of the American Shakers*, New York, 1940

Arnold, J. *Queen Elizabeth's Wardrobe Unlocked: an Inventory of the Wardrobe of Robes, 1600*, Leeds, 1988

Aston, M., *England's Iconoclasts* 2 vols, Oxford, 1988 and 1997

Ashwin, C., *Drawing and Education in German Speaking Europe 1800-1900*, Ann Arbor, 1981

Bach, J., *The Voices of the Turtledoves : The Sacred World of Ephrata*, Gottingen 2002

Barbour, H., and Roberts, A.O. (eds.), *Early Quaker Writings 1650-1700*, Grand Rapids, 1973

Barnstone, A., Manson, M.T., and Singley, C.J (eds.), *The Calvinist Roots of the Modern Era*, Hanover N.H., 1967

Bauman, R., *Let your Words be Few: Symbolism of Speaking and Silence among Seventeenth-Century Quakers*, Cambridge, 1983

Baynes, K., and Pugh, F., *The Art of the Engineer*, Guildford, 1983

Bennett, J.A., 'Christopher Wren; the natural causes of beauty', *Arch. Hist.*, Vol. XV (1972), pp.5-22

Booker, P.J., *A History of Engineering Drawing*, London, 1963

Bourdieu, P., *Distinctions : a Social Critique of the Judgement of Taste*, London, 1984

Bradshaw, B., *The Dissolution of the Monastic Orders in Ireland under Henry VIII*, Cambridge, 1974

Bragdon, C., *Six Lectures on Architecture*, Chicago, 1917

Broadbent, G., *Design in Architecture*, London, 1973

Buchanan, R., *Practical essays on Mill Work and Other Machinery*, 3rd. ed. London, 1841

Buckley, A.C., 'The Chosen Few: Biblical Texts in the regalia of an Ulster Secret Society', *Folk Life*, Vol. 24 (1986-6), pp.5-25

Canny, N., 'Why the Reformation failed in Ireland', *Journal of Ecclesiastical History*, Vol. 30, No.4, 1979, pp.423-450

Carroll, K., *Quakerism on the Eastern Shore*, Maryland Historical Society, 1970

Cescinsky, H., and Gribble, E., *Early English Furniture and Woodwork*, 2 vols., London, 1922

Cochrane, A.C., *Reformed Confassions of the Sixteenth Century; with an historical introduction*, Philadelphia,1966

Cohn, N., *The Pursuit of the Millennium*, London, Revised ed., 1970

Cook, G.H., *The English Cathedral Through the Centuries*, London, 1960

Collinson, P., *From Iconoclasm to Iconophobia:The Cultural Impact of the Second English Reformation*, Reading, 1986

 Archbishop Grindal 1519-83: The Struggle for the Reformed Church, London, 1979

 and Craig, J., (eds) *The Reformation in English Towns 1500-1640*, London, 1998

Corbishley, T., (ed and trans.) *The Spiritual Exercise of S. Ignatius Loyola*, London, 1973

Cowan, I.B., *The Scottish Reformation: Church and Society in Sixteenth-Century Scotland*, London,1982

Cox, J.E., *Thomas Cranmer: Miscellaneous Writings and Letters*, Cambridge 1846

Craig, M., *The Architecture of Ireland from the Earliest Times to 1880*, London, 1982

Davis, K.R., *Anabaptism and Asceticism: a study in intellectual origins*, Scottdale, Pennsylvania, 1974

Dickens, A.G., *Lollards and Protestants in the Diocese of York 1509-1558*, Oxford, 1959

Drummond, A., *The Church Architecture of Protestantism: and Historical and Constructive Study*, Edinburgh, 1934

Duke, A., Lewis, L., and Pettigrew, A., *Calvinism in Europe (1540-1610): a collection of documents*, Manchester, 1992

Freedberg, D., *Iconoclasm and Painting in the Revolt of the Netherlands*, London, 1988

 The Poser of Images: studies in the Histiory and Theory of Response. Chicago, 1989

Freeman, R., *English Emblem Books*, London, 1948

Ford, A., *The Protestant Reformation in Ireland 1590.1641*, Dublin, 1997

Garrett, W., *American Colonial: from Puritan Simplicity to Georgian Grace*, London/ New York ,1995

Garvan, A., 'The Protestant Plain Style before 1630', *Journal of the Society of Architectural Historians*, Sept. 1950

 Architecture and Town planning in Colonial Connecticut, Yale, 1951

Gilbert, C., *English Vernacular Furniture, 1750-1900*, Yale, 1991

Gilbert, K.R., *Henry Maudslay: Machine Builder*, London, 1971

Glassie, H., *Pattern in the Material Folk Culture of the Eastern United States*, Philadelphia, 1968

Hall, B., 'Puritanism: the problem of definition', *Studies in Church History*, Vol 2, ed. G. Cuming, London, 1965

Hamilton, A., *The Family of Love*, Cambridge, 1981

Herbert, G., *A Priest to the Temple, 1652*, Oxford, 1978 ed

Hill, C., *Society and Puritanism in Pre-Revolutionary England*, London, 1964

Hillebrand, H.J., *The Reformation in Its Own Words*, London, 1964

Holtgen, K.H., *Aspects of the Emblem: Studies in the English Emblem Tradition and the European Context*, Kassel, 1986

Hostetler, J.A., *Amish Society*, Baltimore, 4th ed. 1970

Howells, W.S., *Logic and Rhetoric in England, 1500-1700*, New York, 1961

Huray, P. le, *Music and the Reformation in England 1549-60*, London, 1967

Jencks, C., *Le Corbusier and the Tragic View of Architecture*, London, 1973

Johnson, P., *Elizabeth I: a Study in Power and Intellect*, London ,1974

Jones, W.R., 'Lollards and Images: The Defence of Religious Art in Later Medieval England', *Journal of the History of Ideas.* Vol.34, 1973, pp.27-50

Kaminsky, H., 'Wyclifism as an Ideology of Revolution' in *Church History,* 32 1963, pp.57-74

Keeble, N.H., *Richard Baxter: Puritan Man of Letters,* Oxford, 1982

Kidd, B.J., *Documents Illustrative of the Continental Reformation,* Oxford, 1911

Knowles, D., *Bare Ruined Choirs:The Dissolution of the English Monasteries,* Cambridge, 1976

Korzenik, D., *Drawn to Art: A Nineteenth Century American Dream,* Hanover, N.H., 1986

Kraybill, D.B, (ed.) *The Amish and the State*, Baltimore, 1993, 2000

Lidbetter, H., *The Friends Meeting House,* York ,1961

Leff, G., *Heresy in the Later Middle ages: The Relation of Heterodoxy to Dissent 1250-1450,* 2 vols, Manchester, 1967

Marsh, C.W., *The Family of Love in English Society, 1550-1630*, Cambridge, 1994

Matarasso, P., *The Cistercian World; monastic writings of the twelfth century,* London, 1993

Maclure, M., *St Paul's Cross Sermons, 1534-1642,* Toronto, 1957

McClean, A., *Humanism and the Rise of Science inTudor England*, London, 1972

McRoberts, D., 'Essays on the Scottish Reform', *The Innes Review,* Glasgow, 1962

Miller, G.E.P., *Nature's Nation*, New York, 1967

Miller, G.E.P., and Johnson, J.J., (eds) *The Puritans: a Source Book of their Writings,* New York, 1963

Moore, R.I., *The origins of European Dissent*, London, 1977

More, C., *Skill and the English Working Classes, 1870-1914*, London, 1980

Morton, A.L., *The World of the Ranters: Religious radicalism in the English Revolution,* London, 1970

Morawski, S., 'Marxist Historicism and the Philosophy of Art' in Porphyrios, D., (ed) *On the Methodology of Architectural History,* London,1981

Mowls, T., and Earnshaw, B., *Architecture Without Kings; the Rise of Puritan Classicism under Cromwell,* Manchester, 1995

Mullett, M.A., *Radical Religious Movements in Early Modern Europe*, London, 1980

Nasmyth, J., *Autobiography*, New York, 1883

Ong, W.J., *Ramus, Method and the Decay of Dialogue,* Harvard, 1958
 Rhetoric, Romance and Technology: Studies in the Interaction of Expression and Culture, Cornell, 1971

Paley, W., *Natural Theology: or Evidences of the Existence and attribute of the Deity Collected from the Appearances of Nature,* London, 1802

Panofsky, E., *Gothic Architecture and Scholasticism*, London, 1957

Phillips, J., *The Reformation of Images: The Destruction of Art in England, 1535-1640,* Los Angeles, 1973

Pulos, A.J., *American Design Ethic*, Cambridge, Mass., 1983

Raistrick, R., *Quakers in Science and Industry,* Newton Abbott, 1968

Rieman, T.D., and Burks, J.M., *The Complete Book of Shaker Furniture*, New

York, 1993

Ronan, M.V., *The Reformation in Dublin, 1535-1588*, London, 1926

Rosenblum, R., *Modern Painting and the Northern Romantic Tradition*, London, 1975

Rossi, P., *Philosophy, Technology and the Arts in the Early Modern Period*, New York, 1970

Francis Bacon: from Magic to Science, London, 1968

Rupp, G., *Patterns of Reformation*, London, 1969

Scavizzi, G., *The Controversy on Images; from Calvin to Baronius*, New York, 1992

Scholes, P.A., *The Puritans and Their Music*, Oxford, 1934

Scribner, R.W., *For the Sake of Simple Folk: Popular Propaganda for the German Reformation*, Cambridge, 1981

Schaefer, H., *The Roots of Modern Design*, London, 1970

Scholem G. *Major Trends in Jewish Mysticism*, London, 1955

Seabourne, M., *The English School; Its Architecture and Organization*, London, 1971

Sider, R.J., *Andreas Bodenstein von Karlstadt: the development of his thought, 1517-1525*, Leiden, 1974

Smalley, B., 'The Bible and Eternity: John Wyclif's Dilemma' in *Journal of the Warburg and Courtauld Institues*, Vol. 27, 1964

Stone, L., *Sculpture in Britain in the Middle Ages*, London, 2nd ed., 1972

Strong, R., *Gloriana; the Portraits of Elizabeth I*, London, 1987

Swank, S.T., *Shaker Life and Architecture: Hands to Work and Hearts to God*, New York, 1999

Taylor, E.G.R., *The Mathematical Practitioners of Tudor and Stuart England*, Cambridge, 1954

Thompson, E.P., *The Making of the English Working Class*, London, 1963

Turner H.W., *From Temple to Meetinghouse*, The Hague, 1979

Wanscher, O., *The Art of Furniture: 5000 Years of Furniture and Interiors*, London, 1968

Watts, M.R., *The Dissenters from the Reformation to the French Revolution*, Oxford, 1978

Weber, M., *The Protestant Ethic and the Spirit of Capitalism*, tr. Parsons, London, 1976

Wencelius, L., *L'Esthetique de Jean Calvin*, Paris, 1936

Woodhouse, A.S.P., (ed) *Puritanism and Liberty: being the Army debates 1647-9*, London, 1938

Yates, F., *The Theatre of the World*, London, 1969

The Art of Memory, London, 1966

The Rosicrucian Enlightenment, London, 1972

Young, A.R., (ed) *The English Emblem Tradition: Henry Peacham's Manuscript Emblem Books*, Toronto, 1998

de Zurko, E.R., *Origins of Functionalist Theory*, New York, 1957

Index of Names

Index of Topics

Index of Places